Regula Laux, Jean-Marc Felix

Every Wall Is a Door

Urban Art: Artists. Works. Stories.

BENTELI

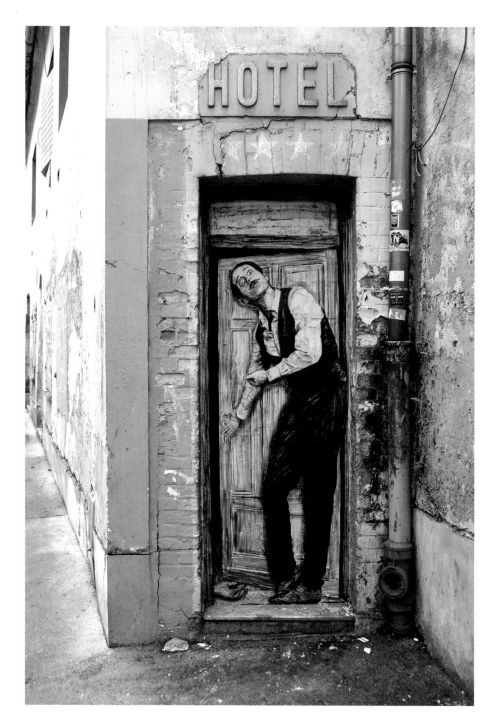

"Welcome" is the name of this work by the Frenchman Levalet. For more works and a portrait of the artist, see pages 100 to 103

Table of Contents

INTRODUCTION

Urban art, street art, graffiti …

Urban art is the umbrella term. It refers to legal or illegal art created in public spaces. That includes monuments, sculptures, installations and interventions as well as street art, graffiti and pavement art. As an art form that's in constant motion, urban art covers a broad spectrum of murals, interventions, stencils, paste-ups and stickers of these mostly illegal, transitory and frequently site-specific works.

With their art in public spaces, the practitioners, the artists themselves, are mostly concerned with self expression. But they often also want to issue wake-up calls and provoke discussion about social, cultural or political grievances. They want to pose questions, pick fights, precipitate incidents and take back public space, which in their eyes has been held hostage to advertisements and imprisoned on sterile concrete walls.

A personal snap-shot
of the international urban art scene

"Every wall is a door" – this statement by the American poet Ralph Waldo Emerson (1803–1882) has become relevant again in the context of street art. Street art opens doors. We found that out by doing the research for this book: In their creation as well as their subjects, murals are inclusive and often surprising. We constantly came across similar subject matter around the world, prepared differently, often running into old acquaintances, or at least friends of friends and people from the same network. Because of the networking and internationality of the scene it was difficult with some of the artists to assign them to a specific country.

It's not our purpose here to provide a comprehensive treatment of street art and the artists. We're more concerned with providing a very personal snap-shot of the international scene. We spent a lot of time with camera and notepad tracking down street art works and the artists in different cities. But not just on the streets. Also in museums and galleries where street art is gaining ground. Our many personal encounters with artists, exhibition sponsors, curators and organizers did something to us.

We want this book to show the high artistic and creative level of this young art genre. Maybe we'll be able to affect you, too, with some of our fascination and enthusiasm. That would be nice.

Regula Laux / Jean-Marc Felix

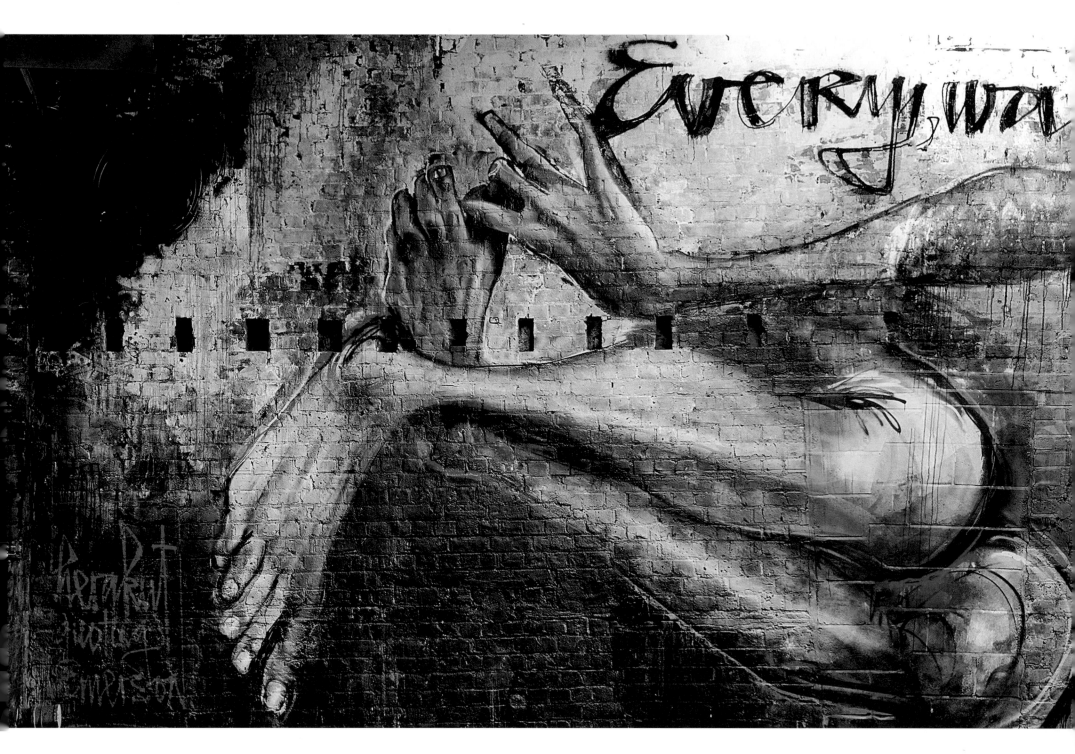

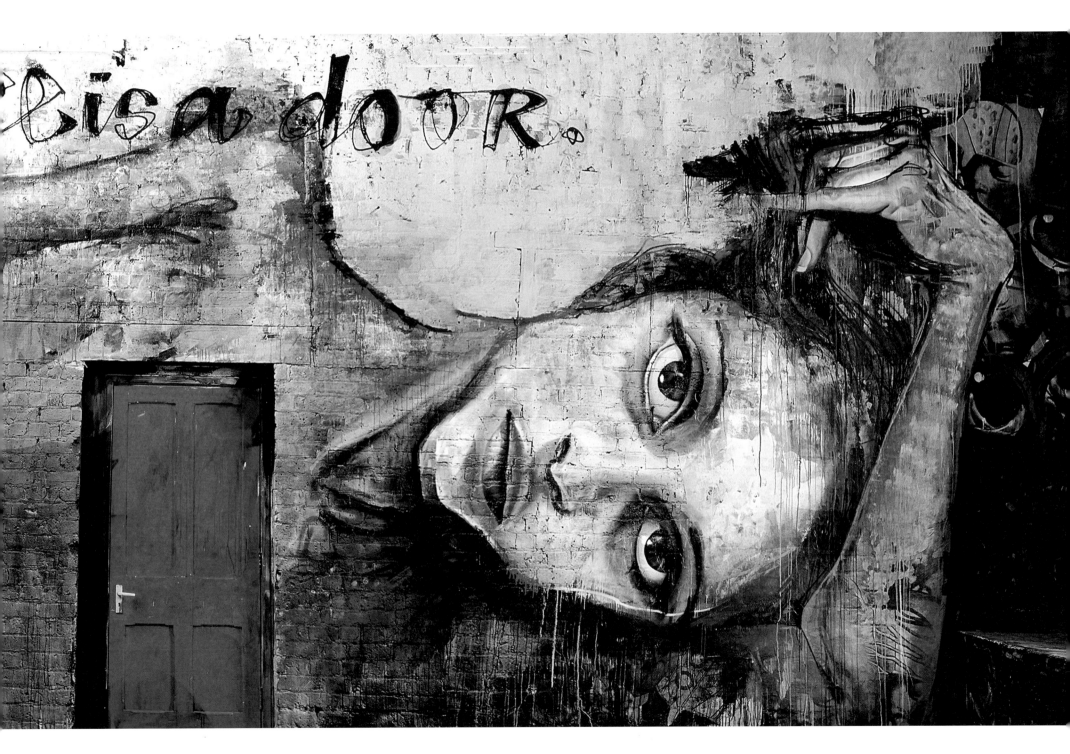

New York

New York is the city of superlatives, also for urban art since the beginning of the movement when youth at the end of the 1960s put their tags on walls and New York subway cars. The scene really took off 20 years later. Among the many artists from this time was the stand-out Keith Haring, who decorated the subway with chalk drawings and was the first to paint the famous Houston Bowery Wall in Lower Manhattan. Since then New York has become the Mecca of urban art, attracting artists from around the world. The scene has in the meanwhile spread to all five boroughs of the Big Apple and is alive and well. New works are constantly being created while others disappear, either painted over or torn down when the building is demolished.

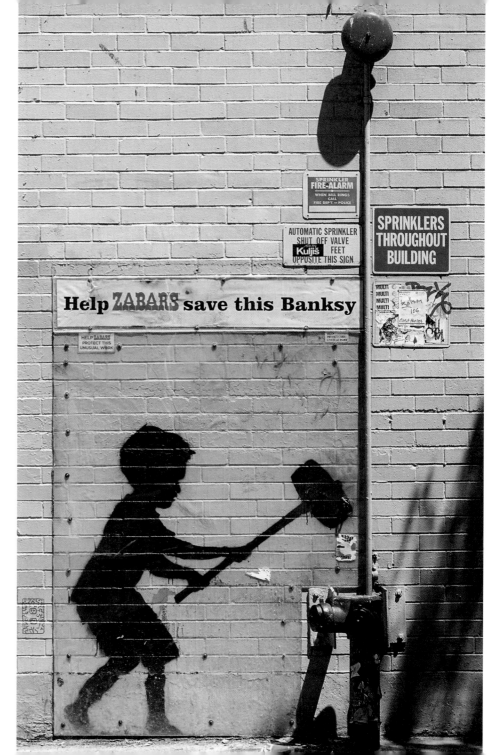

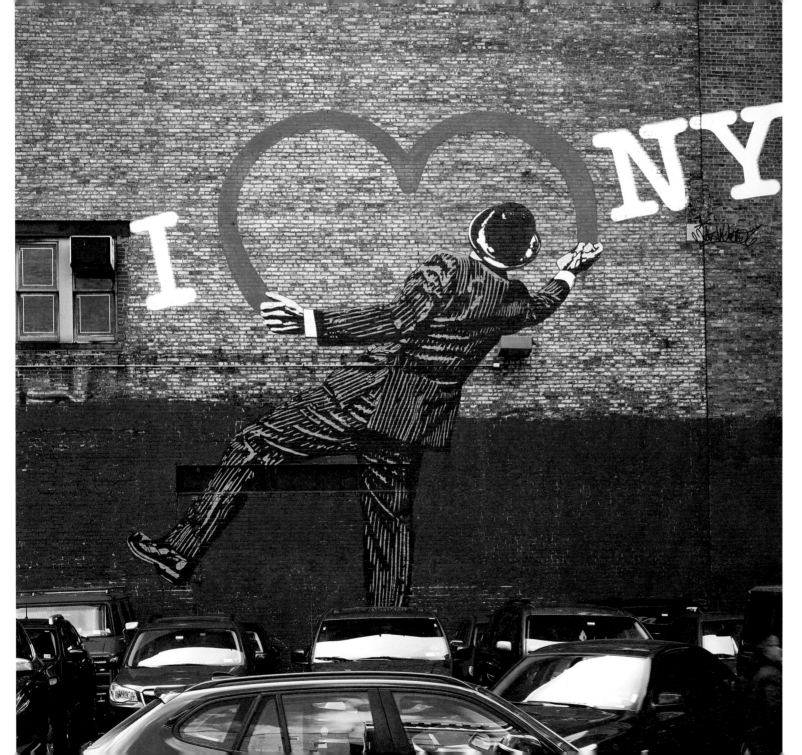

"Love Vandal", a declaration of love to New York
by Nick Walker from Great Britain, in the middle
of Manhattan

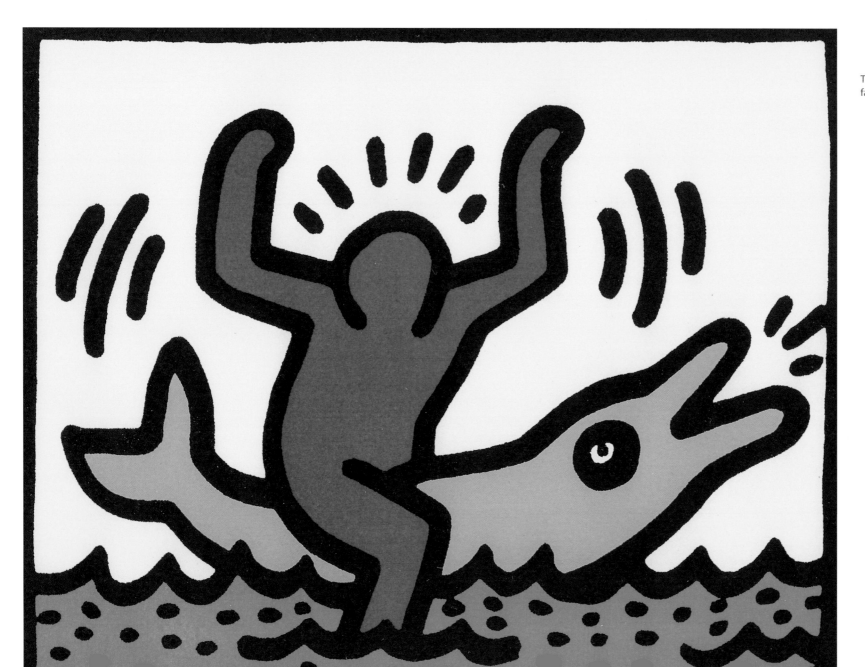

There are several color versions of the famous "Dolphin Rider" by Keith Haring

In 1985 Keith Haring created this picture for the "United Nations International Youth Year". It's supposed to express the significance of youth for the shaping of the future

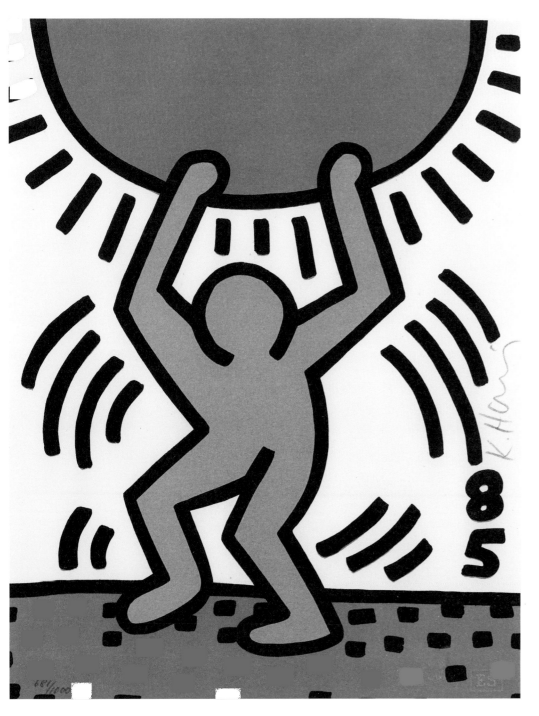

Keith Haring and his famous stick figures

Who hasn't seen them, those simple, colorful stick figures, jumping, dancing, rejoicing and next to, on top or merging with each other? The American artist, born in 1958 in Pennsylvania, first came to public attention at the age of 20 with his chalk drawings on the billboards in the New York subway: The "Radiant Baby" became his symbol. Then came the chalk drawings on black paper, followed by painting on plastic, metal and found objects.

At the beginning of the 1980s Keith Haring also painted an "Andy Mouse", a cross between Andy Warhol and Mickey Mouse for his friend, Andy Warhol. That became his international breakthrough. He painted walls around the world, began painting on canvas and created a body painting for Grace Jones for the video shoot of "I'm not perfect".

Haring took part with his art in various benefit campaigns against AIDS. He was diagnosed with the immunodeficiency disease in 1988. A Keith-Haring foundation was founded and in 1990 he died from AIDS related complications.

But the Keith Haring figures live on, at least as reproductions on postcards, T-shirts and cups in the museum shops around the world …

Queens Welling Court Mural Project

In 2009 the community of Welling Court in the borough of Queens decided to commission a "Mural Project" with the same name, in order "to beautify their neighborhood", as the website explains. The initiative started with 40 murals distributed throughout the neighborhood. Only a few years later the number had grown to 150, with new ones added every year by artists from around the world.

Zéh Palito lives and works in São Paulo, Brazil. He painted the work "We Are One" with his brother Werc

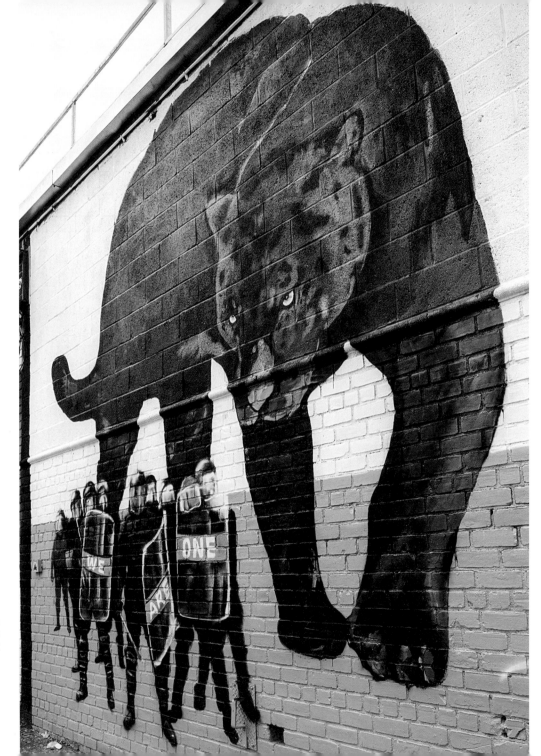

«The mural is not anti-cop or anti-any ‹race›. We believe that we are one human family that can come together to overcome this trying time.»

Werc and Zéh Palito

Lexi Bella and Danielle Mastrion live in Brooklyn and often work together. Danielle's goal is to leave behind a work in every city she visits, around the world

▶ Page 16
Tony "Rubin" Sjöman has Scandinavian roots. "Hisingen Blues", named after a Swedish island, is one of several works he created with Joe Iurato

Page 17
Pyramid Oracle comes from the US mid-west, where he works most of the time

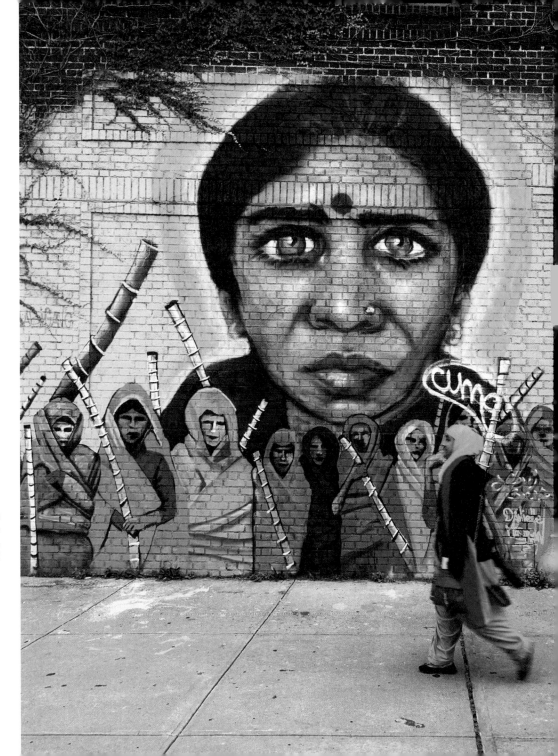

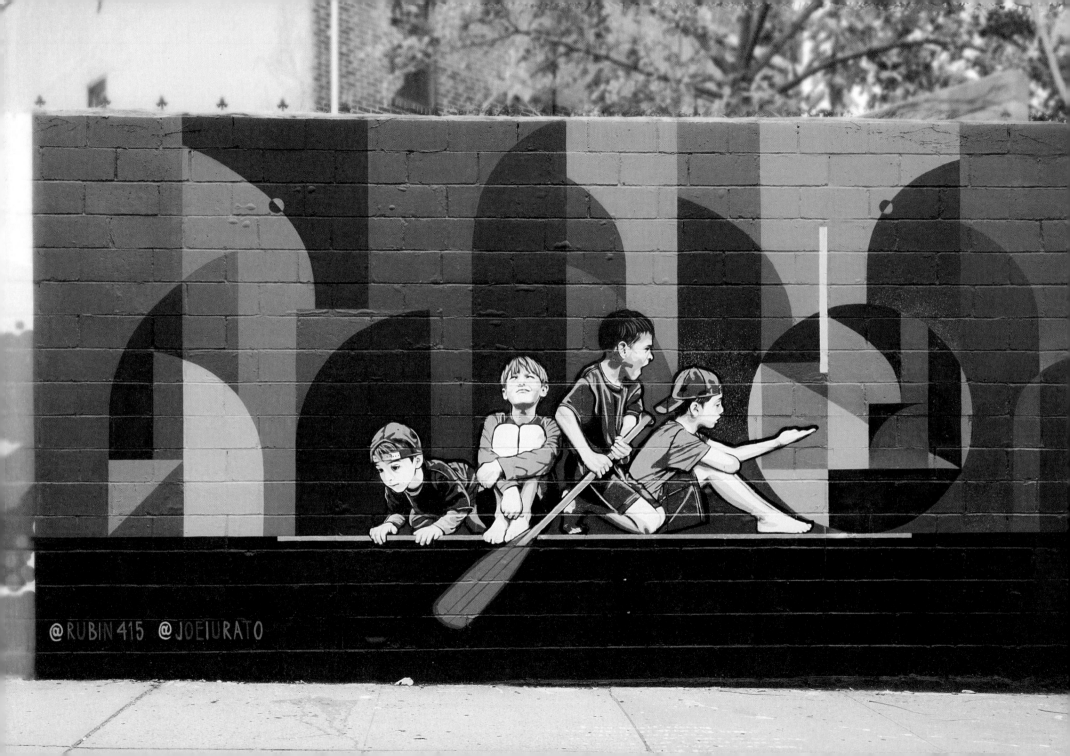

@RUBIN 415 @JOEIURATO

Brooklyn Bushwick Collective

It's only a few minutes by foot from the Jefferson Street station on the L train in Brooklyn to the fascinating Bushwick Collective open-air gallery. Joseph Ficarola, who was raised here, remembers that when he grew up in the 1980s he was not allowed to play on the street because it was too dangerous. In 2011, after a few strokes of fate, he decided to give the surroundings a new face. He founded the Bushwick Collective, which in the meantime has become one of the most important addresses for urban artists around the world.

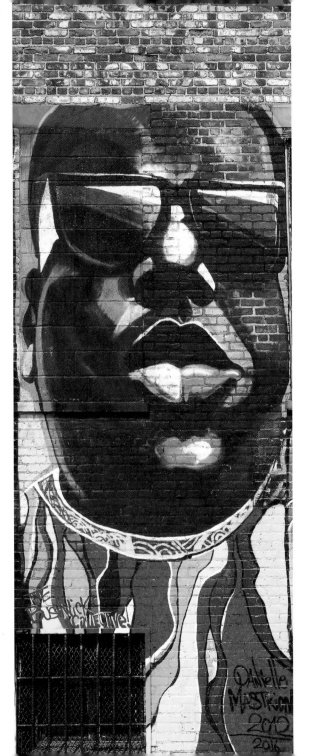

Danielle Mastrion's portrait "The Notorious B.I.G." is a cult icon. The Brooklyn-born rapper was shot in 1997 in Los Angeles

«I'm from Brooklyn. If you would have said to me 15 years ago, or even 10, that Bushwick would become the next ‹art› neighborhood, I would have thought you were crazy.»

Danielle Mastrion

The portrait of a woman is by Michel "Mitch" Velt from Holland. The Englishman Stik painted the little men on the roof

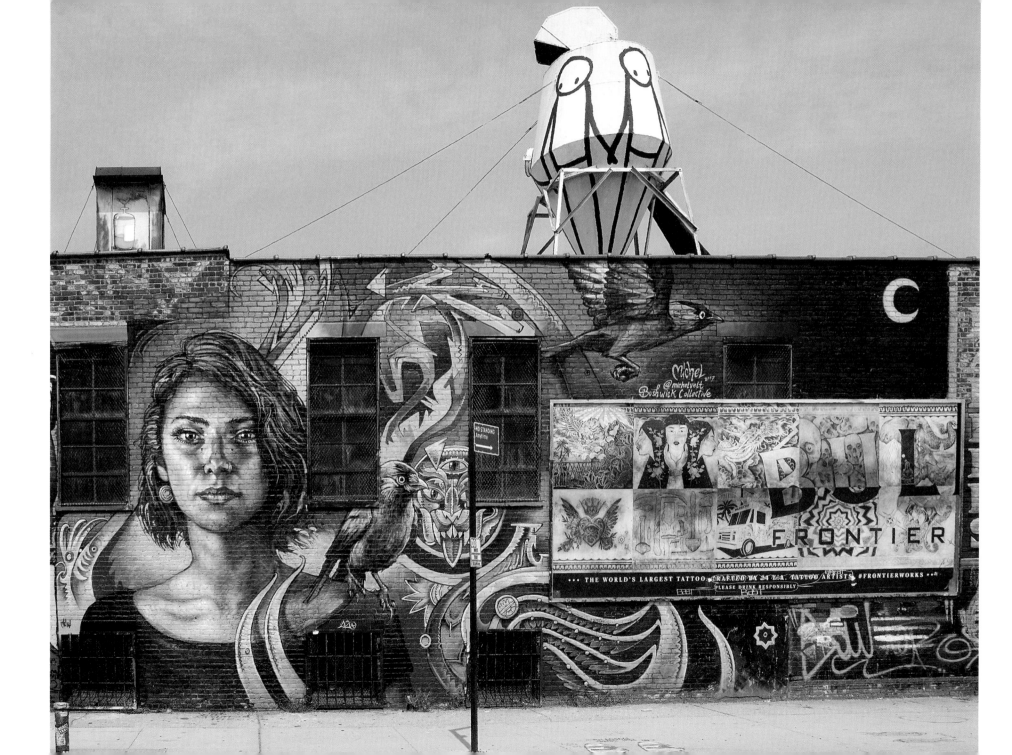

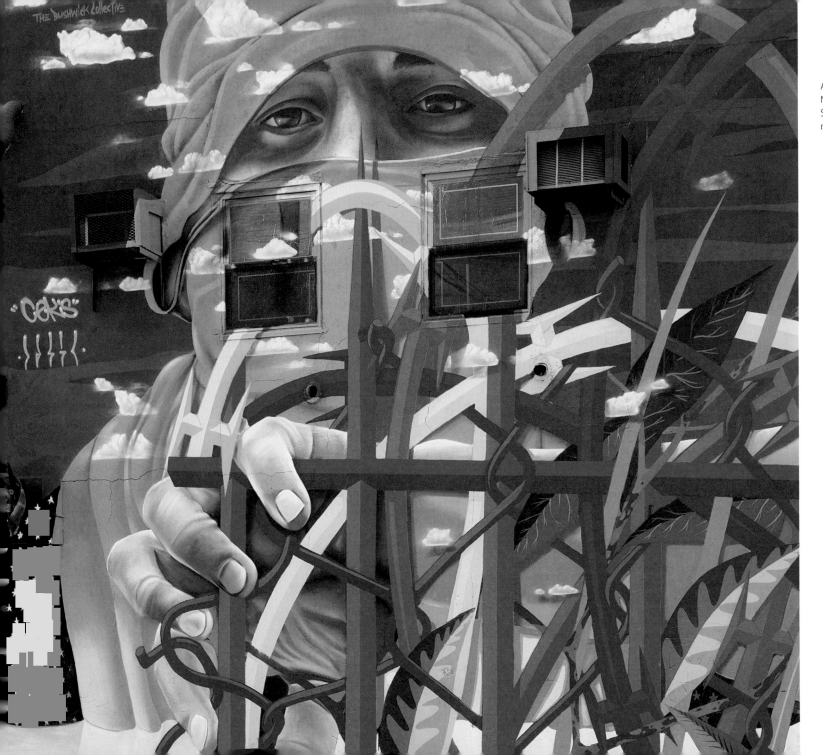

A joint mural by the Chileans Dasic Fernandez and Nelson Riva Cekis. The fence recalls Cekis' "Fence Series", which reflects his time as a young immigrant in New York when he felt being trapped

"Sight of the Sea" is the name of the work by the two stencil artists Joe Iurato and Logan Hicks. For a portrait of Logan Hicks see page 29

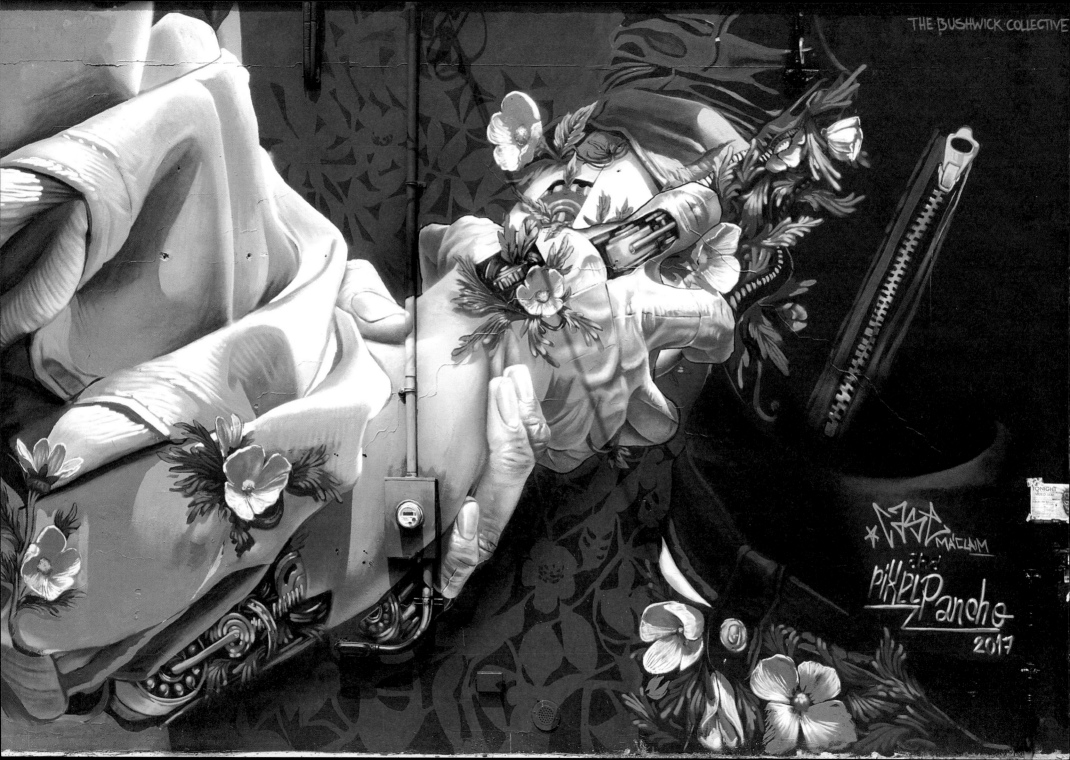

The large-scale murals by the Italian Pixel Pancho often incorporate elements of robots, combined here with the signature hands of the German artist CASE

«That's all I really wanted to ever do: To just get people to stop and maybe introduce art into their lives.»

*D*Face*

"Till Death Do Us Part" is the sarcastic title of the work by D*Face. The exceedingly versatile Dean Stockton from London is the man behind this artist's name

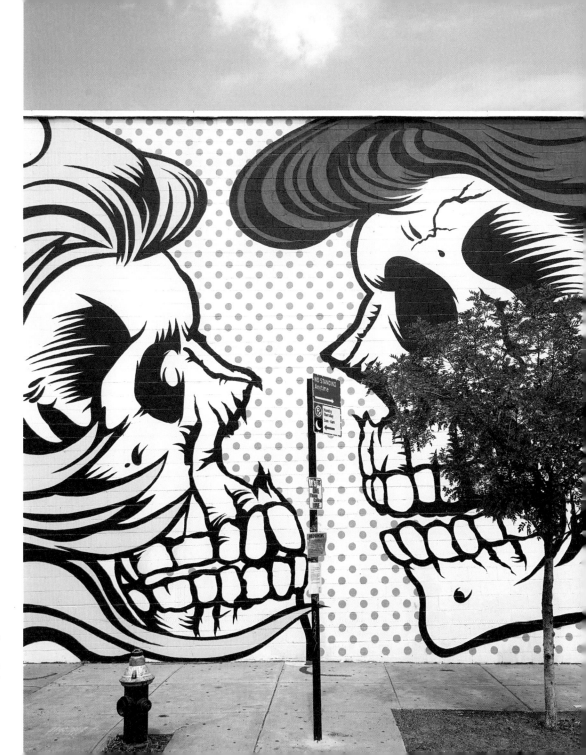

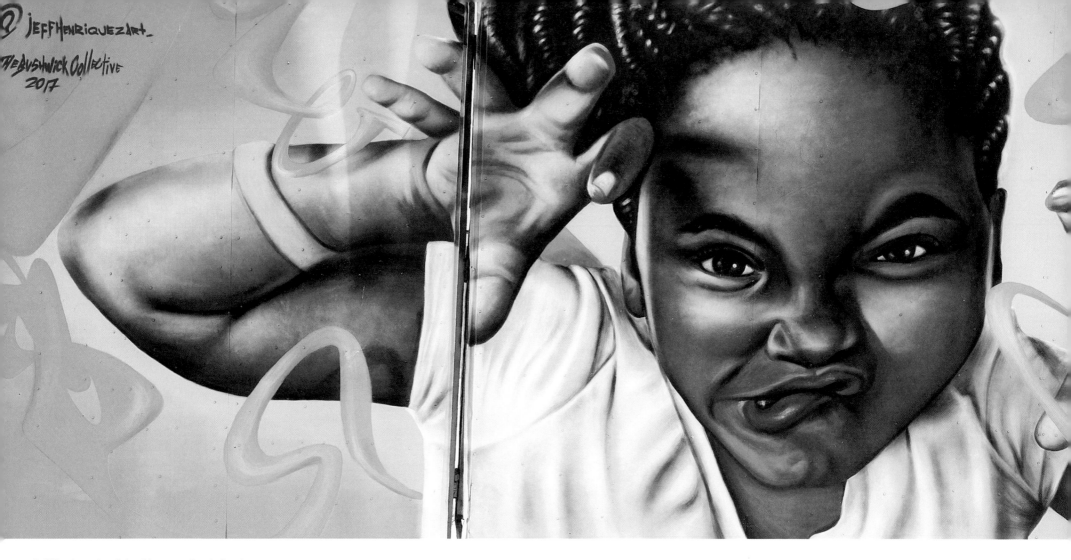

Jeff Henriquez has Columbian roots, lives in Brook-
lyn and prefers oversized, photorealistic portraits

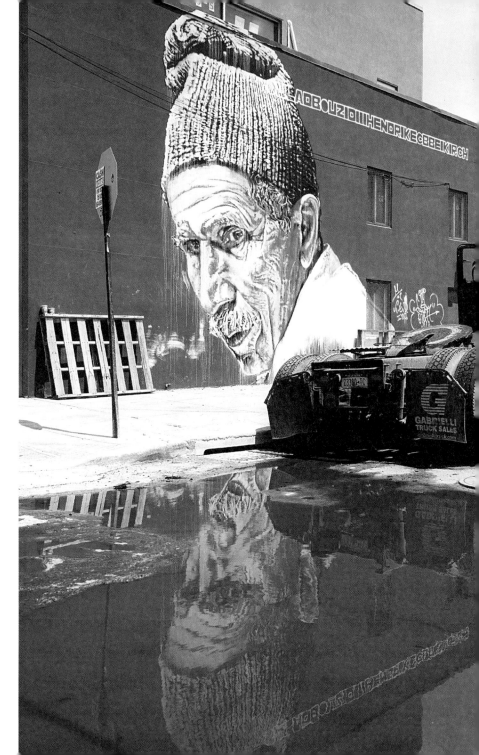

This mural painting by the German artist
Hendrik Beikirch depicts a Moroccan street barber
from the "Tracing Morocco" series. For a portrait of
the artist see page 96

Lower Manhattan
Houston Bowery Wall

If you google "urban art in Manhattan" you'll find many hits in the south of the borough, where the famous Houston Bowery Wall is located. Keith Haring was the first to spray-paint the wall in 1982. Since then new artists are invited every couple of months to do the same. More than 30 years after Haring, Logan Hicks created his largest stencil work to date:

"The Story of My Life". He gathered friends, family members and business partners in the Soho district for a giant photo shoot. Hicks then composed one large photo from the hundreds taken that became the basis for the impressive work which he painted on a 9 meter high and 21 meter long wall with more than 1,000 stencils.

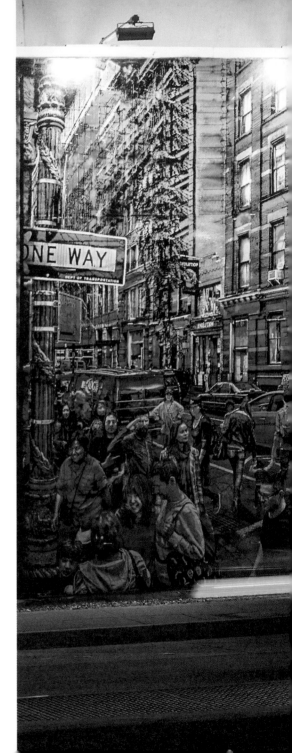

"The Story of My Life", Logan Hicks's biggest mural to date, immortalizing friends, family members and business partners

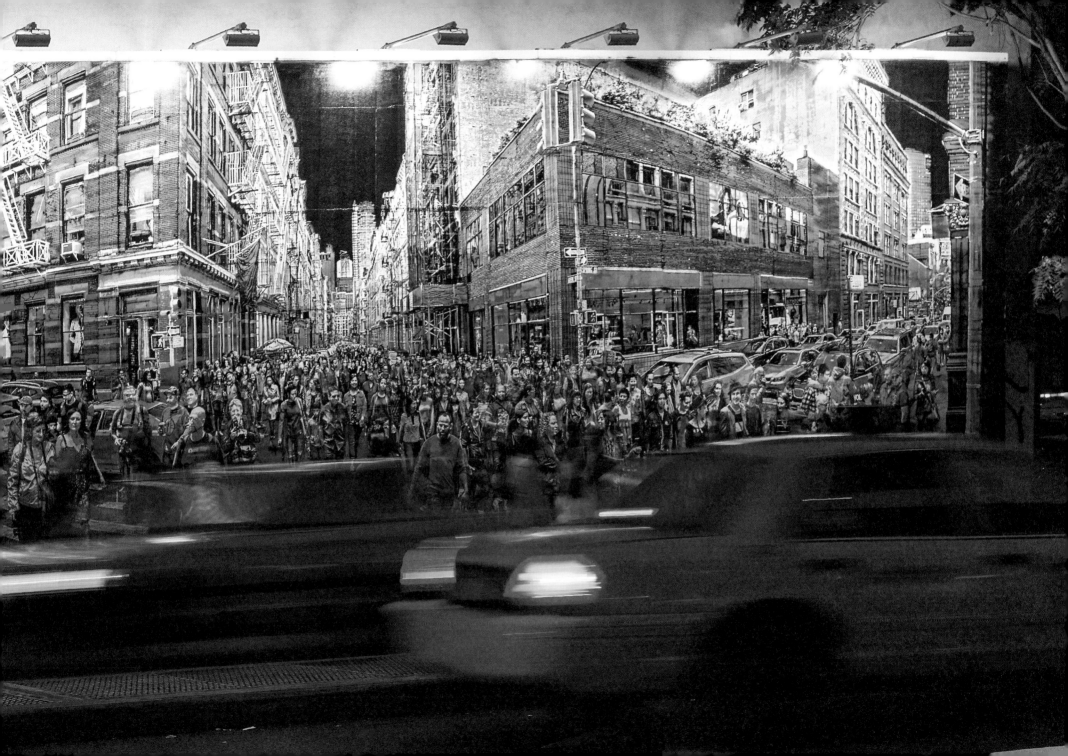

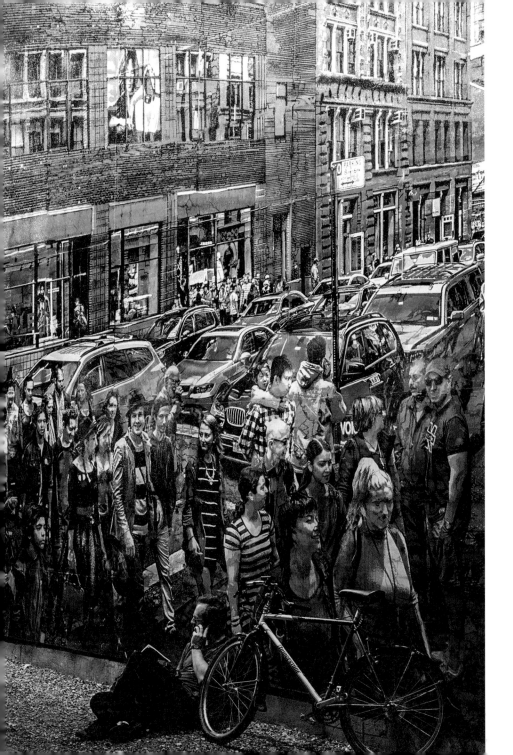

Details of the mural "The Story of My Life".
The boundaries between picture and reality
become blurred

Logan Hicks
"Street art is actually dead"

"My job is to design good art and to show it to as many people as possible, in a museum, a gallery or on the street. I don't have a political message", says Logan Hicks. Hicks has no prior street art career with nocturnal outings and illegal works. He studied at the Maryland Institute of Contemporary Art, earning money with art prints. After a few years in California he moved to New York and in the last ten years became "one of the leading figures of stencil", as reported by the professional magazine "Graffitiart".

In 2016 he was invited to paint the legendary Houston Bowery Wall. He called his work "The Story of My Life" and had this to say: "Doing a mural on the Houston Bowery Wall is a celebration of my ten years mark in New York. And for many, myself included, it's the crown jewel when it comes to street art or murals in general. It's the largest and most visible wall in New York City."

How does Logan Hicks see the future of street art? "The genre is actually dead. But there's no good name for what has come after it." Street art is the first art form of the digital era. Art works are publicized around the world within seconds. Many people who are creating art are roaming the internet, "but like in other areas in ten years you will only remember a few of them", according to Logan Hicks. His place in the history of urban art is already secure. At the beginning of 2018 in Miami he received the prestigious "Tony Goldman Lifetime Artistic Achievement Award".

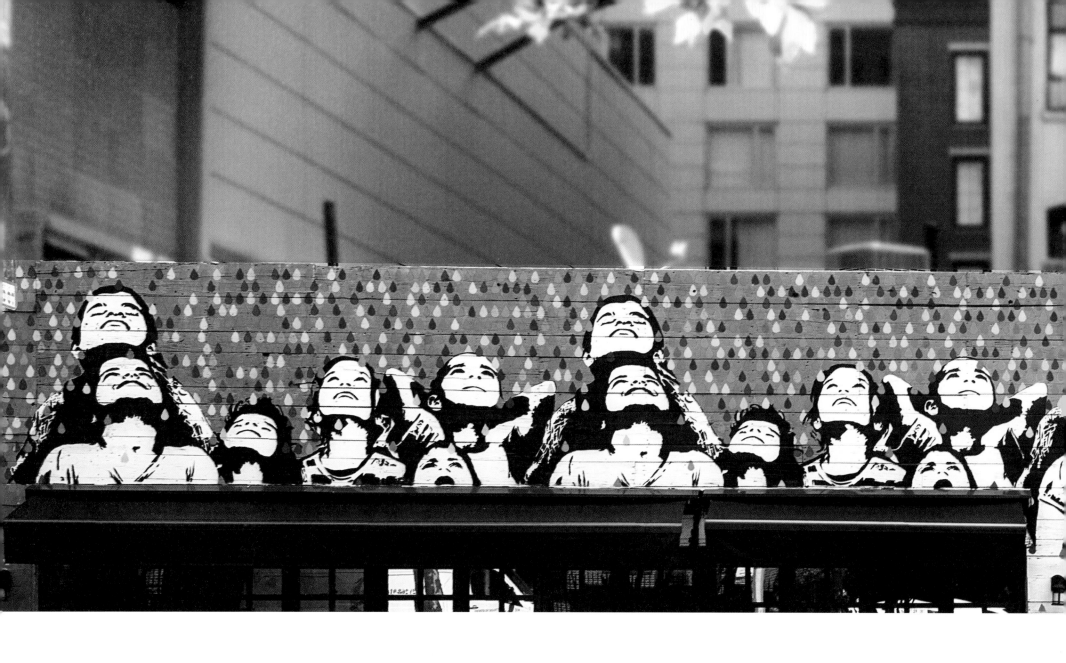

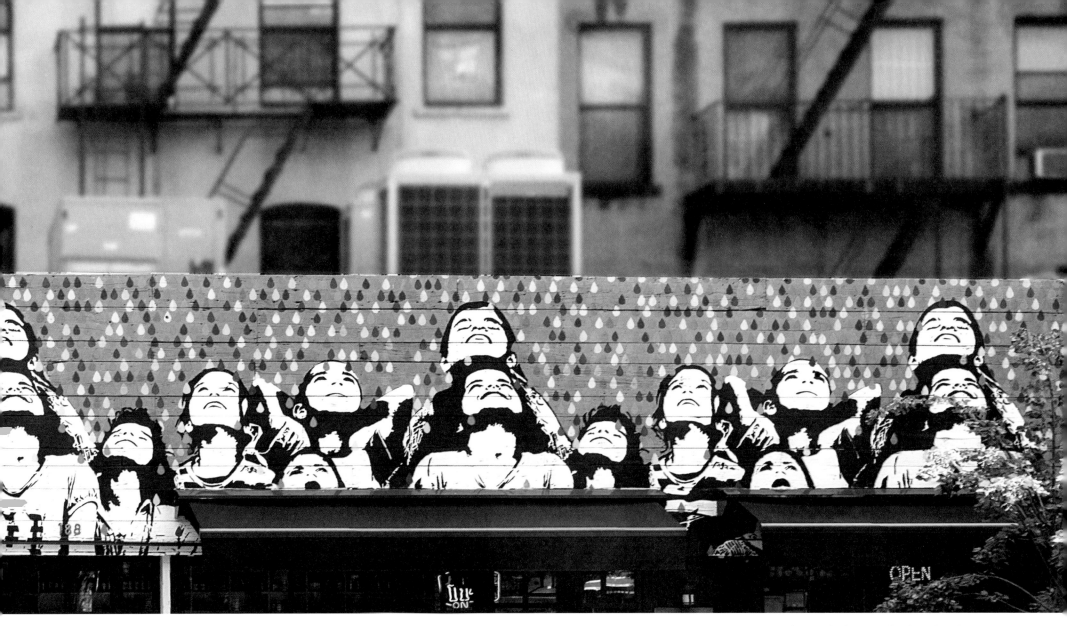

"Color Rain" by the Iranian brothers ICY and SOT, who live in Brooklyn. They have been internationally exhibiting their work on social, political and ecological subjects since 2006

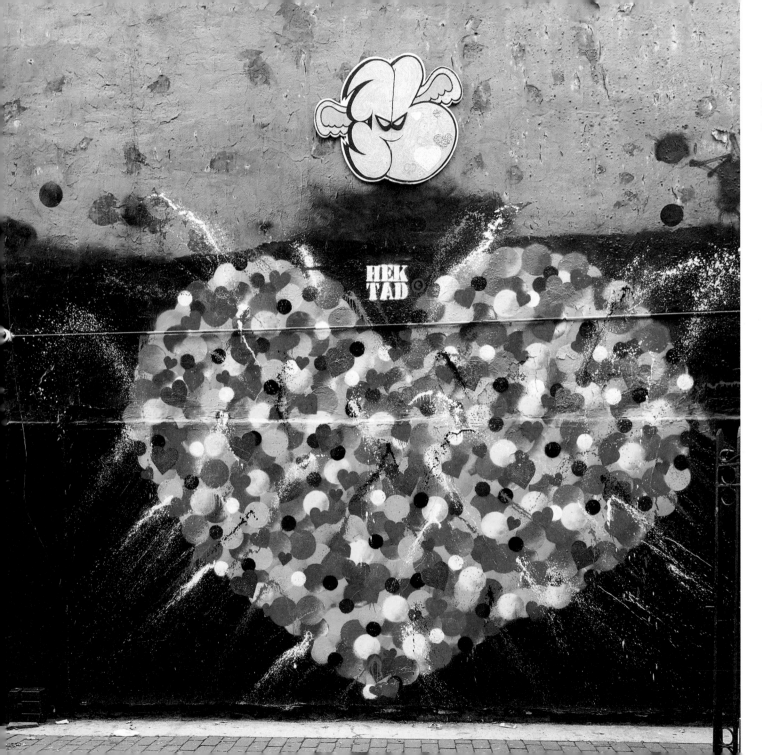

HEKTAD grew up in the Bronx. His name is composed from his tag, HEK and the abbreviation TAD, the name of his former crew. He has decorated many walls in New York with his hearts

Jerkface from Queens has made a name for himself with the interpretation of pop-art

"NYC Vandal" is the name that Key Detail, from Minsk in Belarus, called his work

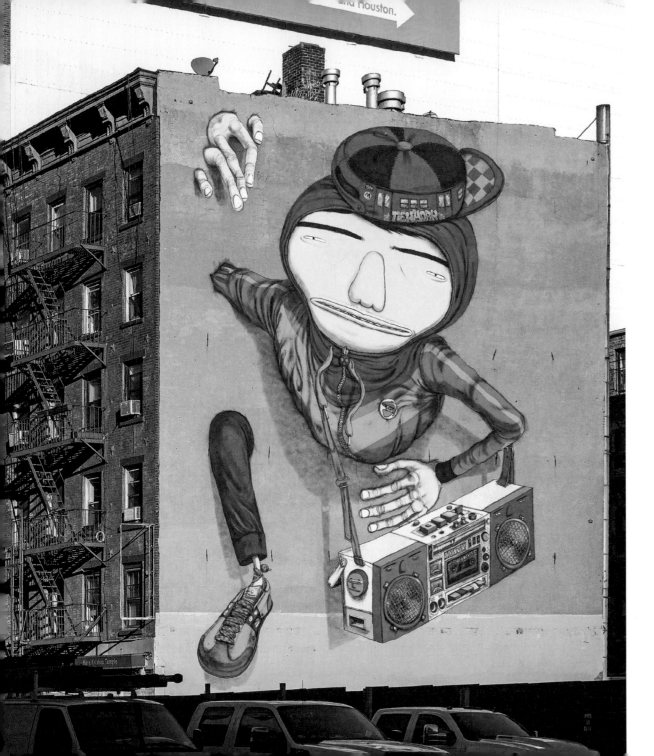

With their mural "B-Boy" the Brazilian twins Os
Gêmeos recall their own past as break-dancers.
For a portrait of the artists see page 91

The two artists Solus from Ireland and John
"CRASH" Matos from New York paid tribute to the
punk legend Joey Ramone with this mural

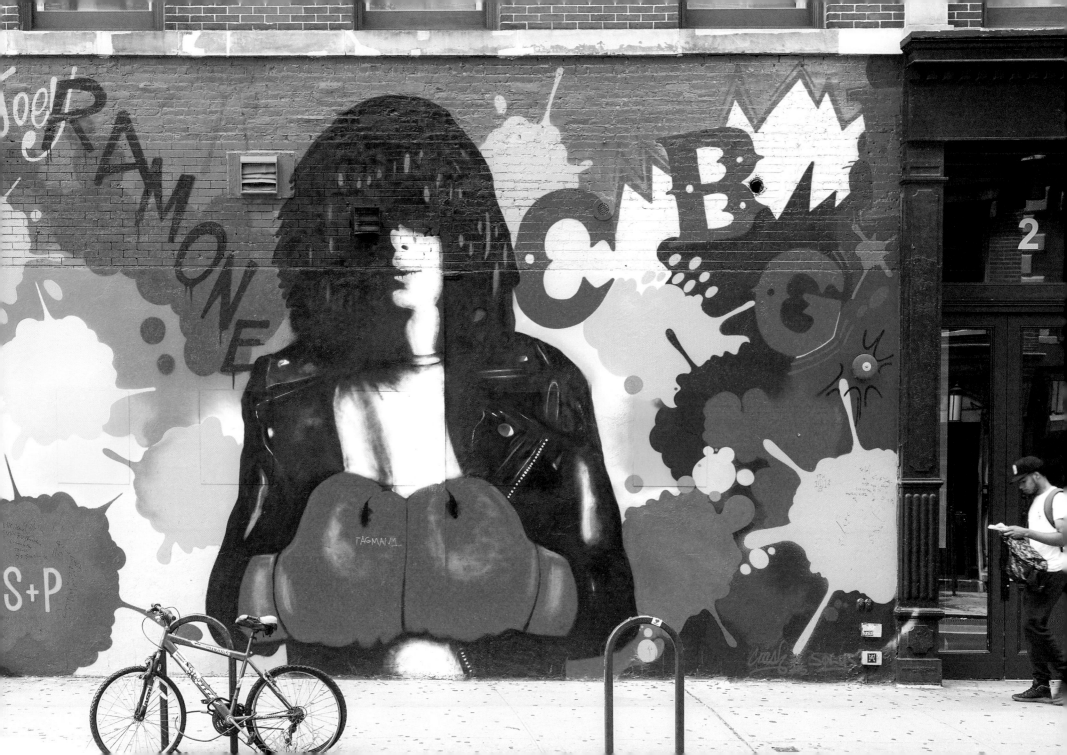

Miami Wynwood Walls

A low-flying airplane is a reminder that Wynwood was a loud, run-down district with abandoned warehouses in the approach corridor of the Miami International Airport before Tony Goldman initiated the Wynwood Walls project in 2009. The founder of Goldman Properties, a prominent real estate company, had a vision: "Wynwood's large stock of warehouse buildings, all with no windows, would be my giant canvas to bring to them the greatest street art ever seen in one place." Tony Goldman passed away three years later. His daughter, Jessica, assumed leadership of the family business and continued to develop Wynwood Walls, with great success. Wynwood Walls has hosted more than 50 artists from almost 20 countries since then.

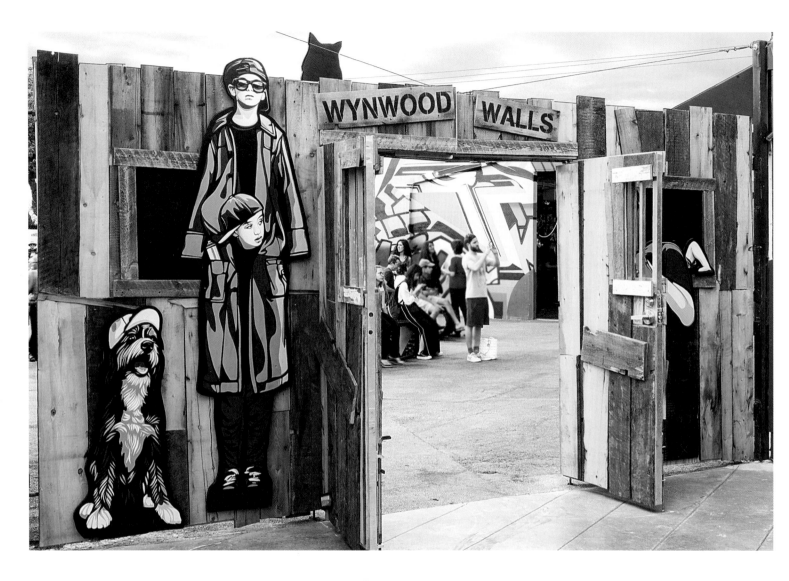

Along with the countless works outside the Walls, Wynwood became a must for those interested in urban art with the number of visitors from around the world climbing to one million. An artist who moved from New York to Florida said: "What goes on here is unbelievable." And there's no end in sight.

Joe Iurato lives with his family in New Jersey. His two sons often serve as inspirations for his stencil and spray paint works

Andreas von Chrzanowski alias CASE from Germany works primarily with spray paint. The oversized hands are one of his trademarks, seen around the world

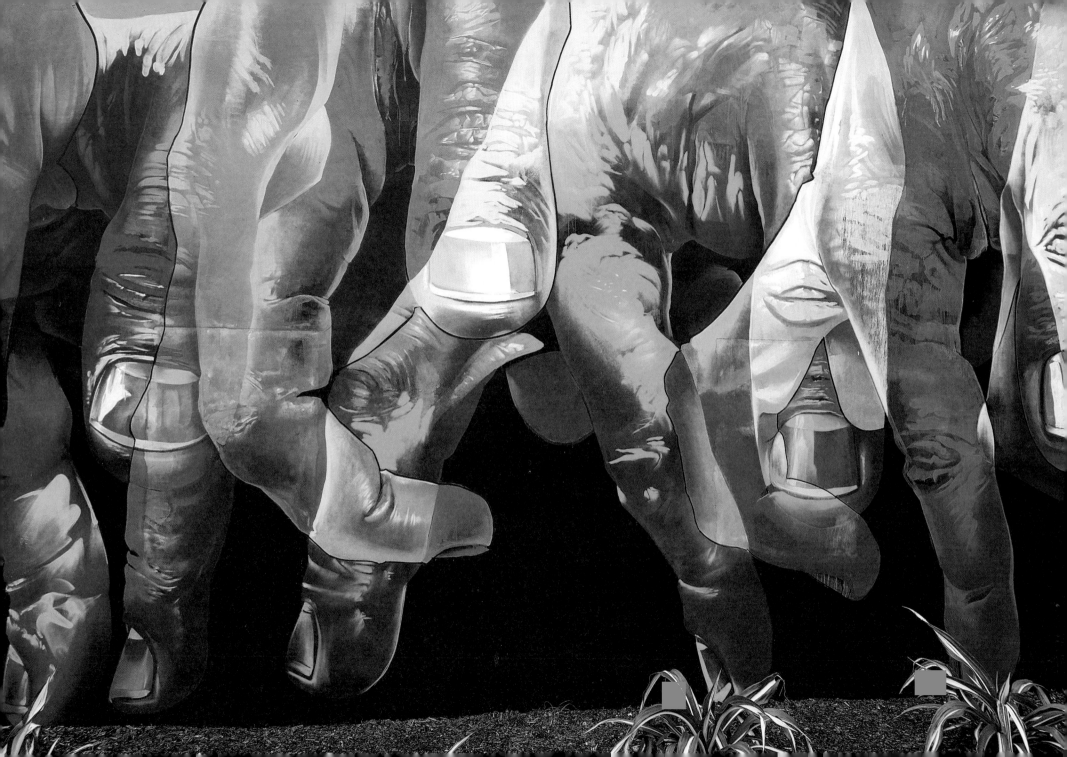

Shepard Fairey is an extremely versatile artist. His portrait of the Wynwood Walls initiator, Tony Goldman, is an homage to the prematurely deceased art sponsor

Jessica Goldman Srebnick
"We all have to make a big effort to be kind to one another"

Jessica Goldman Srebnick is considered one of the influential voices of the street art movement. In 2012 she assumed leadership of the Goldman Properties real estate empire created by her legendary father, Tony Goldman. One of the goals of the company is to breathe new life into dilapidated city districts. "We look at the DNA of neighborhoods, we look what's there and how we can improve that", she says. In comparison with other projects Wynwood had no particular architecture and no historical background. But there was street art. "And there was a lot of it", she found out. That recognition became the seed crystal for Wynwood Walls and the whole district. Jessica is certain that Wynwood has made a contribution to the development of street art as an artistic genre. "We try to take it to another level by setting standards."

The crown jewel of Wynwood, the Wynwood Walls, is a giant open-air gallery where anyone can view the works for free and watch the artists at work. Jessica Goldman is convinced that "Museums and galleries are wonderful but to a majority of the population they are highly intimidating". People don't have to feel that way in Wynwood; everyone is welcome.

She stresses the following point: "It is really important in these days to recognize that we are all human beings and that we all have to make a big effort to be kind to one another." Which is why the motto of the exhibition this year is "Human Kind".

Jessica Goldman Srebnick,
CEO Goldman Properties

"American Power" is the name of the work by the artist from Los Angeles, Tristan Eaton. He is also known as a designer, especially of toys

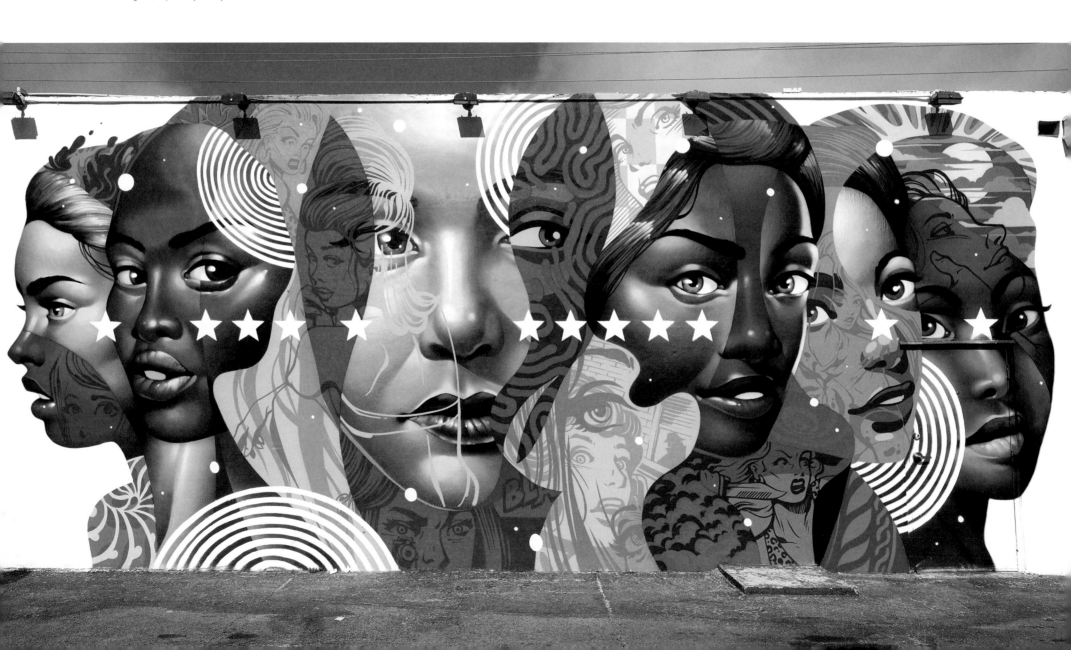

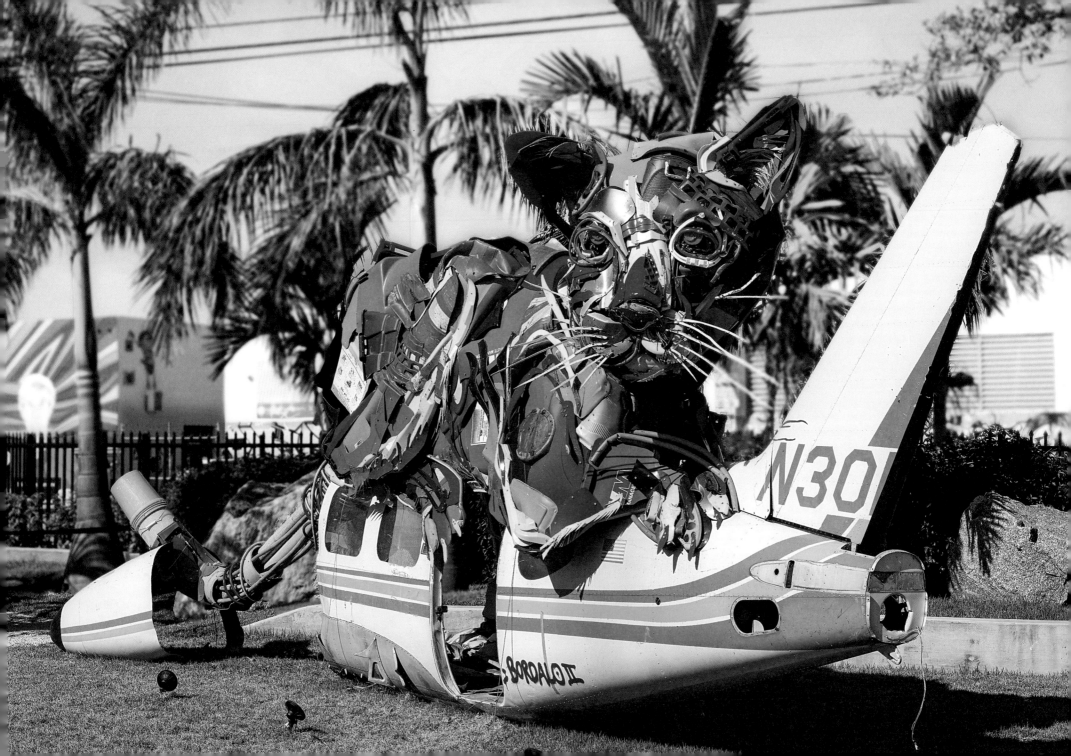

Ola Volo is a Canadian artist. She combines elements of history, folklore and different cultures in her works

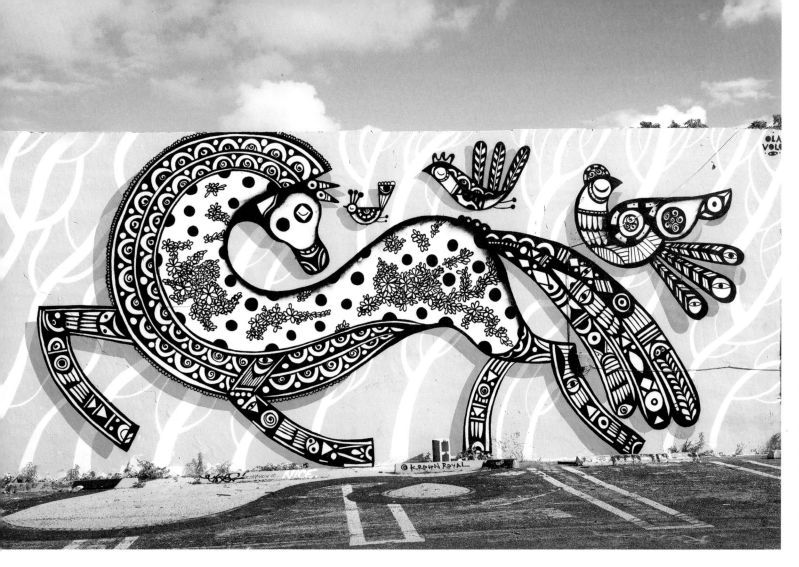

The Portuguese Bordalo II comes from a family of artists and is famous for his installations made of recycling material

Miami
Wynwood

Those in Miami who take the elevated I-195 in the direction of Wynwood can see the large murals from a distance. Starting with Wynwood Walls, the whole district has become an eldorado for street art lovers. Entire streets overflow with urban art. The great names of the international scene are represented alongside local artists. Beginning in December, Art Basel Miami draws more than 70,000 art lovers. Wynwood is part of the event and is a must for many visitors.

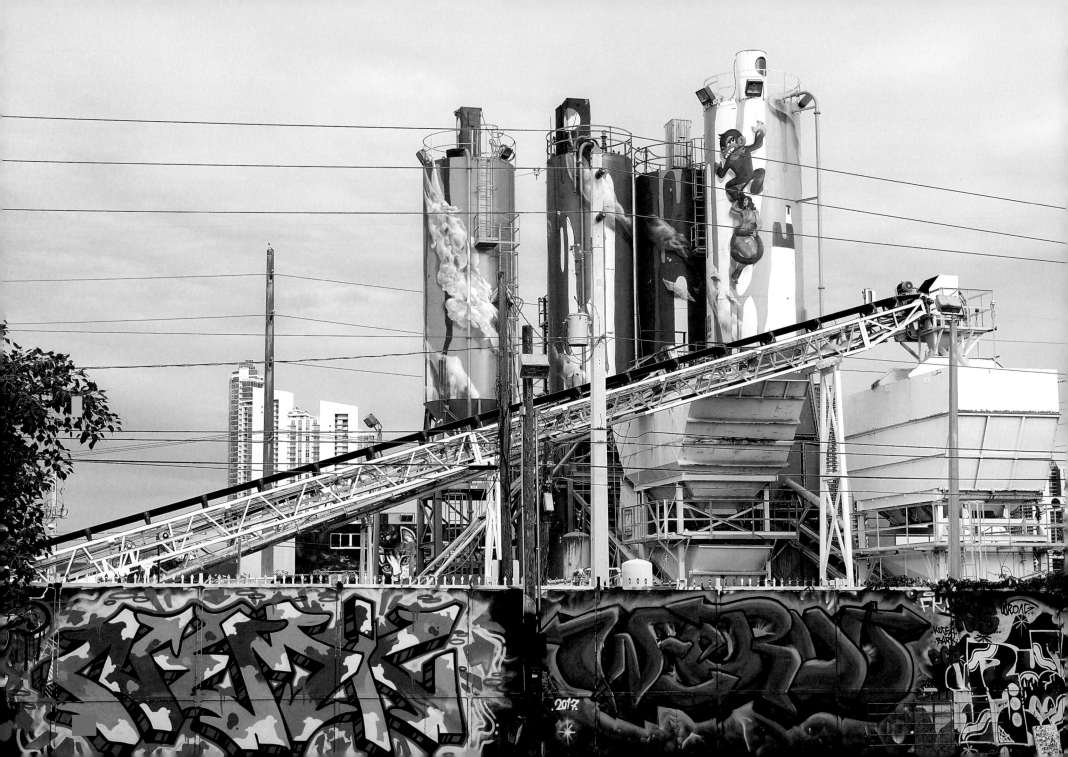

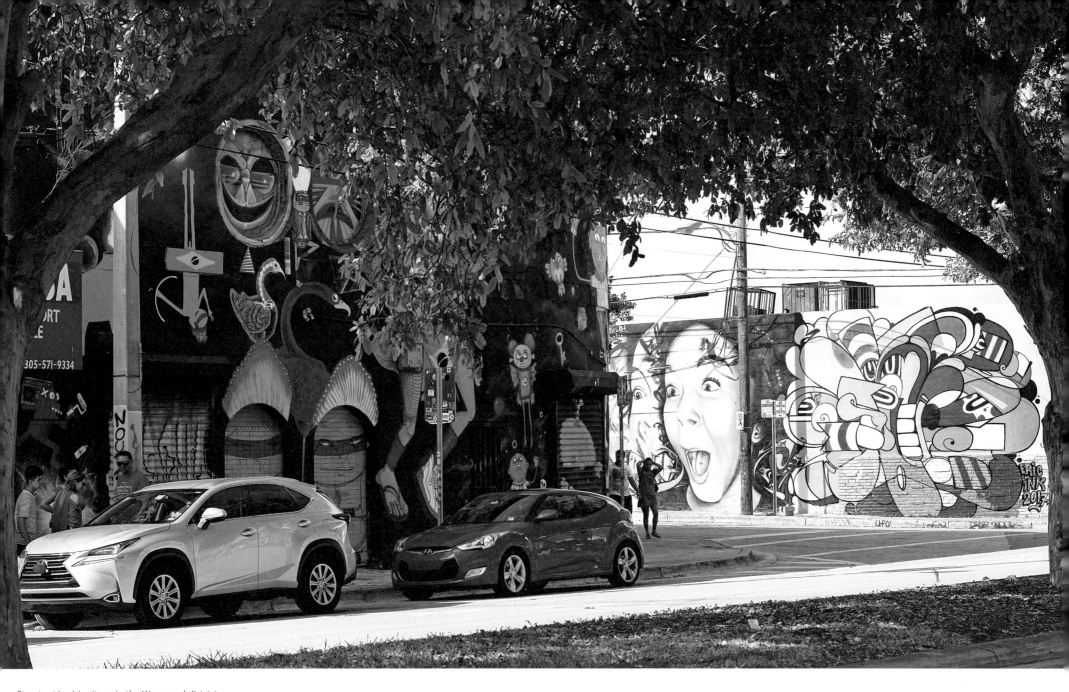

Street art is ubiquitous in the Wynwood district

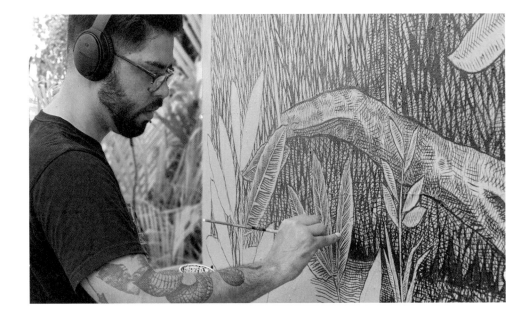

Alexis Diaz places the mythological figure Lilith in the context of the sun, nature and colors of Florida. He worked on this wall for 21 days

Alexis Diaz
"I put elements together like in a puzzle"

Alexis Diaz stands completely absorbed in his work, a large mural on NW 2nd Ave. in Wynwood, Miami. He doesn't seem to notice the many spectators and pedestrians around him. Instead of the spray paint used by other urban artists, he works with a small brush. Which is what distinguishes the special, completely original style of this artist. His murals, composed from the small, and the smallest strokes, exert an irresistible attraction for the viewer. It's no surprise that he is a welcome guest at the most significant festivals around the world. A kind of dialogue develops between him and the wall while he works: "I put elements together like in a puzzle until the moment of mutual understanding." He likes best to paint animals, or to be precise, his own creatures: an elephant with tentacles or a turtle with wings. Diaz was born in Puerto Rico in 1982 and grew up there. Since 2015 he has been living in Miami. In 2010 he created his first murals which he designed with his friend Juan Fernandez alias JUFE. For the selection and design of his works Alexis is inspired by the surroundings, his feelings and impressions. Which means that everywhere, where he works, "something truly individual" is created.

USA

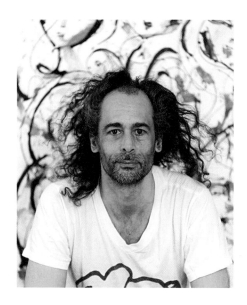

Jordan Betten
"What we did, was
super rock 'n' roll"

Jordan Betten is active on several artistic fronts. He achieved his greatest recognition in fashion with his extravagant one-offs made of leather. He set up his own small manufacturing facility in New York, established himself and clothed artists like Carlos Santana, Bon Jovi, Nicole Kidman, Sheryl Crow and Rihanna. He cus-tom-tailored a leather guitar case for Lenny Kravitz which the musician still has today. "What we did, was super rock 'n' roll", as Jordan Betten recalls. That's no hyperbole: His works are on exhibit in the Metropolitan Museum of Art and in the Victoria and Albert Museum in London. He also made it on the cover of the French edition of "Vogue".

But leather wasn't rocking anymore: "I switched mediums, from leather to painting, although I had always liked to paint", he said. Since 2016 he has worked and lived in a loft near Wynwood Walls in Miami. He works freehand and without templates and his spray paint lineature is very special, for female heads or for animal drawings. Unmistakably Jordan Bettens, not just in Wynwood Walls. And it's rocking and rolling again: this time with spraying and painting!

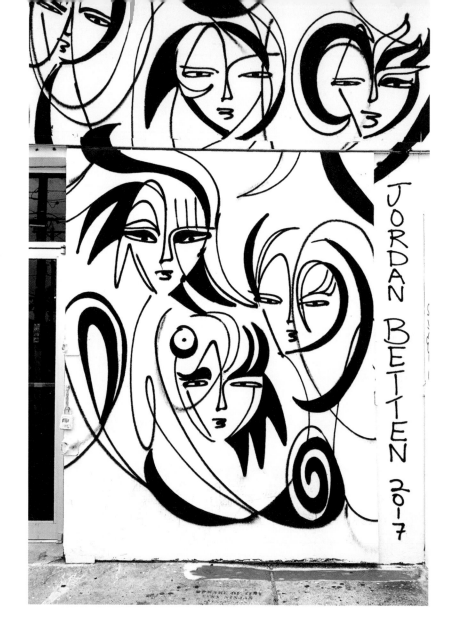

Jordan Betten's buoyant lineature is evident in all his works

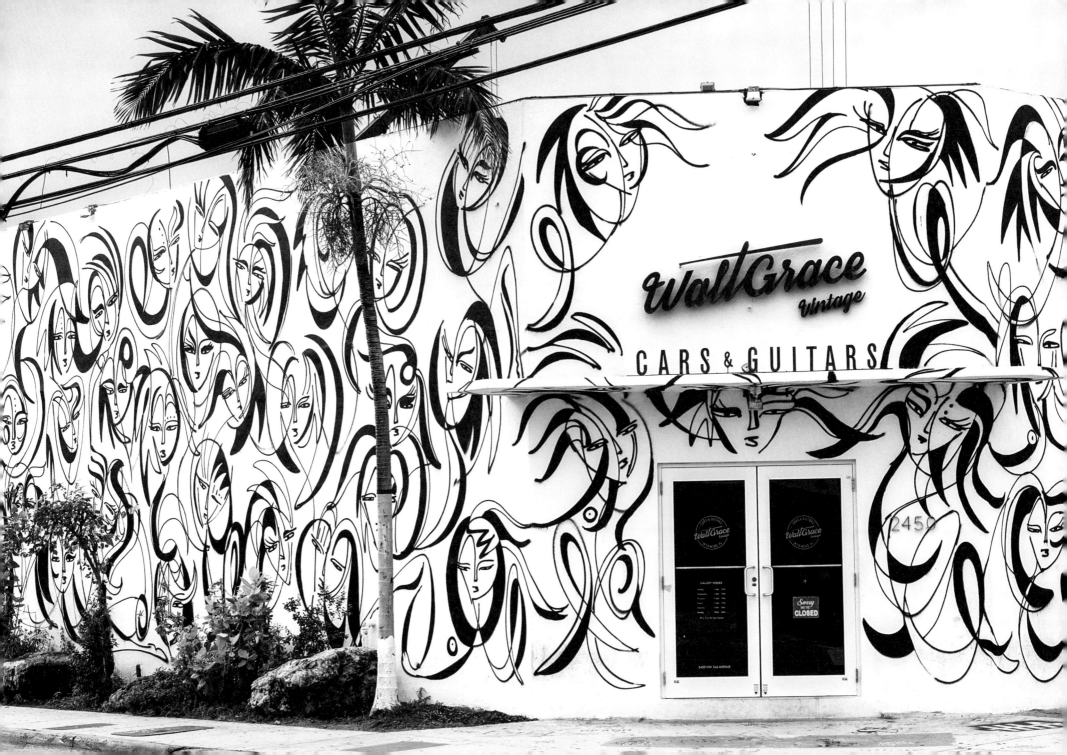

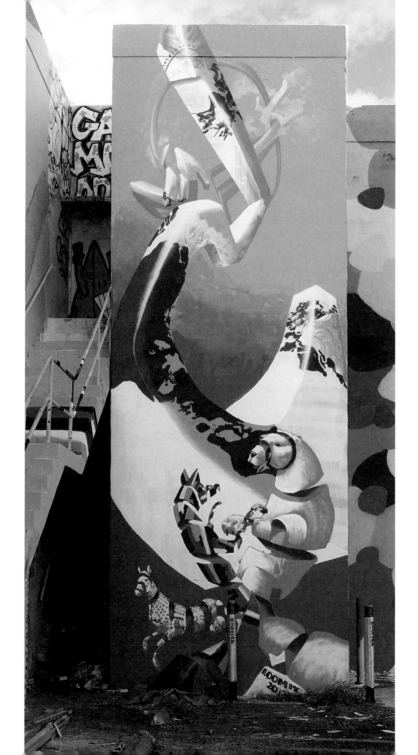

The Munich-based street artist LOOMIT has left behind his artistic foot prints on all continents of this world

«Graffiti crossed my life at the age of 14, meaning fun in the first place, but later on an obsession in painting.»

LOOMIT

Arlin Graff is Brazilian and lives in São Paulo and Detroit, USA. The geometric structures of his works are unmistakable

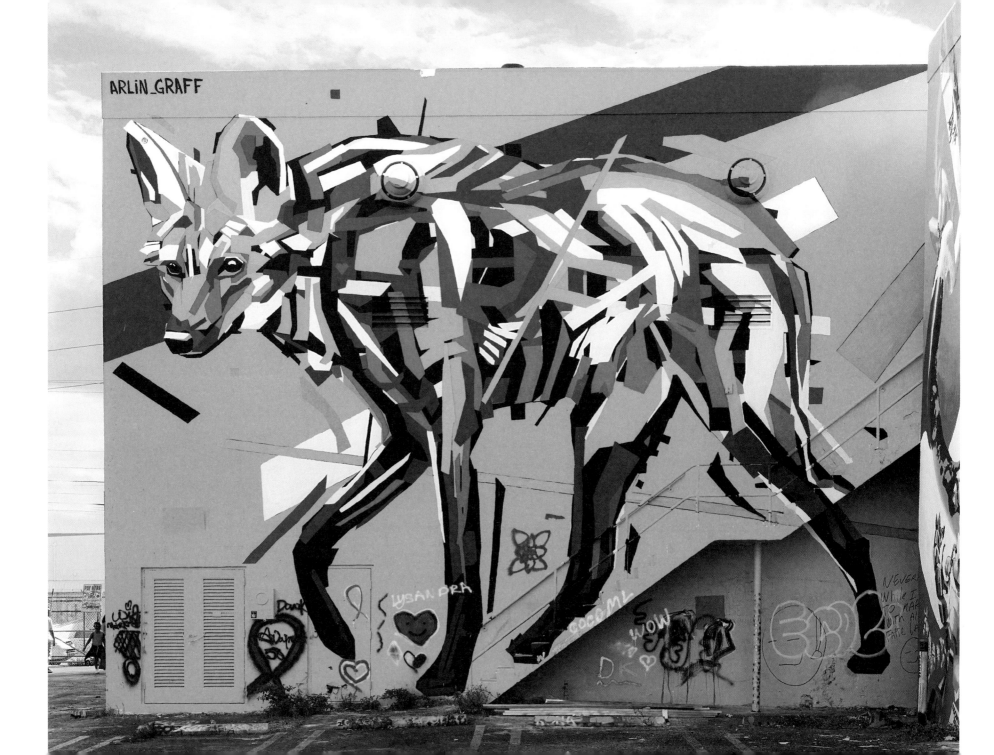

The Belgian ROA paints animals on large walls, mostly black and white with a brush. The identity behind the pseudonym is unknown

The large-scale works of Marco Buressi alias ZED 1 from Florence are often whimsical and funny

The likeness of the revolutionary Ernesto Che Guevara is still present today in the streets of Havana

Havana

The capital city of Havana can definitely be considered a cultural stronghold, with its historic buildings, antique automobiles, countless museums, lots of live music and zest for life … Street art in Cuba is mostly political, with frequent depictions of deceased statesmen, sloganeering for socialism and calls to arms against imperialism. Many street art works can be as morbid and dilapidated as the buildings they decorate.

"It is important to me that the urban artist expresses himself freely, not restricted by anyone, whether it's a gallery or the government", says Yulier Rodríguez Pérez, known as Yulier P., in an interview. His creative and artistic works can be found in almost all streets in Havana. The 20-year-old Fabián Lobet Hernández, who works with Rodríguez, has left behind his hooded faces everywhere with the formula 2+2=5, a clear social message, he thinks.

The American Gianni Blass Lee is known as a
music producer/DJ and fashion designer as well as
an international street artist

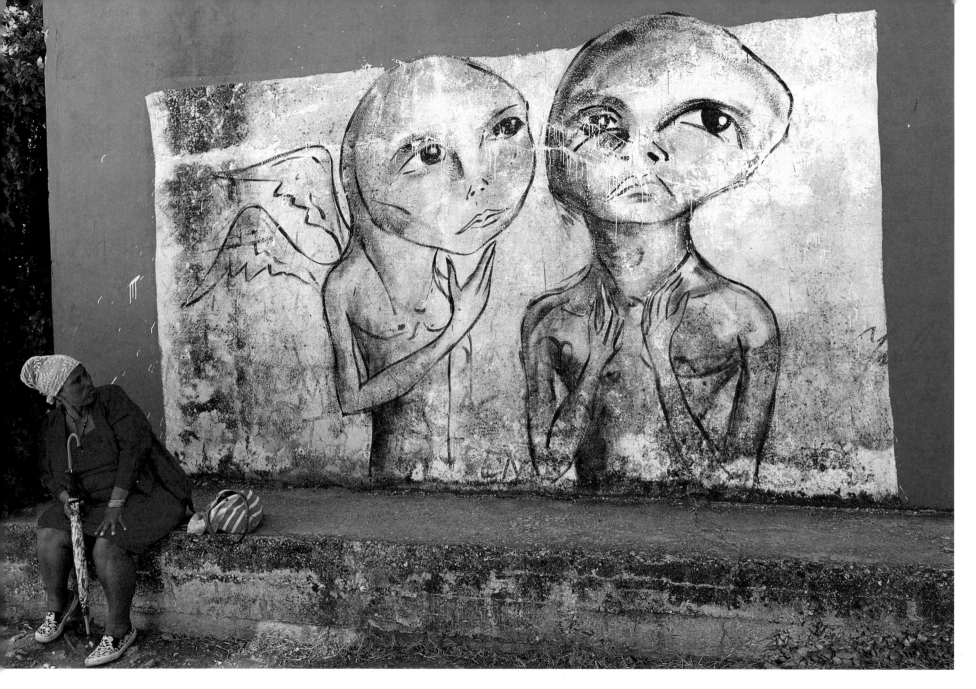

In 2017 street artist Yulier Rodríguez Pérez alias Yulier P. was ordered by the Cuban police to paint over his approximately 100 works in Havana. Until now he has not taken advantage of their kind invitation

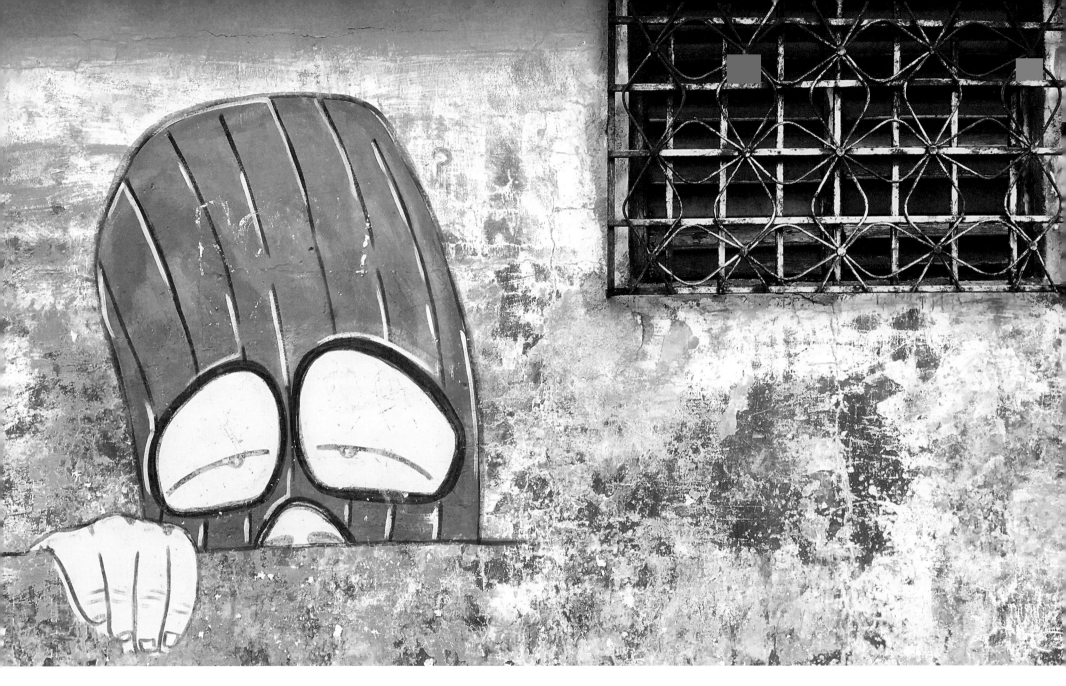

Fabián Lobet Hernández is a younger artist who works in Yulier's studio
and always signs his hooded faces with the tag 2+2=5

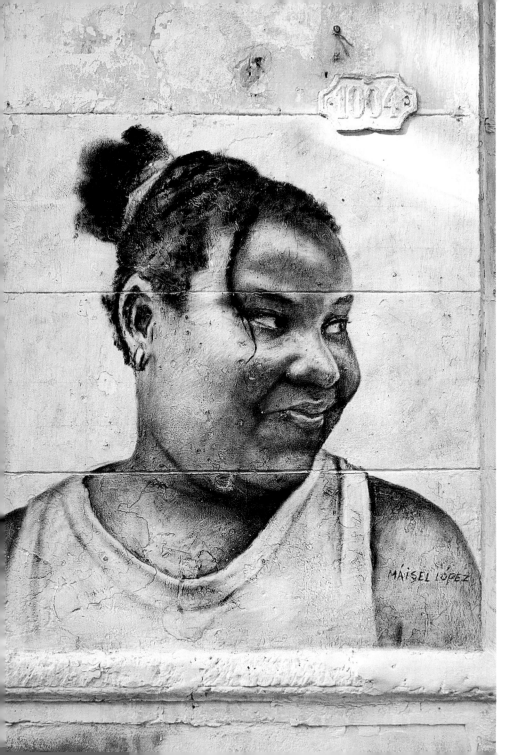

In the "Colossi" series Maisel Lopez paints portraits of local children on the wall. He works only with permission and needs four to seven days for a work

Dilapidated rows of houses, exciting street art and old, brightly painted and gleamingly polished cars. That's Havana today

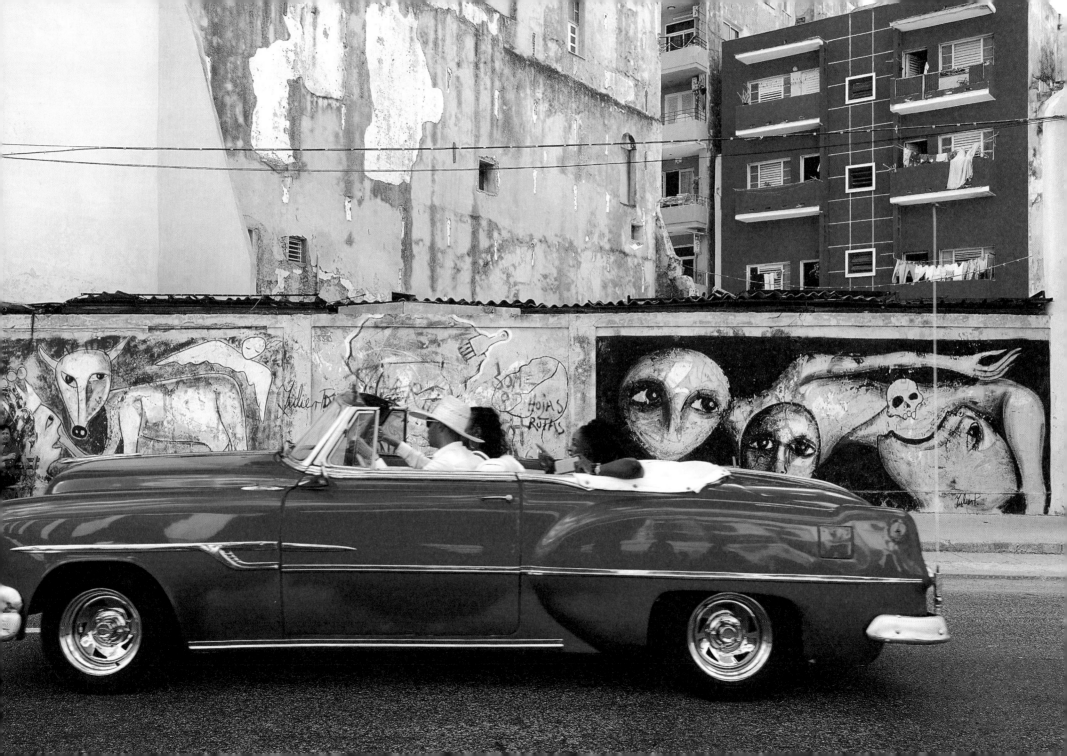

Berlin

Before it fell in 1989 the Berlin Wall was a place where street artists could freely express their opinions. On the way they helped advance Berlin as an international address in the urban art community, which the capital city still is today. In 1991 the longest remaining section of the Wall along the Spree was placed under monument protection as the East Side Gallery. One of the artists from the very beginning is the Frenchman Thierry Noir, who was already taking risks with his activity on the Wall in the 1980s. His "Tribute to the Younger Generation" is enshrined on the East Side Gallery. But the voice of urban art also has a future in Berlin. A gallery owner very near to the East Side Gallery is convinced that Berlin is producing artists who will do great things. And on an institutional level things are really moving, too. In September, 2007 the Urban Nation Museum opened shop.

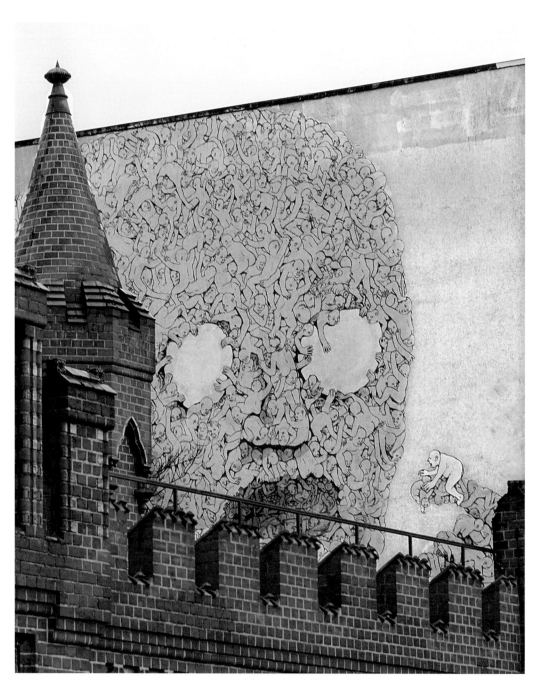

"The Pink Man" by the street artist Blu is composed of many small, intertwined human beings. The large creature with the dead eyes is just about to gobble the little white man on his finger that seems to be the only individual in the picture.
For more on Blu see page 184

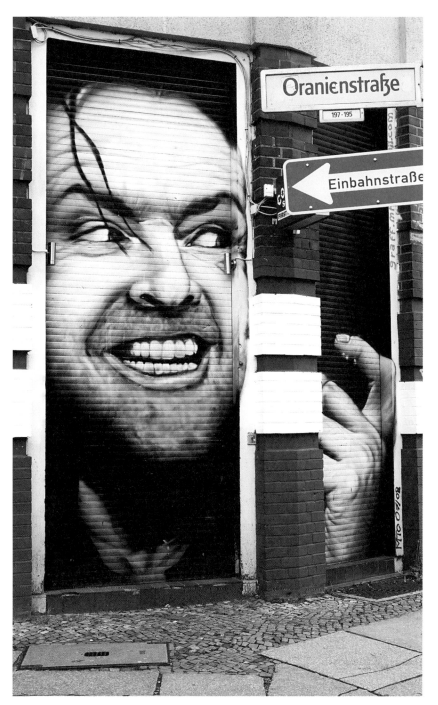

The street artist Mateo, MTO for short, was born in France and works mainly in Berlin. Not much is known about MTO. The gray portraits of personalities from the music and film scene, like this picture of Jack Nicholson, are typical

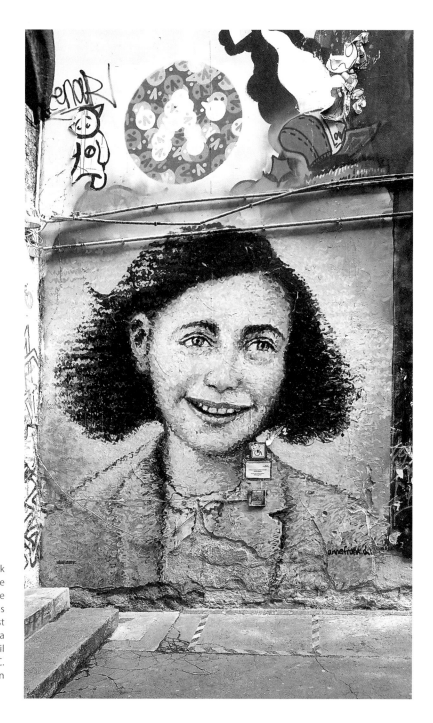

The portrait of Anne Frank at the entrance to the Anne Frank Center in the Berlin Mitte district was done by the Australian artist Jimmy C. (James Cochran) as a cross between classic oil painting and graffiti. Jimmy C. lives in London

GERMANY

Bolle, Jörni and Kimo are known in Berlin as the street art combo Die Dixons. They also run the xi-design communication agency

The former bank building had to give way to 65 luxury apartments, to be completed by the end of 2019

Mario Mankey plants a pair of giant feet in "The Haus". His name is supposed to show the connection or contradiction between human beings and other primates

Die Dixons
"We showed with 'The Haus' that we can do it!"

There is nothing left of the art project "The Haus" at Nürnberger Strasse 68 in Berlin Charlottenburg: The former bank building has been demolished, with 65 luxury apartments scheduled to be built by the end of 2019. In April and May 2017 things looked much differently: The investor Pandion turned over the demolition candidate to Die Dixons rent-free for interim use. A mega project soon evolved from a smart idea, with 165 artists from 17 countries transforming the 10,000 square meters of the condemned building with spray paint, installations, drawings and sculptures in 'The Haus' into a temporary total artwork.

But what is a work of art without someone to look at it? The idea caught on and people came in droves: A total of 60,000 or around 1,200 visitors per day, sometimes standing in line for hours in order to see the artwork in 100 rooms on five floors. Only 200 people were let in at one time and a cellphone and photo ban was in force, to increase the suspense but also in order to promote the in-house book project, at 30 Euros a good source of income. The neighbors, including the residents of a home for the elderly, were invited along with the press to the preview, various companies and political representatives were on hand and everything was recorded in photos and film … From a marketing standpoint no one could have done it better than Die Dixons, which generated a certain amount of criticism in the scene, but didn't faze the self-assured Dixons a bit: "We want to make it known that urban art can be considered on the same level as the art in museums like the MoMa", according to Jörn Reiners, one of the three activists. And the answer to the question of Kimo von Rekowski, whether there might be similar projects in the future was no less positive: "Yes, there have been international requests. But things have changed now that we have shown that we can do it with 'The Haus'!"

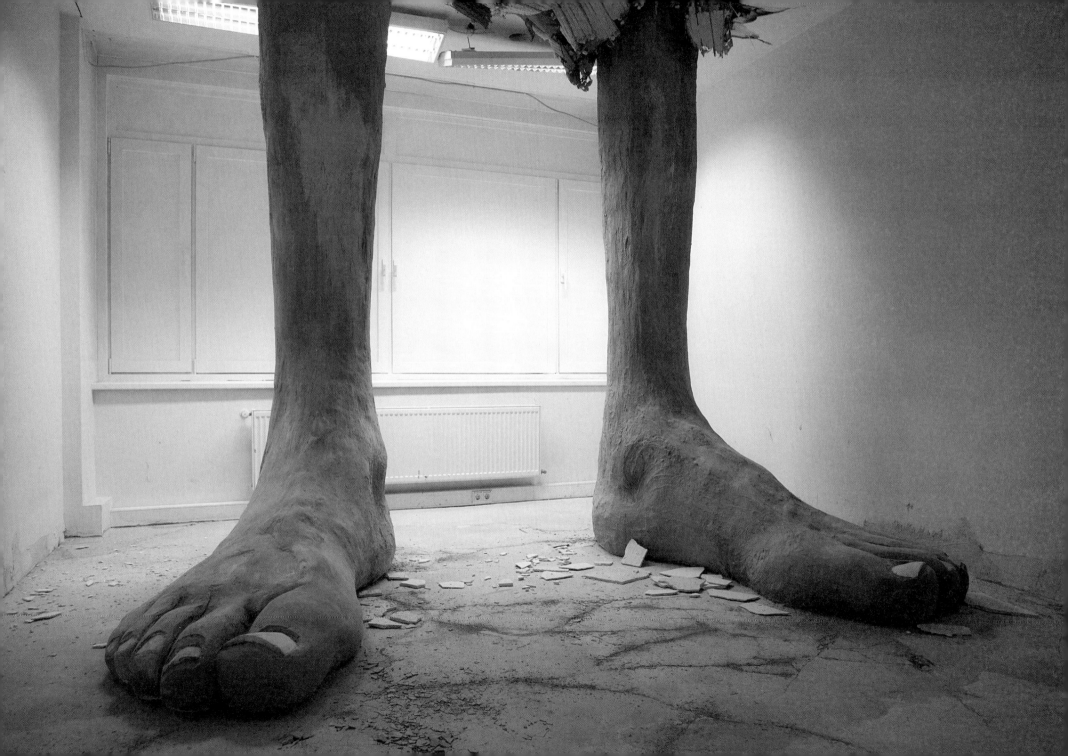

«I think the mural is totally cool. The red lips greet me every morning on the way to work and say good night to me every evening.»

David N., Berlin Friedrichshain

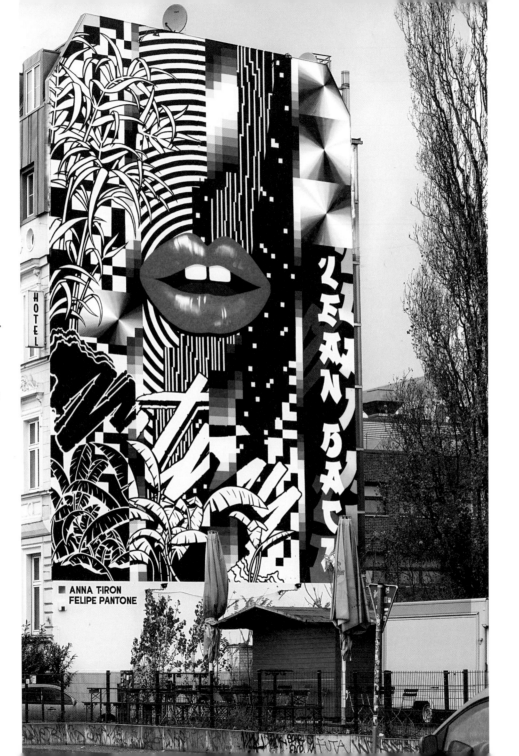

In November, 2017, the Sonos loudspeakers brand gave Anna T-Iron from Hamburg and the Spaniard Felipe Pantone a free hand to realize their ideas on the approximately 200-square-meter façade on the Warschauer Strasse in Friedrichshain

In 1984 the Frenchman Thierry Noir became the first artist to paint the west side of the Berlin Wall with his colorful figures. In 1991, with artists from around the world he designed the East Side Gallery, which has since become internationally famous

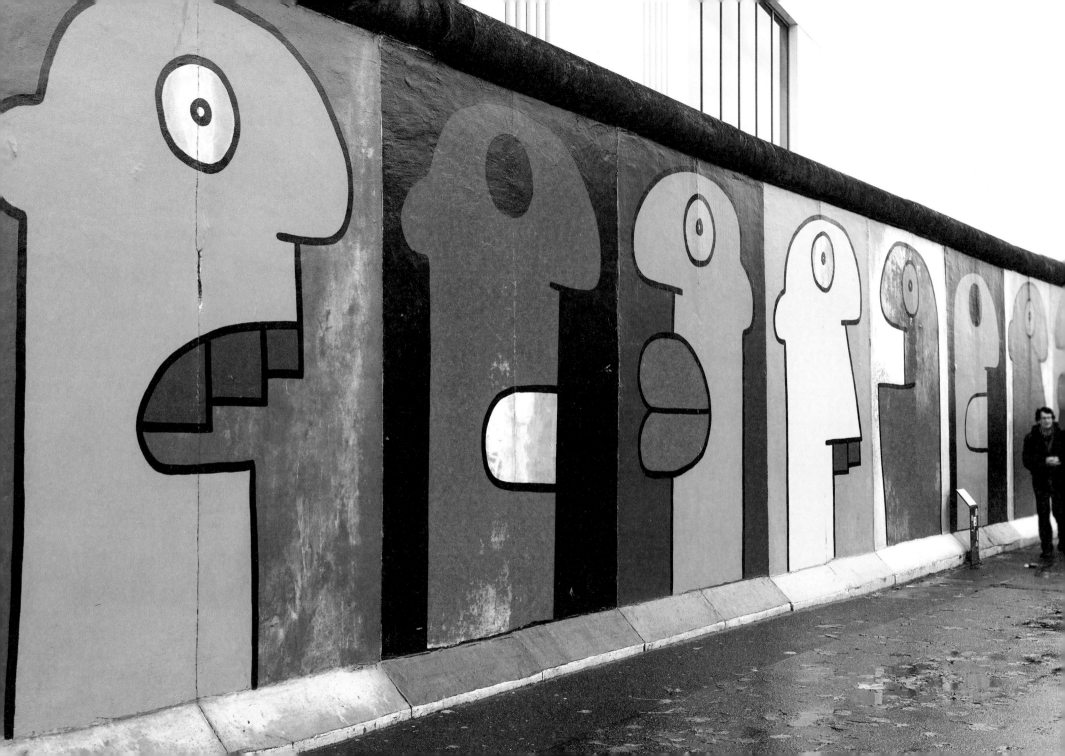

The Urban Spree Galerie

The Friedrichshain-Kreuzberg district in Berlin has the lowest median age of all districts in the city, is very alternative and creative and famous for its nightlife and the manifold cultural scene. The RAW grounds are located in the middle of Friedrichshain. RAW stands for "Reichsbahnausbesserungswerk" (Railway Repair Works). From 1867 until five years after the fall of the Berlin Wall trains from the Deutsche Bahn were maintained and repaired there. After the old workshops were decommissioned they were converted into a location for alternative culture and recreation. The Urban Spree Galerie, founded in 2012 by Pascal Feucher, is also located there. In every sense of the word it's in the midst of things, geographically and as a key part of the cultural scene.

Edward von Lõngus, a stencil artist from Estonia, is often compared with Banksy. His works frequently revolve around the subject of digitalization. They can be animated with an app

**Pascal Feucher
"We're one hundred percent
self-financed"**

The owner of the Urban Spree Galerie, Pascal Feucher, doesn't see the often discussed contradiction between art and commerce. Since the opening of the gallery in 2012 he has developed a business model with four pillars, the three most popular of which, namely the artist residences, concerts and the beer garden, contribute to the financing of the experimental areas. "We're not dependent on public or other financial support. We're one hundred percent self-financed. That makes us unbelievably free", he says for the record in his unmistakable French accent. How did a Frenchman, a former investment banker in Paris, end up in an art gallery in Berlin? "I had to reboot after the financial crisis." He had always been interested in art, especially urban art, but Paris was not the right turf for him. "Paris is like a giant, historical open-air museum, it's missing the rough edges, the incomplete, everything that Berlin has, even if it is steadily losing that aura." "Berlin", he is convinced, "is currently moving up in the street art category: the talents that will soon be big names are working in Berlin." And he is indeed currently showing big names in his gallery. For the tenth anniversary of the mural art icon "Astronaut Cosmonaut" he brought the works of the French-Danish artist Victor Ash to the gallery.

Edward von Lõngus combines historic figures from his homeland in Estonia with the digital world

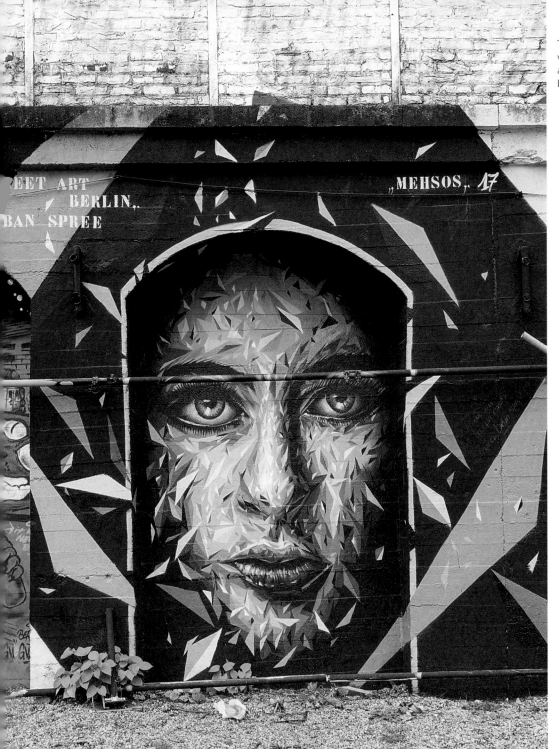

The Belgian artist Mehsos uses human and animal visages in order to put across emotions. He thinks animals have stronger emotions than people because they are more honest

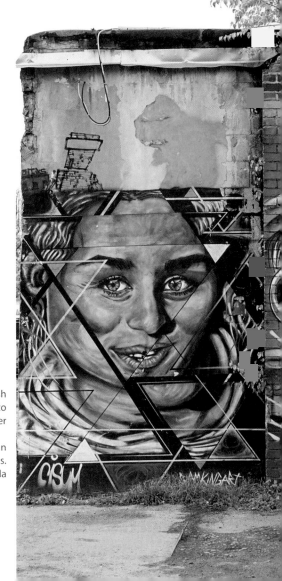

To the left: Sam King, born in 1995, is a British artist who lives in London and who, in addition to painting, also works as a photographer

To the right: Bruno Smoky grew up in a Brazilian slum and is active in different youth organizations. He lives in Canada

Shalak Attack is a Canadian-Chilean artist who often works with "phantom animals" that are threatened by human beings

The French-Danish artist Victor Ash
in front of one of his works

Victor Ash
"The Astronaut opened lots of doors for me"

Just under 13,000,000 tourists visit Berlin every year, many of whom look at the mural "Astronaut Cosmonaut" by the French-Danish artist Victor Ash and buy postcards or T-shirts with the image. In spite of the political statement of the work Ash doesn't consider himself a particularly political artist; "un peu", a bit, he says, because the lust for power of many politicians turns him off. Subjects like protecting the environment, freedom of expression or equality among human beings are much more important to him in his work.

Did the big breakthrough with the Astronaut limit his development, like an actor who becomes so strongly identified with a role that he doesn't get any new jobs and is stuck? "Not at all. The Astronaut opened doors for me as well as influencing my artistic expression in public space", he asserts. He orients to developments in the "underground" in all areas of art. "I'm looking for the new, the rare, artistic standouts." As an artist who has been very involved for the last 30 years he has no use for banalities or populism.

«A work in a public space creates an interaction with people whom you otherwise would never talk to. I see it as a kind of gift to the public.»

Victor Ash

The "Astronaut Cosmonaut" in Berlin Kreuzberg from 2007: the key work of the versatile artist Victor Ash

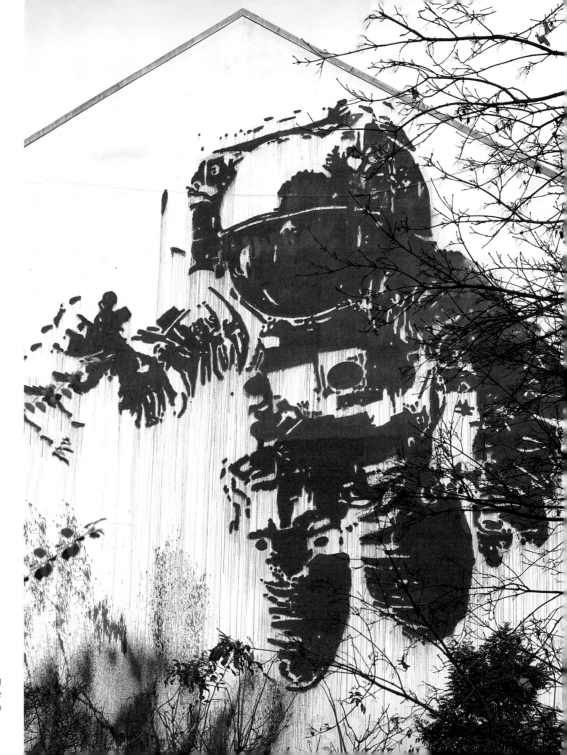

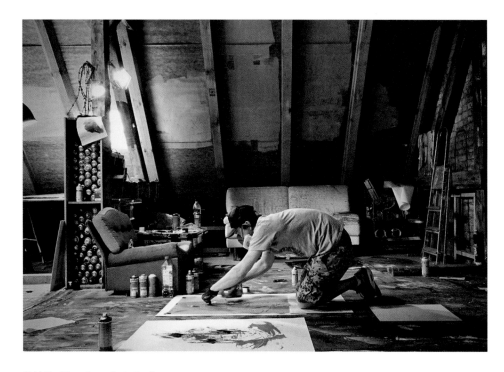

ALIAS in his attic studio in Berlin

ALIAS
"I'm interested in the crises of human beings"

ALIAS grew up in a village of 60 between Hamburg and Berlin in the 1980s. He knew from early on that he wanted to do something with art. "I welded my first metal sculptures when I was still a boy", he remembers. He then started in with graffiti, but in the countryside that was almost unheard of and just didn't fit in with the timber frame houses, which quickly led to run-ins with the law.

When he was in his twenties ALIAS went to Hamburg. Inspired by the budding street art movement, he started working with stickers and posters. "It was an alternative to classical graffiti, to influence public space without having to fear financial or legal consequences."

ALIAS finds the models for his pictures today mostly in the internet. He processes them, shaping individual areas into collages, prints them out and makes stencils from them. What he depicts is saddening and enormously expressive: mostly a person, with a child or a young person in a strange or hopeless situation – a boy with a shaved head sitting on a bomb, a crying child with its hands in front of its face, a hooded Death with a baseball bat in the hand …

"I'm interested in the crises of human beings", ALIAS explains.

He wants to provoke thoughts, awaken emotions, but is rather unpolitical about it. It's important that ALIAS' work is shown in public spaces, which only heightens their effect.

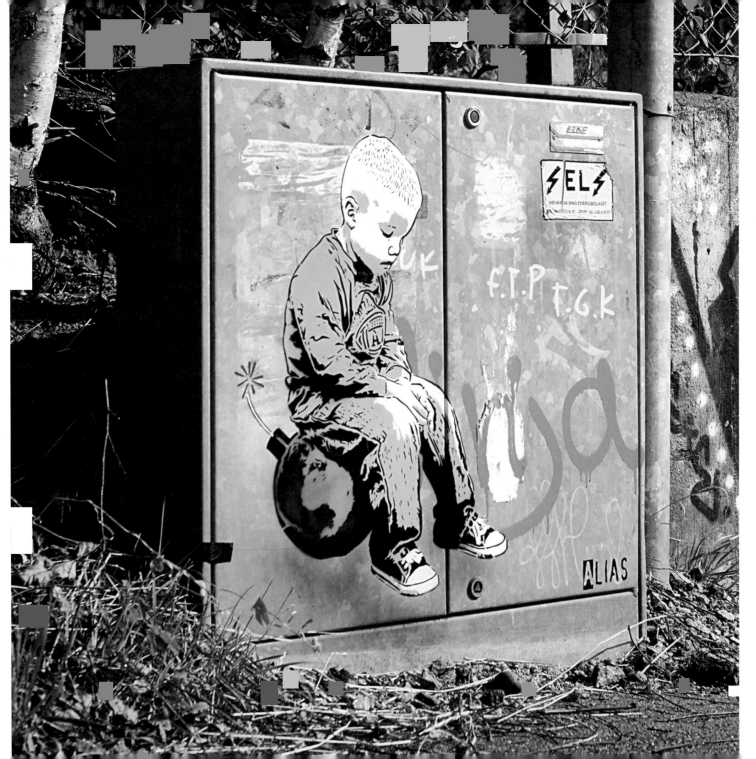

A sad-looking boy sitting on a globe with a fuse.
An earlier work of the artist

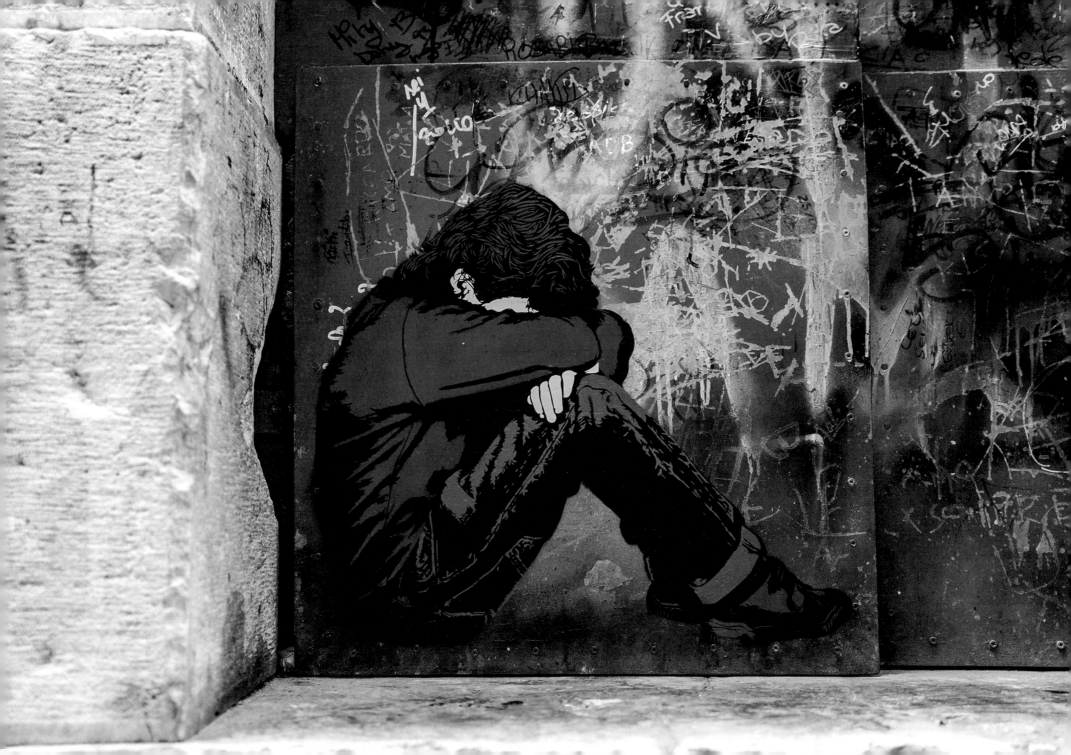

ALIAS depicts mainly children with his
stencils, looking mostly isolated, withdrawn
or even hopeless

The raw environment which ALIAS selects
for his delicate motifs is a significant aspect
of his street art

The Urban Nation Museum

When he was asked about urban art, the prominent American street artist, Ron English, had this to say at the opening of the Urban Nation Museum in September 2017 in Berlin: "It's the biggest art movement ever produced by human kind. And to not have a museum is insane." The new house for "urban contemporary art" is intended to bring together artists and residents from all Berlin districts. As a sign that those in a position of responsibility are serious about bringing art out of the "hallowed" halls into public space, one sees façades, shop windows, gates and walls that are full of first class art when approaching the museum. And the exhibit itself has something to show, too.

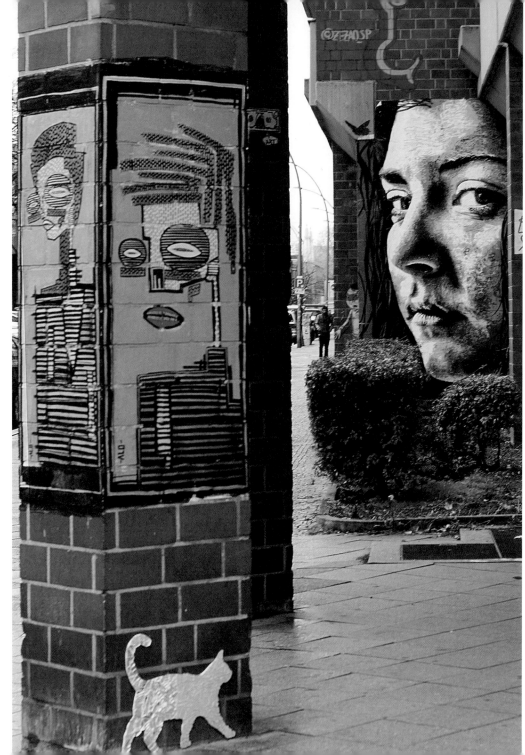

A pillar expressionistically designed by ALO, Aristide Loria, next to which a girl's face by Nils Westergard, Viginia, USA peaks out

The canvases and street pieces by the artist ALO are very elaborately designed and have a high recognition factor

A piece of the Berlin Wall, captured by the Argentine street artist, Hyuro. She lives in Valencia, Spain

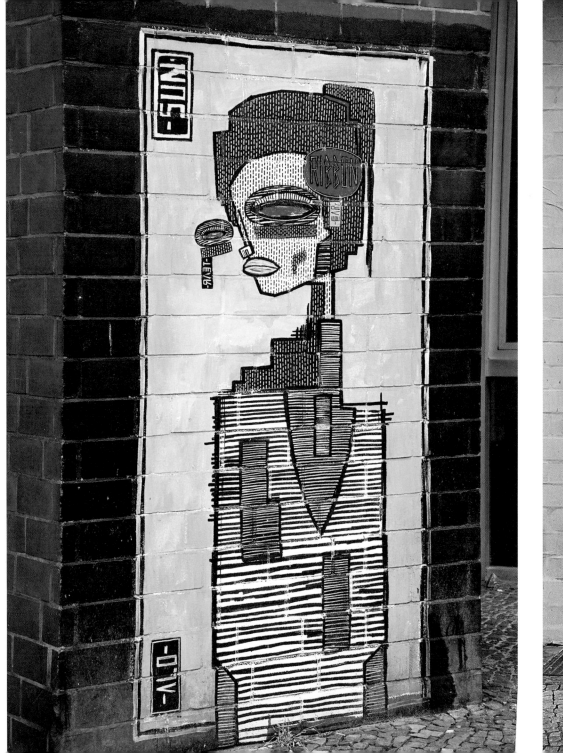
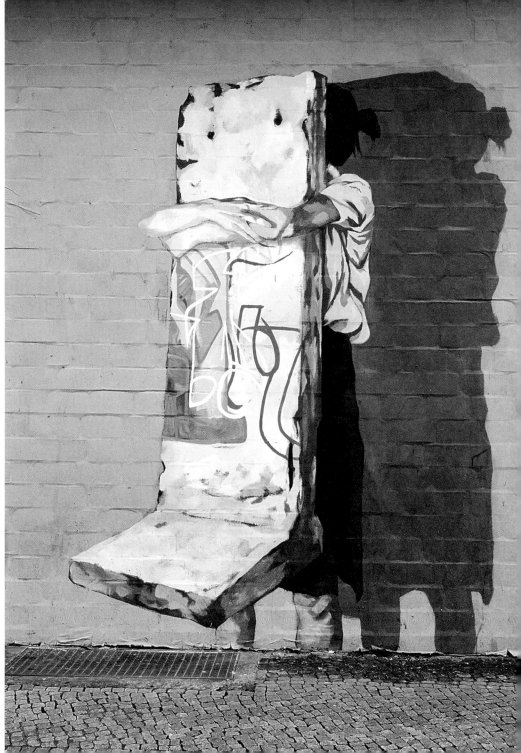

GERMANY

The artist Cranio, from "cranium", always shows his Indians in different situations and poses

Cranio
"I get my ideas from different sides"

Meter high walls, pictures, life-size sculptures… and it's the blue Indians that are always the basis of Cranio's works. He wanted to create a character with his trademark figure which represented the indigenous people of Brazil, his homeland. The blue figures couldn't do that better.

They're unmistakable, conspicuous and are always in special or funny situations, provoking their viewers to think about current problems, like racism, exaggerated consumption, corrupt politicians or the environment – without preaching, with a wink and a sizeable dose of humor.

"I get my ideas from all different sides: like cartoons, the famous painter Salvador Dalí, but from life itself", explains Cranio, who was born in 1982 in São Paulo with the name of Fabio de Oliveira Parnaiba. He is always working on new techniques, while trying at all times to keep to his own style.

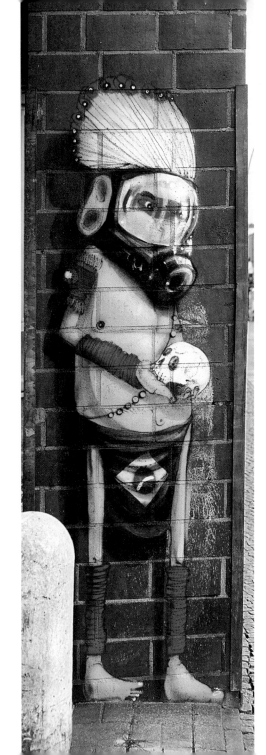

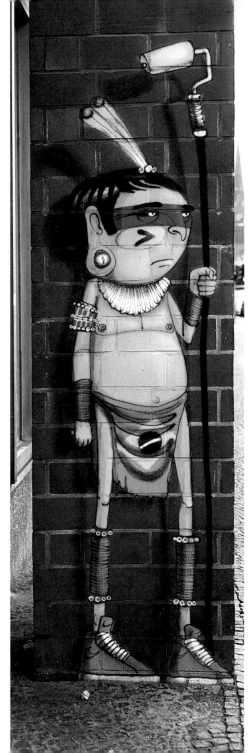

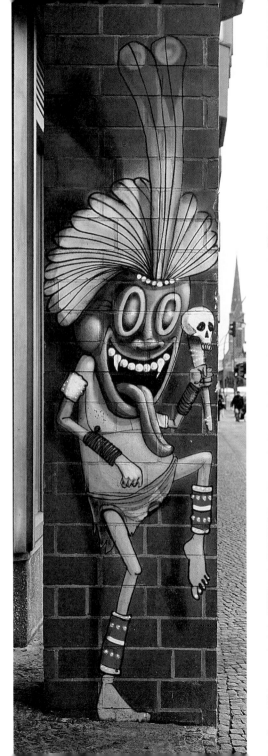
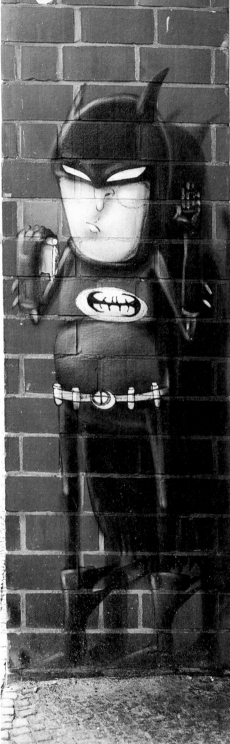

Munich
MAGIC CITY

The exhibition series "MAGIC CITY Die Kunst der Strasse" (MAGIC CITY The Art of the Street) started up in Dresden in August, 2016. Around 40 artists from around the world assembled there and created new urban works of art on several thousand square meters. The invitation was issued by Dieter Semmelmann's SC Exhibitions, one of the largest concert and exhibition organizers in Germany. Afterwards Dresden MAGIC CITY 2017 moved to Munich, recruiting new artists on the way. In 2018 the event moved to Stockholm, but the cities after that haven't yet been revealed. According to Christoph

Scholz, the director of SC Exhibitions, a total of ten exhibitions are planned at different locations. "For event organizers like us, MAGIC CITY is a stocktaking of the most popular art form today and we think, the most lively", according to Scholz. And Carlo McCormick, curator for exhibitions, adds: "MAGIC CITY is not a physical city made of stone and mortar. It's an urban space of internalized meanings. It is the city as subject and projection screen, not a theme park or a stage setting. It's an exhibition which shows some of the most original and famous artists who are currently working in and on the city."

Inspired by the nightmare of all parents, the defiant phase, the "Temper Tot", the favorite figure of the American Ron English, is as strong as the Hulk

The Frenchman Blek le Rat (Xavier Prou, born in 1951) is considered the ancestral father of stencil art in public space.
His works are mostly black and white

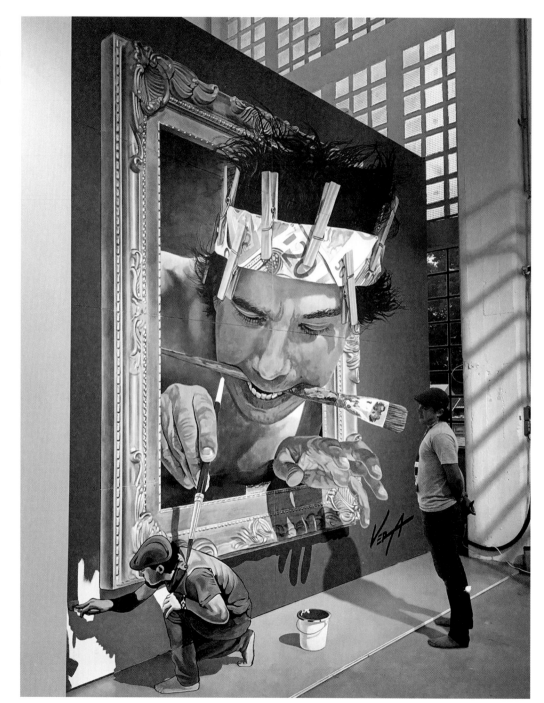

In three separate works the Mexican Juandres Vera has addressed the subject of himself under the title of "The Mind is the Beast (Me, Myself and I)"

Juandres Vera
"Find me a photo model that would do that"

The photo-realistic works of Juandres Vera, born in 1980, exert a powerful attraction on their viewers. His two and three-dimensional wall and floor drawings jump out at the viewers who frequently mass photograph them. Juandres Vera provides the subjects for selfies: a kiss with the giraffe, touching a free-floating tennis shoe or stirring a pot of paint. The Mexican artist has no preferred subjects: from public transportation, religion, politics to lots of self-portraits. Those are the easiest because he can photograph himself until they work for him as a model. "Find me one photo model that would do that so long", he laughs.

Starting out with decorative murals and painting on canvas, he switched to street art in 2007. Since then he has participated in dozens of street art projects, in the US, Great Britain, in Holland, Italy, Germany, Thailand and Mexico.

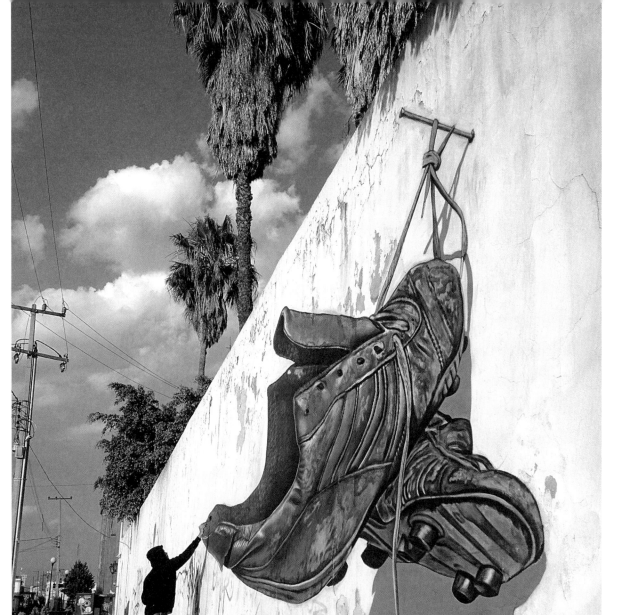

You could almost put it on: the oversized and three-dimensional soccer shoe with the title "Tribute" by Juandres Vera/Anamorphic Murals in Salamanca, Mexico

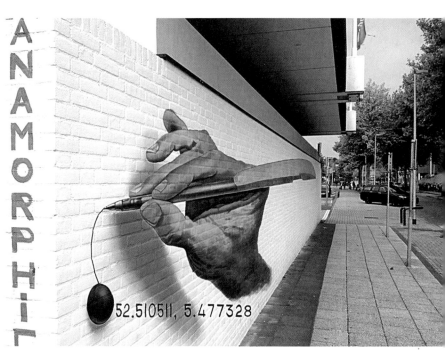

The "Connecting Dots" in Lelystad, Holland have an extremely real effect in 3-D

Herakut – Falk Lehmann and Jasmin Siddiqui

Herakut
"We have very similar ideas about life and work"

The Herakut figures look out with huge, imploring eyes in the big cities around the world, from Toronto to Kathmandu, from San Francisco to Melbourne. The creative art process they share is dialogic, among the figures themselves and with the outside. The focus is telling a story, creating imaginary worlds and inspiring their figures with individual characters. Hera establishes the form and proportions, while Akut splices in the photo-realistic elements. The two artists then develop the rest of the process together. And since 2004 it seems to work because that's how long Jasmin Siddiqui and Falk Lehmann have been away from their base in Berlin. "We very much agree about what one can and must say in art and what not", says Jasmin, with Falk chiming in: "Yes, we have very similar ideas about life and work."

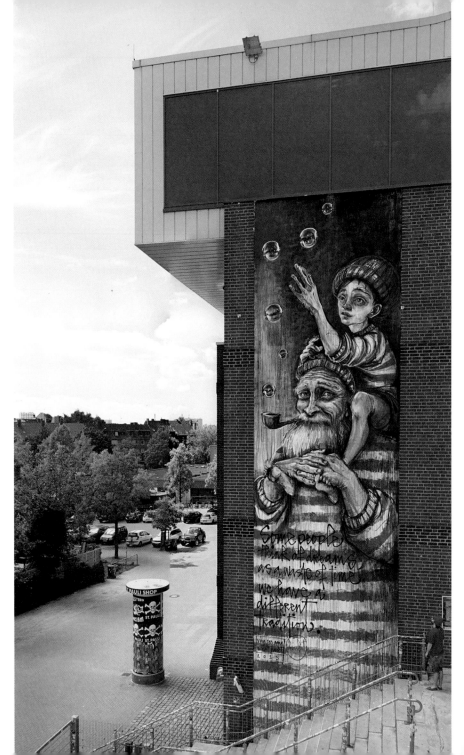

Grandfather with grandchild in the Hamburg harbor

Macabre scene in Tel Aviv

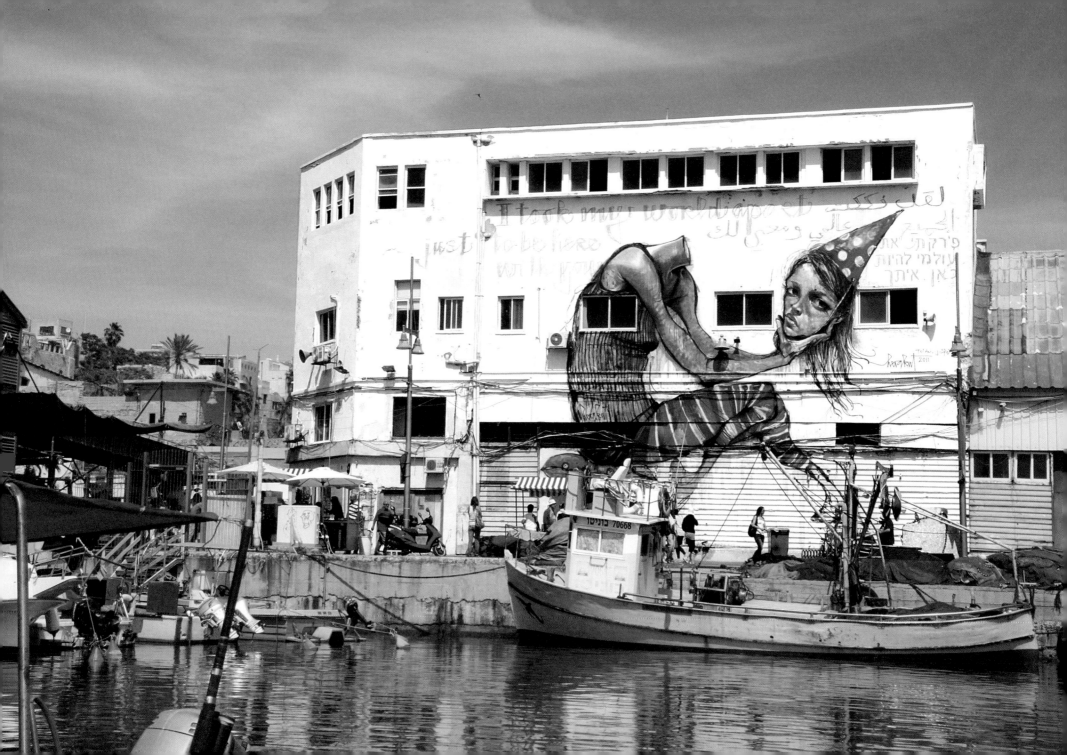

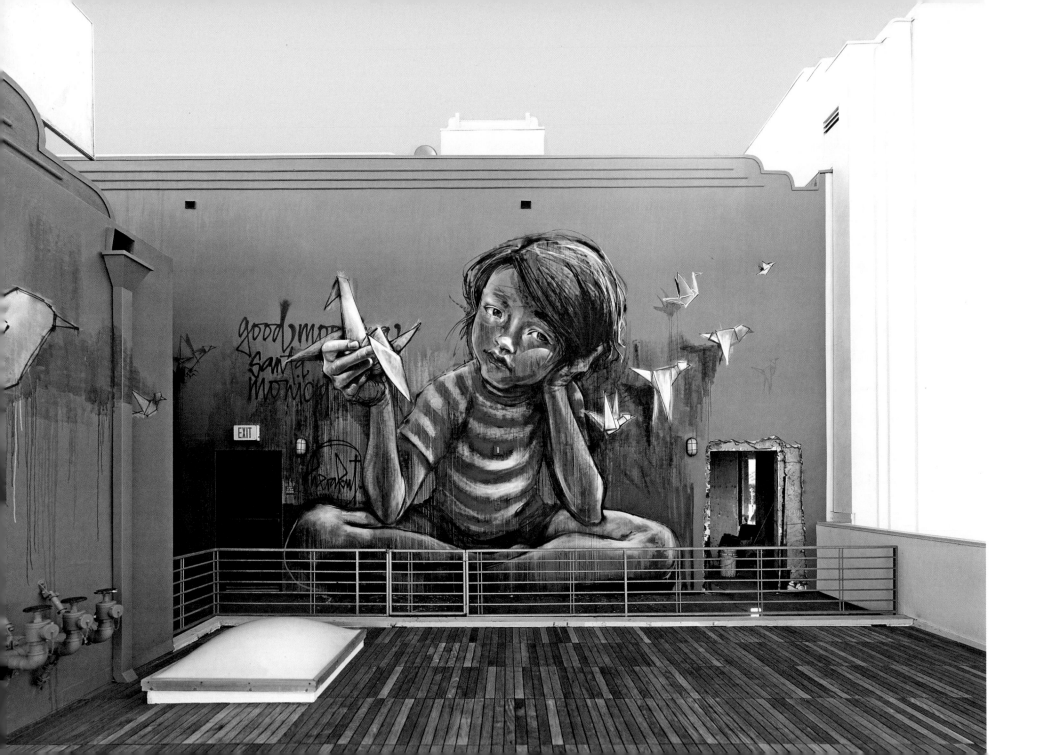

When paper airplanes turn into birds:
Herakut in Santa Monica, California

Art? That's the question the artist
duo Herakut asked in California

Munich
Siemens Campus

With the fitting title of SCALE, a total of 15 known street artists from seven countries went to work for a week on the huge walls of the Siemens Campus in Munich in the summer of 2017. The campaign was sponsored by PAT ART LAB, which supports creating art in public spaces and livening up existing real-estate surfaces. In addition, according to those in charge, SCALE is connected with a benefit. Prints of the murals were sold and the proceeds were donated to the current building projects of the PATRIZIA KinderHaus-Stiftung. Additional projects are planned.

Those at SCALE and artist Daniel Man (Germany) were able to enlist the support of the following artists: Aryz (Spain), Axel Void (USA), Mirko Reisser / DAIM (Germany), jana&js (Austria/France), LOOMIT (Germany), Okuda (Spain), Os Gêmeos (Brazil), Sainer (Poland), SatOne (Germany), Stone Age Kids (Germany).

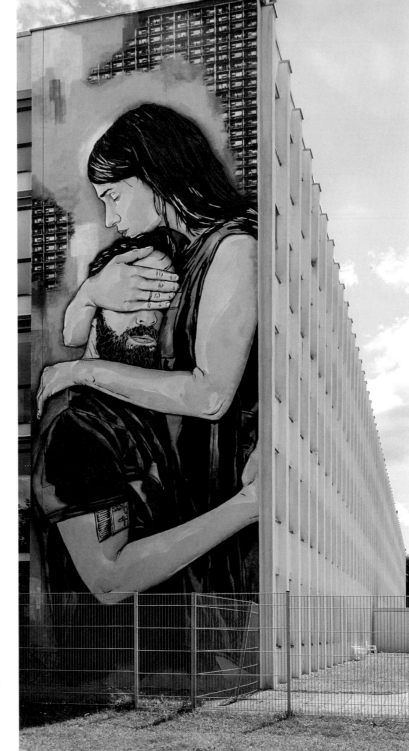

Architecture and the human being in the course of time. jana&js realized this subject in stencil technique

Daniel Man
"It will never be finished"

He was known as Codeak when he was a street artist, but that was a long time ago. "Today I am more concerned with getting to the bottom of things", explains Daniel Man, who lives near Munich. In addition to his work as an artist, he is a mediator, organizer and moderator. For background he can draw on his studies in the Academy of Fine Arts. Rather unassuming in his public appearances, Daniel Man, who has Chinese roots, is always concerned with networking different kinds of art and the artist. He was in charge of the SCALE campaign on the Siemens Campus grounds. When he realized that as an artist one was always part of a huge network, he began to record these entanglements in a diagrammatic drawing titled "The inSight of sideOut". The work of 148 x 413 centimeters consists of hundreds of artists' names connected with lines and circles. It was exhibited in Völklingen at the Biennale and "It will never be finished", according to Daniel Man.

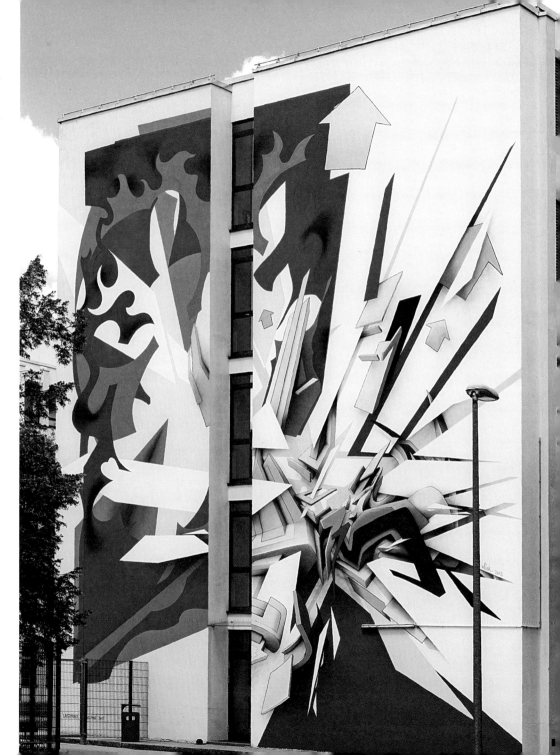

"Layermania" is a joint effort work of Daniel Man and Mirko Reisser (DAIM) created with reference to an earlier work by DAIM with the title "Monomania"

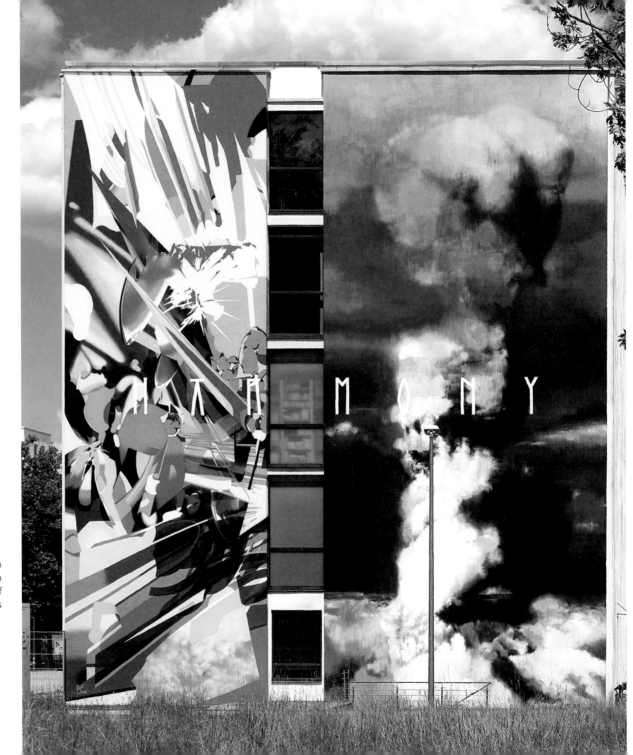

"Harmony" by SatOne and Axel Void is based on an image of the atomic bomb from 1945 in Hiroshima, Japan, and addresses the subject of catastrophes caused by human beings

«When I paint humans or faces with these multicolored geometric patterns, I try to symbolize all skins and races in one, all colors in one, multicultural world.»

Okuda

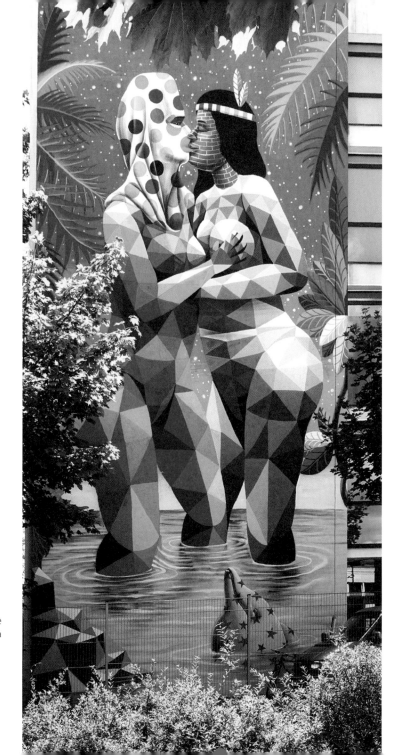

A colorful homage to love and freedom by the Spanish street artist Okuda

The twins Os Gêmeos

To the left a "Man's Picture" by the Spanish artist
Aryz, to the right a work by Os Gêmeos in
collaboration with LOOMIT and Peter

Os Gêmeos
"No one tells you how,
where or why"

Born in 1974 in São Paulo, Brazil the identical twins, Otávio and Gustavo Pandolfo, grew up in the hip-hop movement, starting out as break-dancers before producing their own graffiti in 1987. They had no money for spray paint so unlike the street artists in New York they painted with brushes, cheap façade paint and wall paper rollers. Portraits, like those of young people in colorful sweaters, were done on freight trains and railroad tunnel walls. Oversized, jaundiced faces and thin limbs became the hallmark of Os Gêmeos (Portuguese for "The Twins"). In the beginning they oriented to their direct surroundings and American models, but later they moved on to traditional folk art and Brazilian mythology in their works. Newspapers report about the brothers in and beyond South America. The twins participate in exhibitions worldwide and are often mentioned in the same breath with giants like Shepard Fairey. In an interview Otávio Pandolfo described the impetus for their work. "Very simply, graffiti is characterized by freedom and energy. No one tells you how, where or why you should make something. It's a direct form of communication."

Völklingen UrbanArt Biennale®

Jean-François Perroy, better known as Jef Aérosol, often focuses on cultural icons in his work. Depicted here is the artist Jean-Michel Basquiat

Rust brown, dusty walls, walk-in silos, a weathered crane and machinery, bushes growing out of old walls … you couldn't find a better setting for urban art! In 2011 the first UrbanArt Biennale® was held in the Möllerhalle of the former ironworks, now the UNESCO Völklinger Hütte world cultural heritage site. In 2015 the facility was augmented by an additional 100,000 square meters of open space. Prof. Dr. Meinrad Maria Grewenig, the general director of the Völklinger Hütte world cultural heritage site, had the idea for the UrbanArt Biennale®. "The goal of the Biennale is to give exposure to current positions of this art form, to document every two years their development and to provide a global overview of the urban art scene", according to Grewenig. Each Biennale is dedicated to a specific subject, with emphasis on geographic, artistic or personal aspects. He's convinced that "The Biennale documents the turn of this art from the streets into the museums." The initial skepticism of many artists about official exhibitions and museums seems to have been overcome here and the participants' list of more than 100 international artists from 17 countries and four continents reads like a "Who's Who" of urban art.

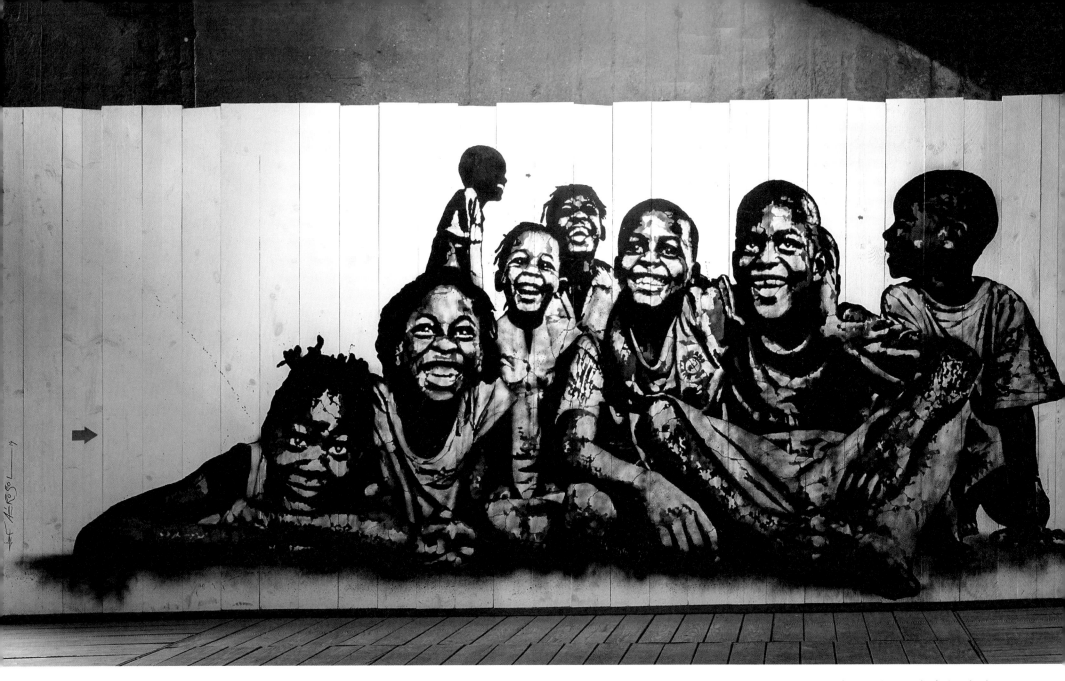

"Black is Beautiful" with the typical Jef Aérosol red
arrow. For a portrait of the artist see page 157

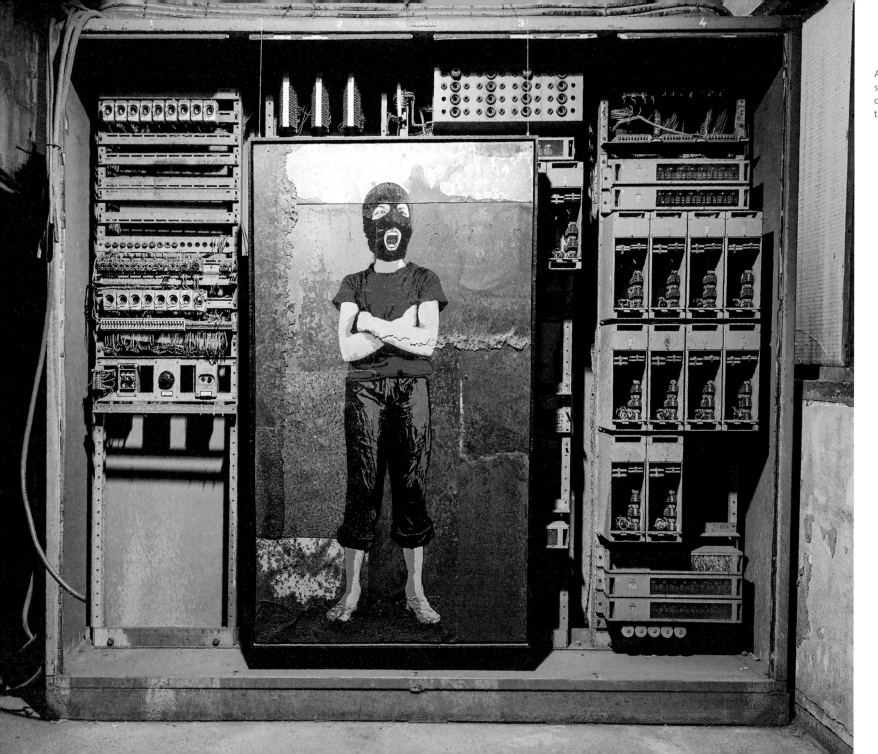

A boy in a ski mask and red T-shirt screams in rage. The Berlin artist ALIAS calls his work "Dissident". For a portrait of the artist see page 70

The "Newspaper Boy" by Jef Aérosol fits perfectly in the moribund industrial landscape of the Völklinger Hütte

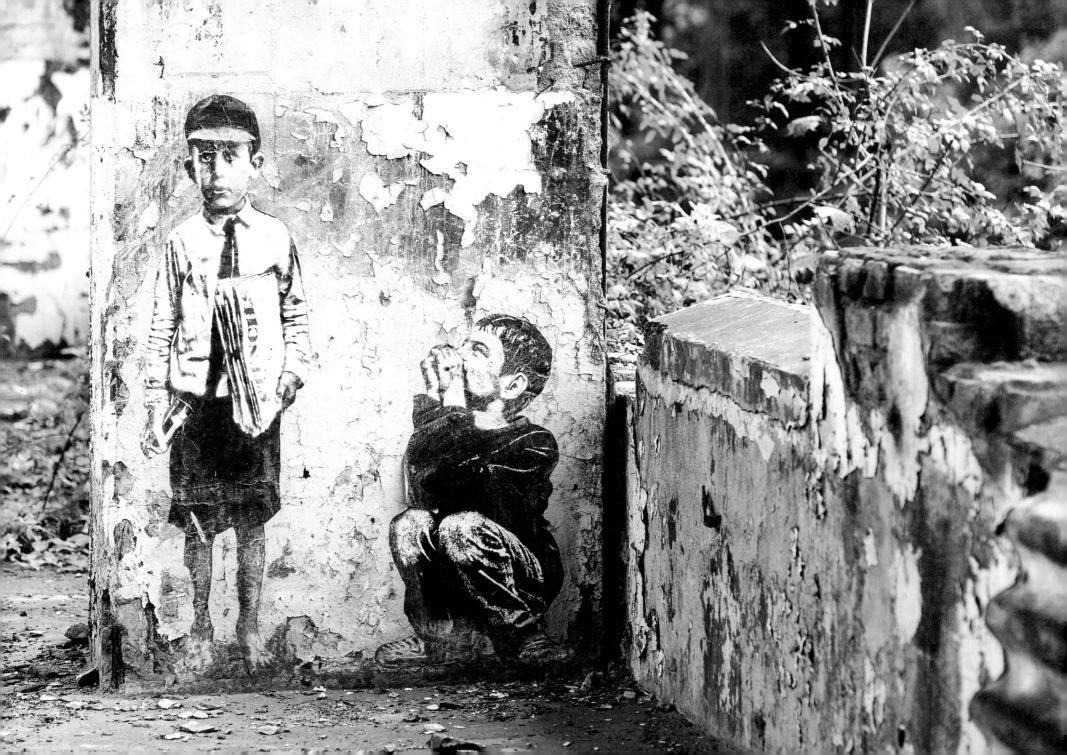

GERMANY

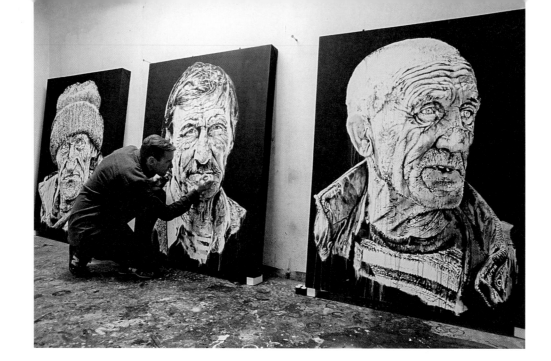

Transnational ties: the portrait
of a Moroccan man on a tower
in Naestved, Denmark

Hendrik Beikirch:
Wrinkles as traces of
life experience

Chance encounters, fleeting glimpses and scraps of discussion comprise the inspiration for the portraits by Hendrik Beikirch. The striking large-scale faces with their wrinkles and creases their experiences have left behind are honest and authentic. Sometimes he distorts the faces by elongating or compressing them, but Hendrik Beikirch always remains true to photorealism and the painstaking attention to detail. With his portraits, Beikirch tells the stories of people who are mostly unknown. When asked why none of them smile, Beikirch says: "The basic tasks for the painted portrait is to create an image which wrestles with two problems. One is to depict reality and the other is to make visible the inner life of the person being portrayed." He looks for faces which don't attempt to counteract or break with the mood of the city, but to share that mood as a silent companion with the viewer. Furthermore, the absence of smiling faces is a helpful prophylactic measure against all forms of advertising in public space, according to Hendrik Beikirch.

In 2012, in the city of Busan, the second largest city in South Korea, he created his largest mural to date, a 236-meter picture of an old fisherman, which caused a stir at the time. The unique setting was the futuristic Haeundae I'Park Tower Complex, designed by the famous architect Daniel Libeskind. More, equally breathtaking works were to follow, among them the biggest murals in India and the Benelux countries. In his mid-forties, the reserved artist seems to have playfully burst the boundaries of current portrait dimensions, without using projectors or grid overlays. A modern interpretation of classic portrait painting full of warmth and humanity!

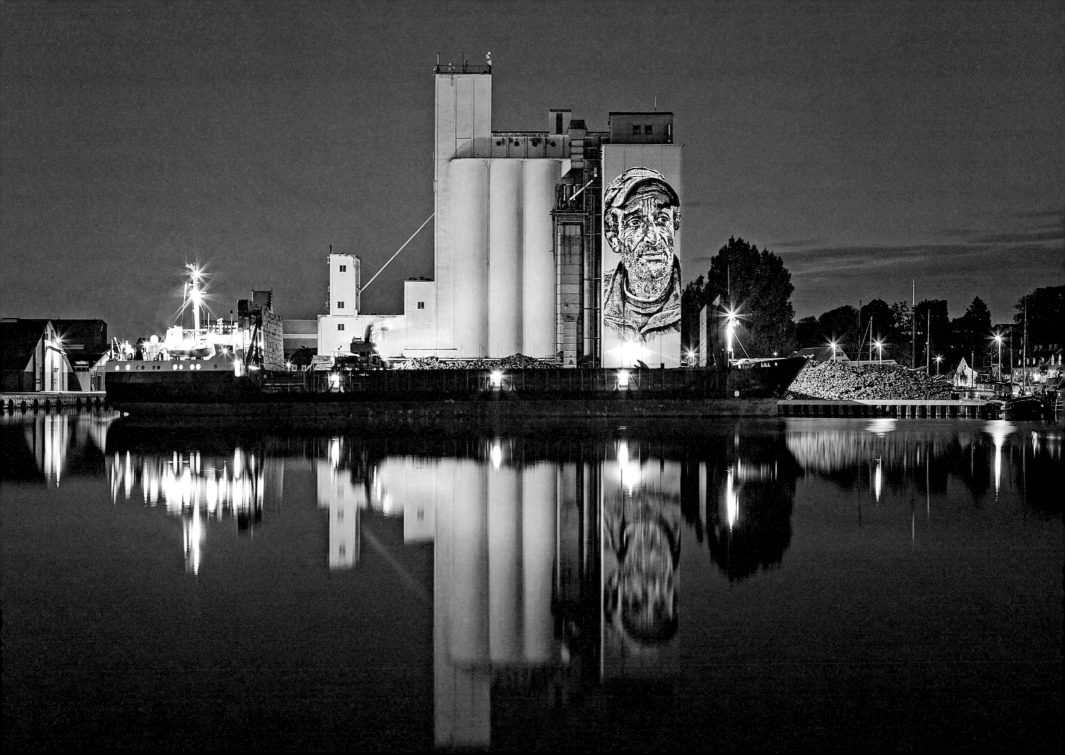

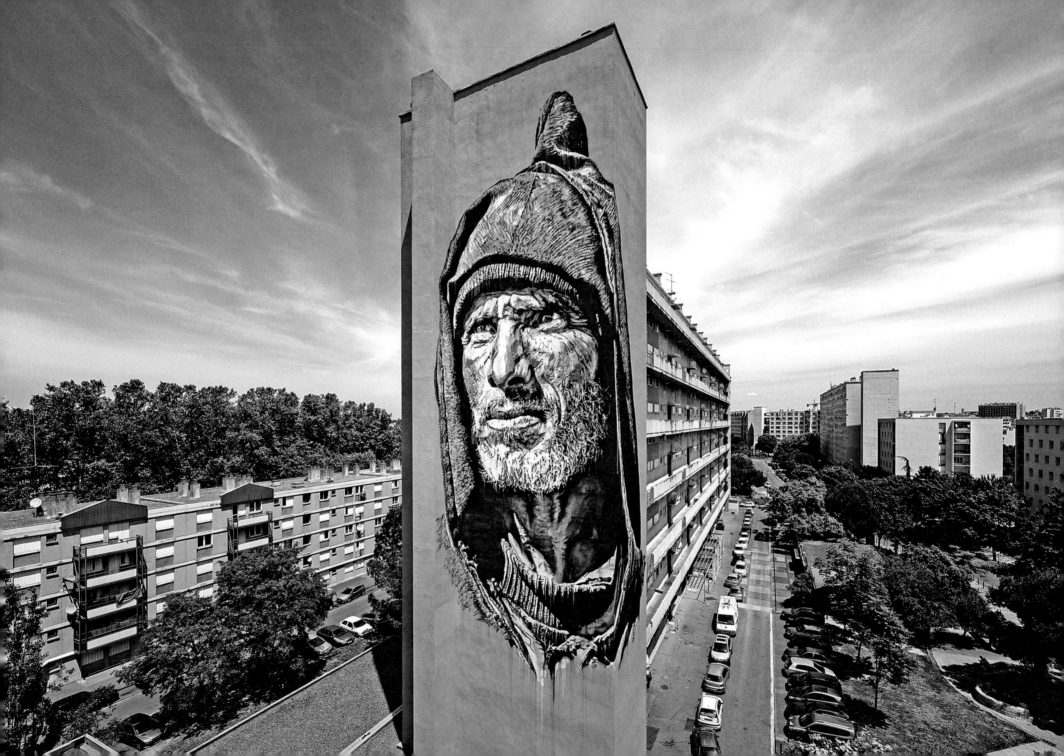

For his "Tracing Morocco" project Hendrik Beikirch followed the trail of Moroccan workers. A gigantic work in Toulouse, France

The geometric patterns created by the American artist Jordan Seiler can be set into motion with a smartphone. The app can be downloaded under www.publicadcampaign.com

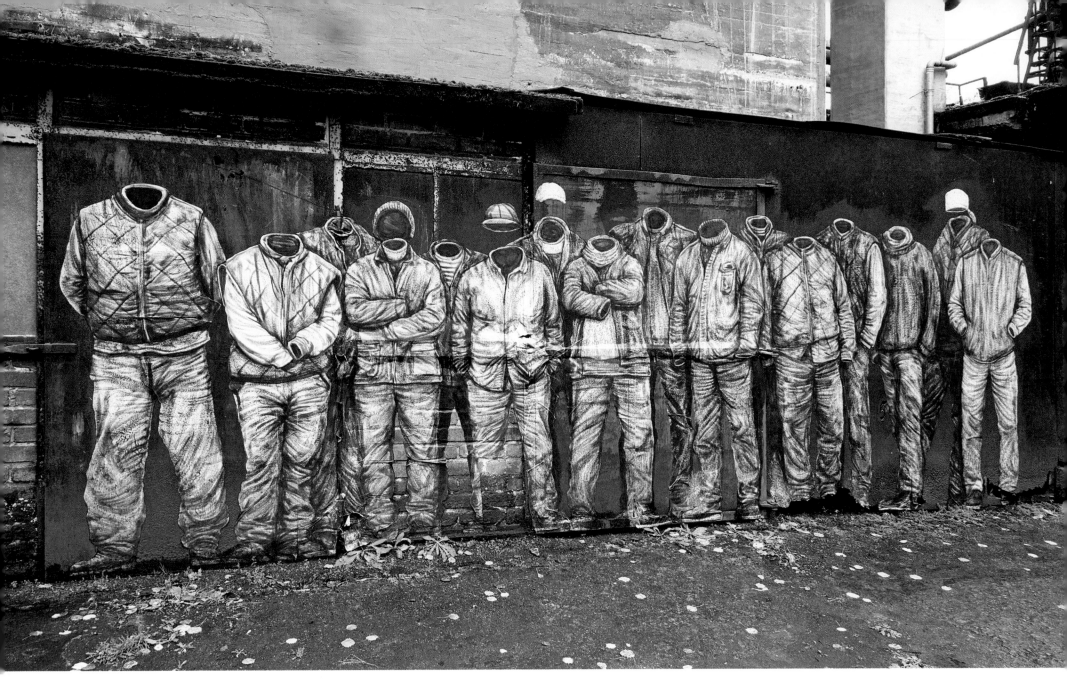

What's left are the work clothes of human
beings: "Plan social" by Levalet in Völklingen
from 2017

Levalet
"I'd like to let the viewers draw their own conclusions"

When Levalet, Charles Leval, is outside, he looks very closely at his locations: concrete blocks, a crack in the wall, a window façade. He measures the location, photographs it and takes notes. Sometimes it lasts a year or more until he uses it. Maybe never. The location and the pictures of human beings he puts there must form a unity, both graphically and in content. He then paints his picture with Chinese ink on paper and glues it on the surface on site. "All my works are one-offs", he explains. "And since up to 90 percent of what I do is illegal, I have to execute it quickly on site." But he has never had problems with the police. He derives his inspiration from many sources: films, books, art, but also newspapers or music. He prefers jazz and plays saxophone and hasn't yet run out of ideas. A creative vacuum would be his worst nightmare. "It already hurts when I go one day without doing something constructive." But even if he addresses social subjects in his works, he doesn't see himself as a political artist. He never becomes involved with single issues and consciously avoids text in his pictures. "I'd like to let the viewers draw their own conclusions." Humor and comic elements are never far from his works. He compares his figures with the American silent film era actor Buster Keaton, whose comic goings-on are always accompanied by a touch of melancholy.

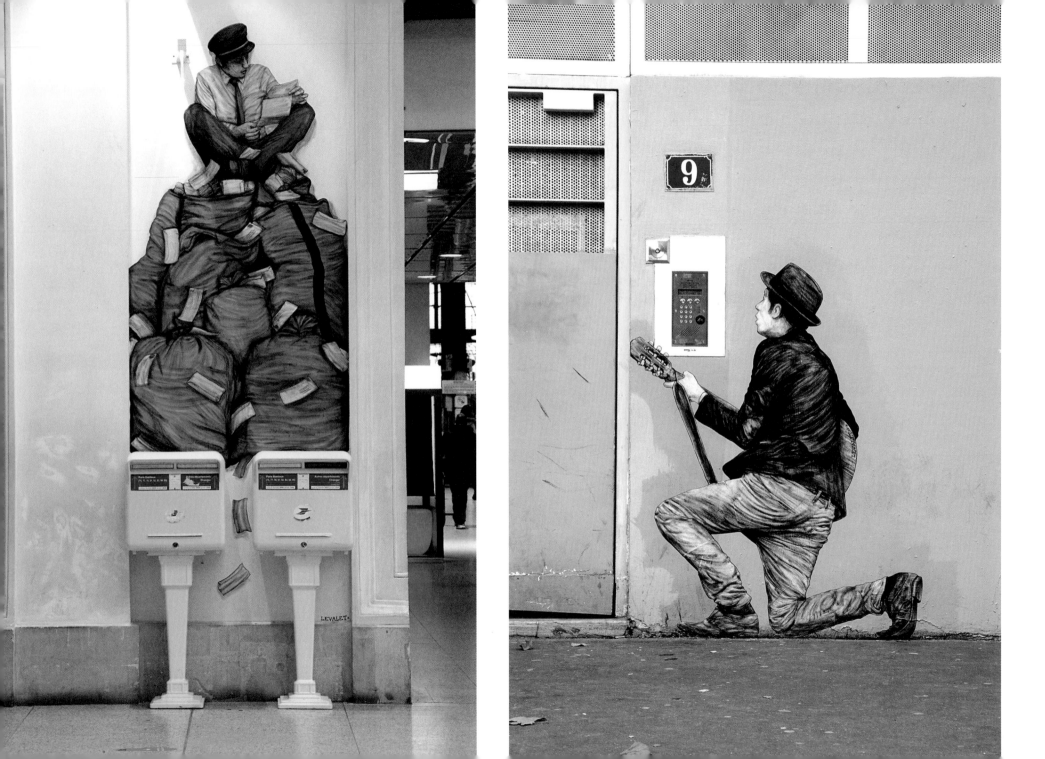

A lot of complaints that have to be processed, presented by Levalet

A small concert in front of the door, a stencil work by Levalet

In "Gestation – Délivrance – Naissance" Levalet describes the liberation from pregnancy to birth

**Vermibus
"It's not me, they're the ones who are stealing our public space"**

The Spanish artist Vermibus, who lives in Berlin, experiences advertising as pollution, as rubbish. The flawless or flawlessly retouched models on the advertisements of large fashion firms disturbed him. His counter-measure became "ad-busting". But in the case of Vermibus it should actually be called "dissolving". Because the artist and activist processes advertising posters with solvent. He discovered the technique by accident in his earlier life as a fashion photographer, exactly the profession that he harshly criticizes today: "I used the wrong developer and the wrong paper for a work. I was totally enthusiastic about the effect that it had by mistake!"

Vermibus removes the real ad posters from the showcases with skeleton keys and changes them in his studio. He blurs the faces with solvent, smears and erases the advertising logos and brings the posters back to the showcases where they came from. With these altered, dehumanized advertising models he sharply criticizes the advertising industry. The street is crucial for the message of Vermibus' work. It's where his art begins and ends.

When questioned about his illegal interventions the artist says: "It's not me, they're the ones who are stealing our public space." For Vermibus "they" is the advertising industry and companies who want to sell fashion and cosmetic products with the aid of flawless faces and bodies.

One of the most striking works from the ad-busting series "In Absentia"

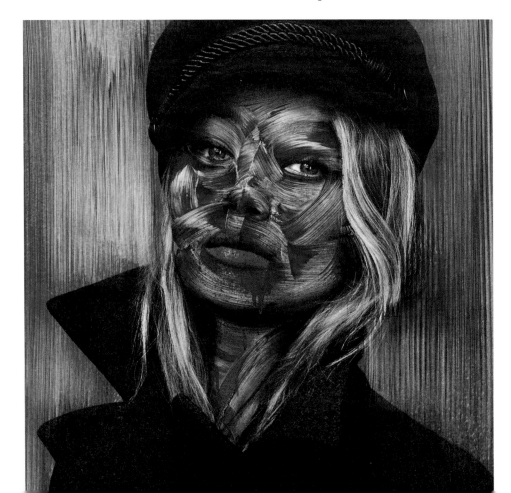

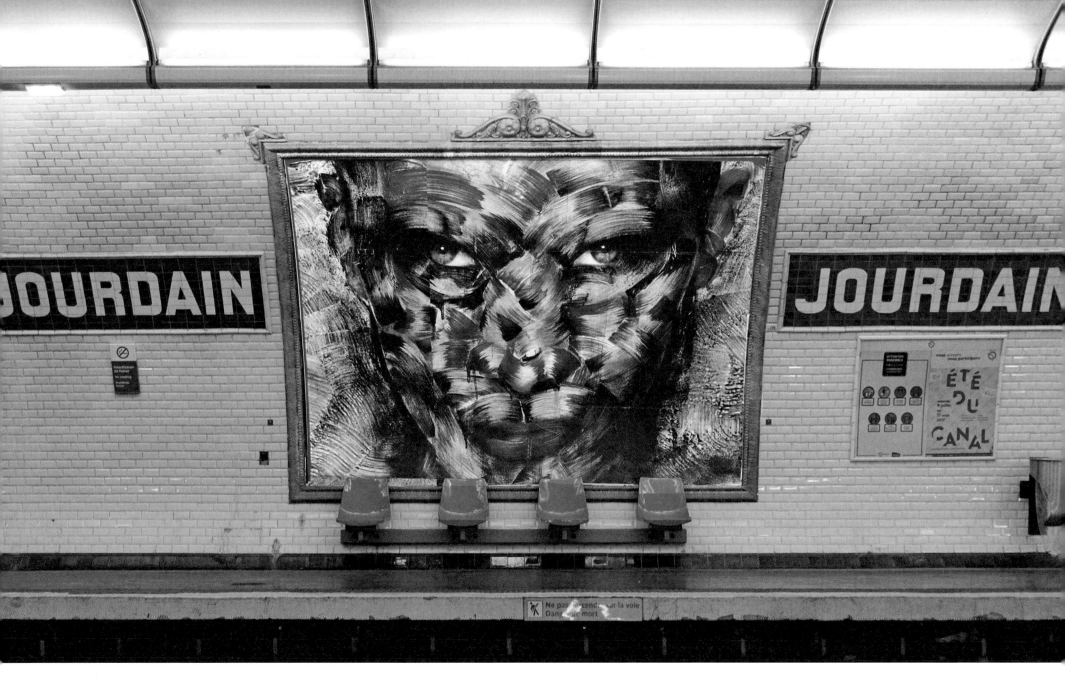

Vermibus was here, too: In the Metro station
Jourdain in Paris at the boundary of the 19th
and 20th Arrondissements

SWITZERLAND

Zurich

Besides Basel, Zurich is considered a street art hotbed in Switzerland. Among the most prominent representatives are the brothers Dr.Drax (*1983) and Pase (*1981), forming the duo One Truth which has become internationally known for their colorful murals. There are others from the Zurich scene, but here are three who are exemplary: the artist crew KCBR which put an exciting video about their illegal "beautifications" of trains in the internet. Or TIKA, Maja Hürst, on tour around the world with her meter-high murals, and Redl, Patrick Wehrli, who, according to his own testimony, produced with its 24 meters the tallest mural in Switzerland in the 5th

District at the end of 2017. Zurich is currently turning from stricter enforcement against illegal interventions to targeted contract work as a measure against illegal "defacing". Whether the policy will pay off remains to be seen.

In the hunt for more information about street art and artists in Zurich the right address is Gabriela Domeisen from Streetart.Limited. And the Kolly Gallery in the Zurich Seefeld district is always a good tip in the urban art scene.

And then there is the legendary "Zurich Sprayer", Harald Naegeli, who racked up 192 criminal complaints in the 1980s. For a portrait of the artist see page 110.

A new, 24-meter-high mural in Zurich: "Melody" by the Swiss artist Redl, Patrick Wehrli

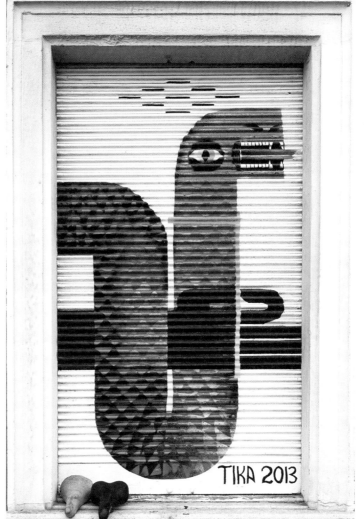

The Swiss artist Maja Hürst is known as TIKA. Her works are characterized by clear, graphic forms. TIKA lives and works in Berlin, Rio de Janeiro and Zurich. You can find the TIKATHEK on the internet, as TIKA calls her visual universe, a play on the German word BiblioTHEK, or library

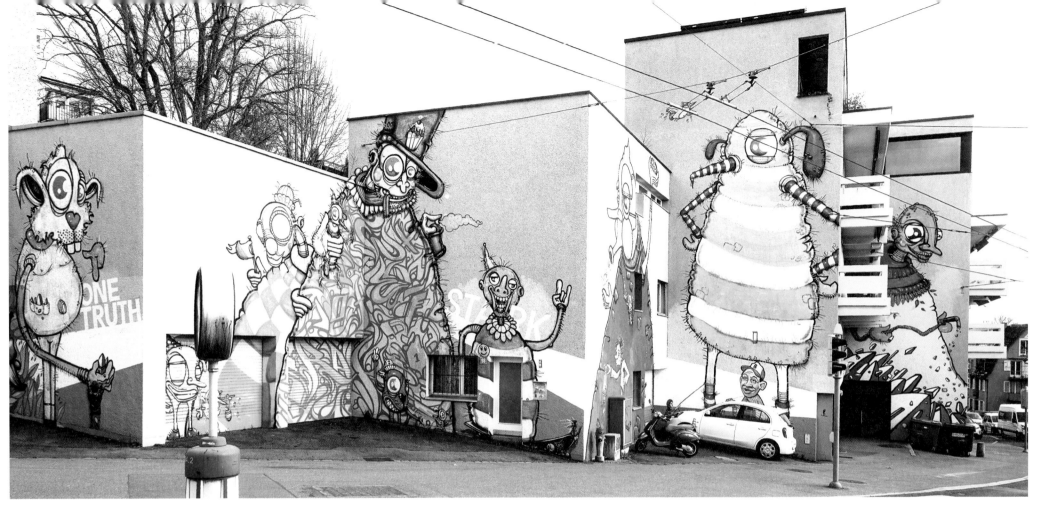

Dr.Drax and Pase work together under the name of One Truth as an artistic collective. Since 1998 the two brothers have been immortalizing themselves with their large format, idiosyncratic figures, especially in their home town, Zurich, but also around the world. They like to work on large-scale projects with other artists, like the Rötelstrasse row of houses in Zurich. Along with Dr.Drax and Pase under the heading of "Gemeinsam stark" (strong together) Snyr, Soup, Spoom and Werk have also attracted international attention

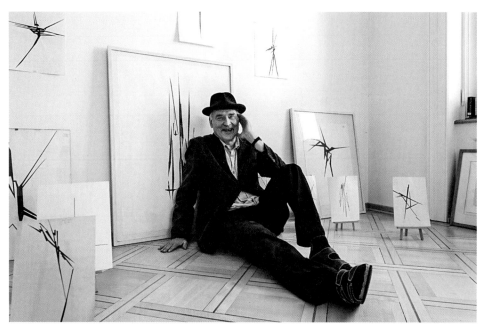

Harald Naegeli in his dwelling in the heart of Zurich. His art covers many styles and goes far beyond the familiar spray paint works

Harald Naegeli
"J'accuse!"
The "Zurich Sprayer" sues!

Known as the "Zurich Sprayer" Harald Naegeli achieved international recognition in the 1980s. His jaunty fish, bolts of lightning, flamingos and female figures were legendary, his method of work spontaneous and rapid. In spite of a price on his head Naegeli's identity was unknown for a long time.

Although his works in Switzerland were considered public defacement for which he was prosecuted, the reactions in Germany were much more positive.

Politicians like Willy Brandt and artists like Joseph Beuys, whom he got to know in 1982 in exile in Dusseldorf, were among the greatest supporters and admirers of his art who also came out for his freedom.

In spite of that support, in 1984 an international arrest warrant led to his extradition to Switzerland and a six-month stay in jail. Although Naegeli has been living in Dusseldorf and consistently speaks High German, he is again spending more time in his art nouveau house in Zurich.

And at almost 80 years of age he is irrepressible: At the end of 2017 Harald Naegeli was in court again in Zurich. But this time he was the one who issued the media savvy "J'accuse!", in the courtroom. "I accuse you of annihilating, destroying, withdrawing from view and rendering unusable any works of art by any and all, and declaring them to be criminal acts instead of protecting and preserving them, as is required for works of art!" A settlement was reached in Zurich, but the matter was continued in Dusseldorf for Naegeli: In February 2018 he was summoned by the court because once again two flamingos which fit in the Naegeli group of works…

Created in a cloak-and-dagger operation in 1978, the canton and city of Zurich today consider "Undine" on the north side of the German Seminar in the Zurich University as worthy of preservation

SWITZERLAND

Basel region

If you travel by train to Basel, you'll pass through a veritable open-air gallery to the left and the right of the train tracks. Since the 1980s, between the SBB main station and the Schwarzwald Bridge countless graffiti artists from all over Europe have risked life and limb for immortality on the "Line" directly on the tracks. The works can be safely viewed from a distance, for instance from the Gellert Bridge or the St. Alban-Promenade. The tours organized by Philipp Brogli from Artstübli, a platform and gallery for urban art and culture in Basel, are recommended. Brogli works closely with the IWB (Basel Industrial Works) and regularly mediates artists to spruce up little transformer houses and other buildings of the IWB. "The artistically designed walls deserve respect", Brogli says. The IWB finances art in public spaces from the cleaning budget.

Many international graffiti artists still leave their immortal marks on the Basel "Line"

If you delve into the graffiti art history of Basel, you will inevitably turn up this name: Dare, Sigi von Koeding, who made a significant impact on the graffiti scene. He also contributed in the tri-border area to the history of the CoLab Gallery in Weil am Rhein which he opened in 2006 together with Edwin Fäh, the director of Carhartt Europe, an enthusiastic collector of urban art. In the mid-1980s Dare was one of the trailblazers of American graffiti in German speaking areas and is considered a legendary graffiti network person and a leading figure in the scene. After his early death in 2010 his artist colleague, Stefan Winterle, who is also active as a stencil artist, curates the CoLab exhibitions.

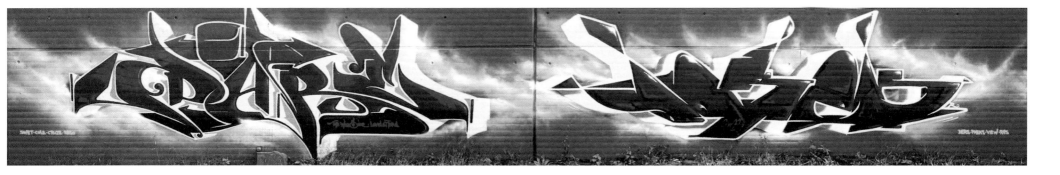

The collaborative effort of two Basel graffiti artists:
Dare, who died in 2010 and was important for
many artists, together with his colleague, Dosek

Graffiti by the three street artists, Crone, Jers
and Smash137 at the famous "Line" just before
the entrance to the main train station in Basel

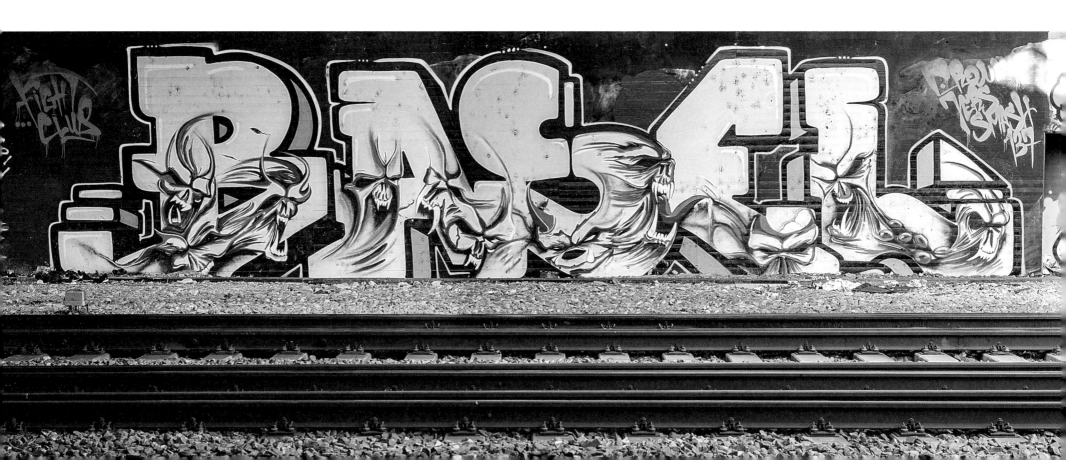

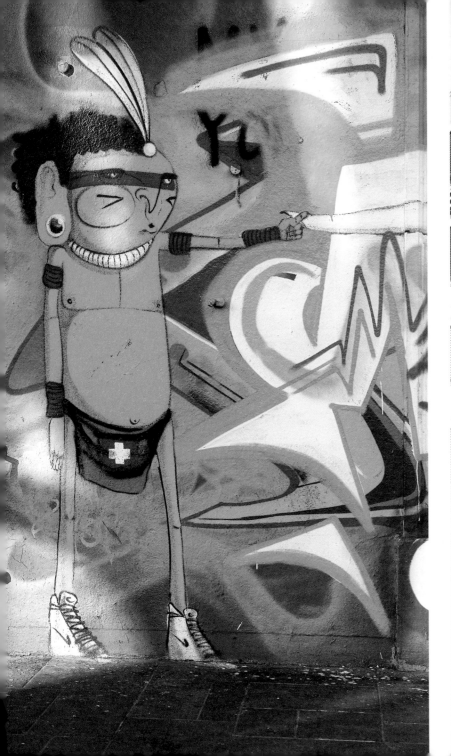

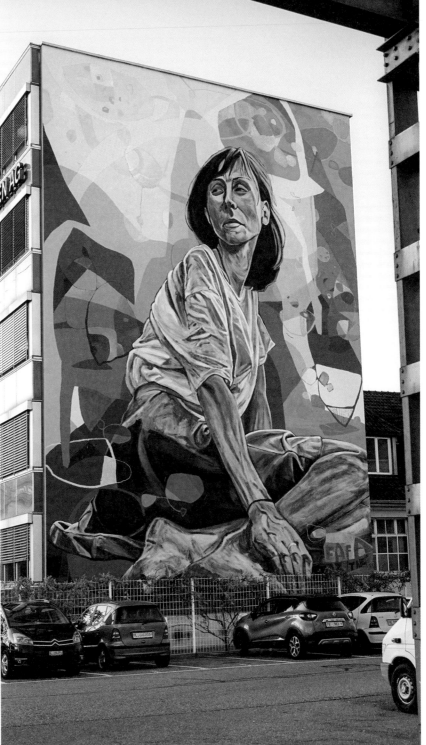

The Brazilian Cranio was also active at the Basel summer casino. For a portrait of the artist see page 76

During the Pratteln Biennale outside of Basel a few murals were created on 1,500 square meters like this joint work by the Basel artist Daniel Zeltner and Rafael "Fafa" Marquez, who grew up in Sevilla. For a portrait of Daniel Zeltner see page 117

Giuseppe Aiello alias THAF likes to work without guidelines, but he had to carefully plan this somewhat complicated façade

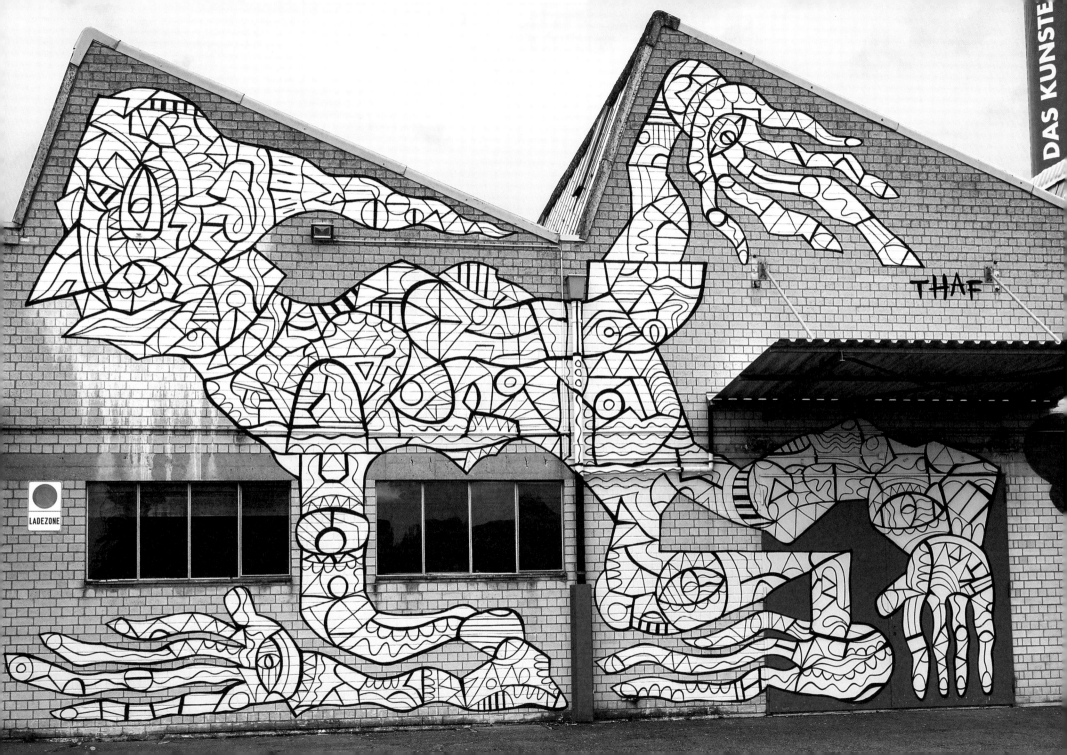

Laufenburg

The story doesn't take long to tell: a small Swiss town in Canton Aargau with a small museum dedicated to a sculptor and, like almost all museums, struggling with a dwindling number of visitors. The new approach was to bring in young artists from the street into the museum, and attract more, especially younger, visitors. It works. In the three months of the street art exhibition more visitors came than in a whole year.

But that's not enough: The responsible parties in Laufenburg adopted the street art idea and commissioned works by the street artists. Which is how a large snail by spray painter POLLO 7 ended up over the small train station building. ERNE, a large building contractor with headquarters in Laufenburg, supported the urban art activities in the museum, not just logistically, but financially, too. The works of the artists who participated in the exhibition were so convincing that the new ad campaign of the contractor now has a street art look. After all, what better places for spray-painters than construction site fences or wooden barriers? All those involved had something from the good work together. And who knows, maybe a sleepy little town in Switzerland will become the next urban art Mecca!

The orange frog by Malik from Aarau, Switzerland, is good fit with the old greenhouse of the Leuenberger firm

**Daniel Zeltner
"I want to go through life with an open heart"**

"I knew about graffiti culture when I was still a child", says Daniel Zeltner, who is 33 years old today. "Since 1983/84 people from around the world have spray-painted along the train tracks." He wanted to do that, too, to spray-paint, be creative and express his feelings. He set out on a path as screen printer, font and advertising designer, went to the School for Design and worked in advertising agencies. "And now I'm at a point where I can earn my money with commission and freelance work, outside on walls and inside with drawings and illustrations."

His father worked for the railroad so spray-painting graffiti was a no-go. "Well, at least he never knew about it!" Today his family accepts his art as work which is a great passion for him.

Daniel Zeltner has his own, special style. "I use a lot of color, very open and free, which is a reflection of my personality. I'm an open person and I want to go through life with an open heart and discover new things." He says he wants to express that in his pictures, puts on the headphones and continues working on the large, cheerfully colored circles on the garage door.

A tribute by the Basel artist Daniel Zeltner to the prominent Swiss sculptor, Erwin Rehmann, born in 1921

SWITZERLAND

Daniel Zeltner from Basel imaginatively realizes the slogan
"ERNE Builds for the Future"

Malik from Aarau combines technology and
manpower for the advertising campaign of the builder

POLLO 7
"The snail is the only animal that hasn't run away from me"

The POLLO 7 trademark is the snail, or to be precise, the slug. With a wink he says "the only animal that hasn't run away from me". The snail as female nude, as a shadow figure, or comics hero or with a rider on top. In one of his largest works to date, "NAPOLLON BONAPAR7E", Napoleon rides a slug. POLLO 7 drew on his nom de plume to create the name of his work. And the talented young artist has a few reasons for the choice of his pseudonym:

"POLLO 7 looks aesthetic, the name reminds me of outer space and limitlessness, it incorporates a part of Jackson Pollock's name, whom I think a great deal of. And in Spanish 'pollo' means chicken, which I like to eat."

POLLO 7 works mostly legally because for him the work quality is the priority which he can't achieve with illegal works. He recently quit his bread-and-butter job to go it alone with art. He has been able to accept his first international jobs, "If things continue like this, then I'll be content", says the engaging young Swiss.

POLLO 7's snails have left behind their tracks at different locations in Laufenburg

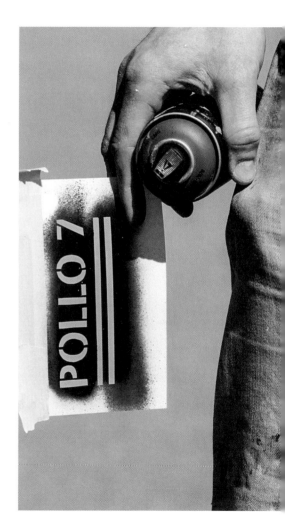

POLLO 7 often uses stencils and has to replenish them frequently

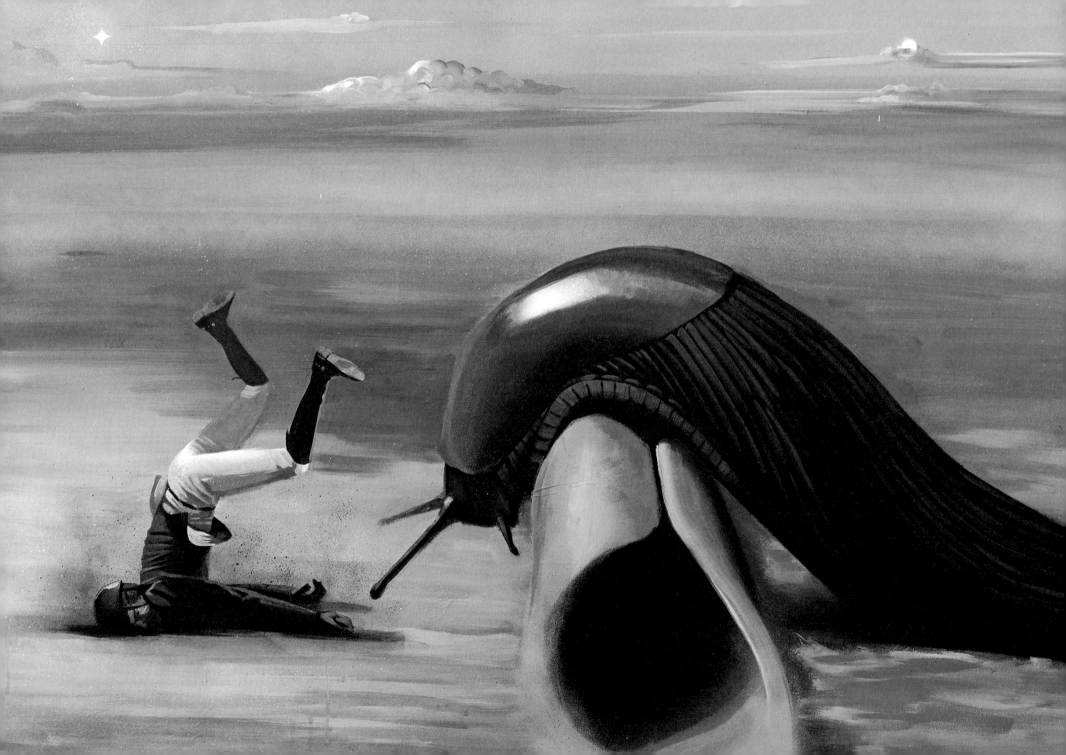

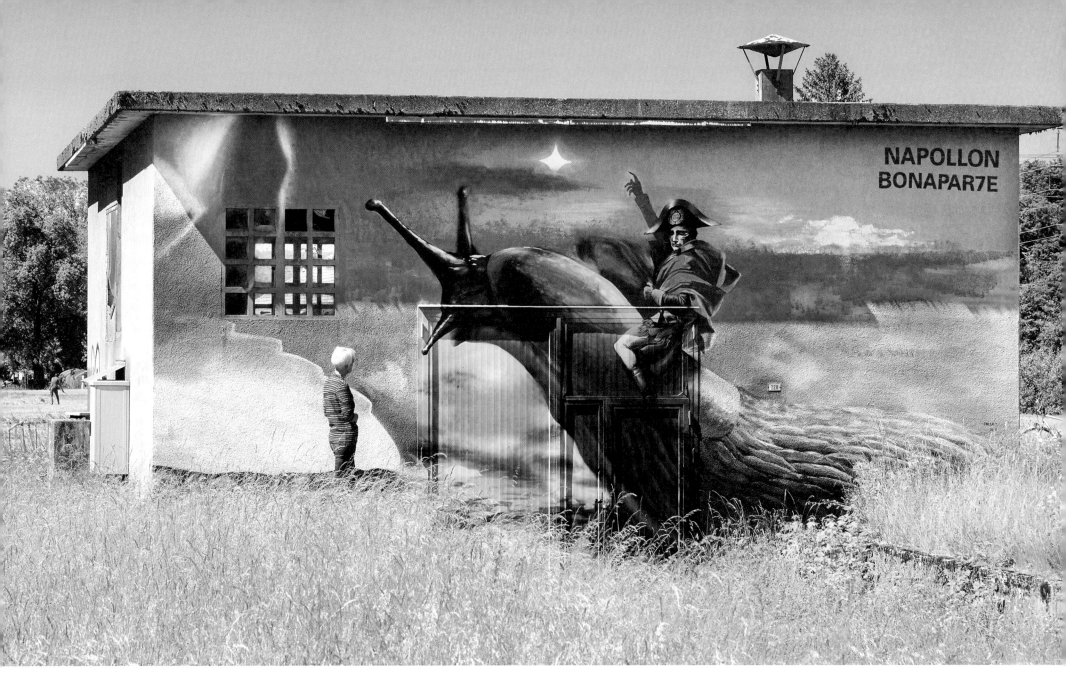

Here POLLO 7 with one of his snail pictures, with its
astonishing proportions, content and subject

In the work "NAPOLLON BONAPAR7E" Napoleon Bonaparte is riding a slug.
The title of the work refers to the name of the artist, POLLO 7

SWITZERLAND

David Monllor
"Graffiti leads each person to something very different"

Strange, utterly realistic, but the rhino and deer are out of place in the old city alleyways. The bear on the iceberg looks more familiar. The current works by David Monllor involve mostly threats to habitats and ecological disequilibrium. But that's not how he started out: "In my youth all my friends were in the hip-hop scene; I worked for years with typography and alphabet technique, with really classic graffiti", David Monllor says. He was born in 1987 to an Italian mother and a Spanish father in Switzerland, in Canton Aargau. David Monllor describes himself as self-taught, with "learning by doing" as his motto. He thinks it's a shame that more traditional painting is not taught

anywhere in Switzerland. "For what I do, in terms of painting technique, an art academy would not help me much."

At some point it became boring for him: "I started making figurative things just with spray paint, which was exciting for years, because not many people were doing that." Today he works primarily with oil colors and hardly at all with the spray can. He spends more time in the studio than on the street, where he only works with colleagues. In his opinion the same roots, in graffiti, lead each person to something very different. "Working together means a real blend of styles, which can be unbelievably exciting."

The photo-realistic works of the Italian-Spanish painter have a special, almost old master aesthetic

David Monllor often "replants" his animals in unusual surroundings, referring in the process to the threats to habitats

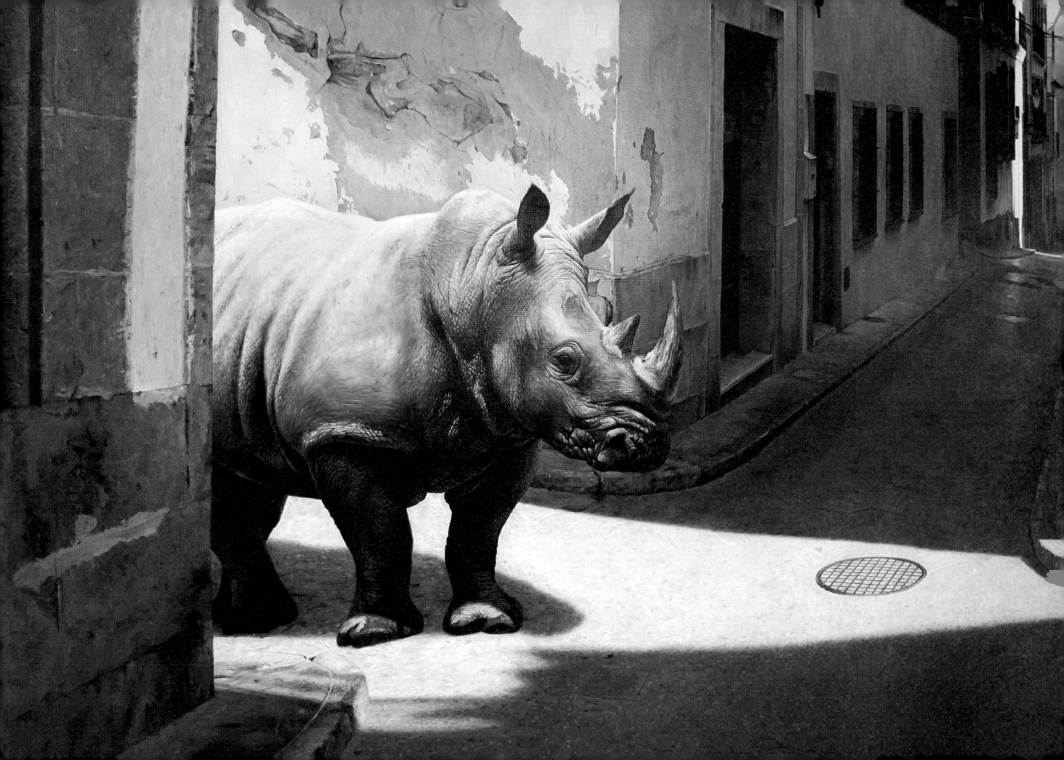

Geneva

Geneva, the city of international organizations and banks with their splendid buildings and urban art: Is that a paradox? Astonishingly not. In the Les Grottes district behind the main train station street art is everywhere. And a little outside Geneva, where the Rhone and Arve rivers merge, there is more good and surprising art to be seen. The city is also good for unusual activities, like the "Insideout" project.

The Paris-based Nadib Bandi has his roots in the classical graffiti scene. This work near the train station was done in collaboration with Tones from Basel

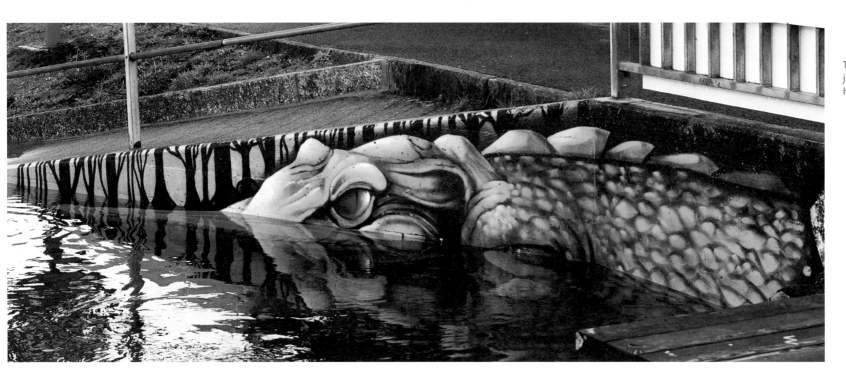

The crocodile by Gamo peeks
just over the water level during a
high-water phase of the Rhone

The comic figure Hulk Rose,
painted by Gamo

SWITZERLAND

The photographer Mark Henley

51 large-format portraits of refugee seekers were glued to the ground in a central location in Geneva in the framework of the "Insideout" project. The exhibition was destroyed overnight by vandals

Mark Henley
"I work in an extremely documentary fashion"

Mark Henley, born and raised in Great Britain, went to Tokyo after completing his studies, moving to Zurich 15 years ago, and then to Geneva. He is internationally active as a photographer and has won several prizes for his press photos. He has also documented the refugee crisis in detail. Which is why he spontaneously agreed to the "Insideout" project in Geneva. He photographed 51 asylum seekers. The large-format portraits were glued on a central location in Geneva, giving faces to the anonymous numbers of the refugees. When he found all the pictures except for five slashed and torn the next day, Mark was shocked. He photographed these pictures disfigured by vandals, one after the other, as if in a trance. "I work in an extremely documentary fashion", he says about his method of work.

"I don't touch things before I shoot, never!" He left the photos alone for a long time. He experienced their disfigurement as a new assault, as a kind of remake of what the refugees had already been through.

Almost a year later he decided to submit the photos in the US photo competition "Pictures of the Year", where the series was promptly acclaimed, thrusting them into public awareness. The "Facing Prejudice" exhibition in Flux Laboratory in Zurich and the publication of large-format brochures followed. Later, the pictures were shown in Athens and at a film festival in Geneva.

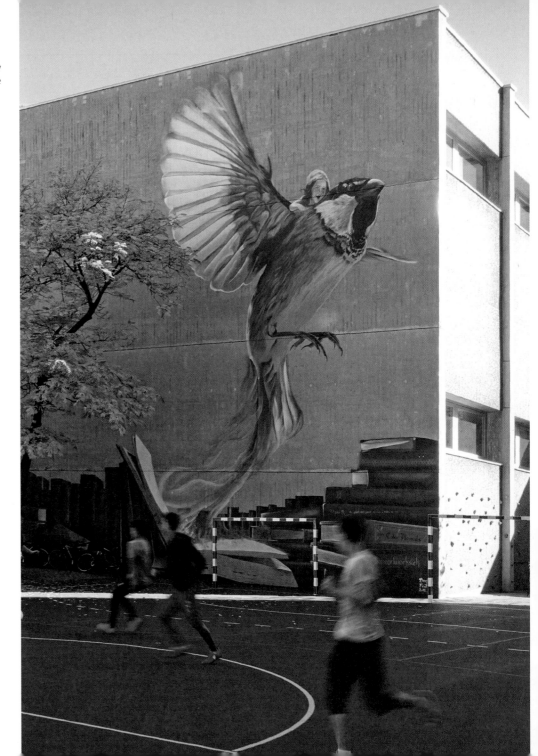

A gift for his former school: a large mural by
Bane&Pest on the Lachen schoolhouse

Chur

Chur in the Canton Graubünden is a good example for how very much the street art activities of one city depend on individual activists: Although some of the works of the 70-year-old Robert Indermaur can still be found in the alleys in Chur, it's the 35-year-old Fabian "Bane" Florin who is leaving his street art marks today. And not just with words and works, but with a gallery, too. His next project will be huge: the

46-meter-high Mühleturm will be the largest mural in Switzerland. The city of Chur set aside 220,000 Swiss francs for it. "I have never painted on such a scale before", says Florin. It will be a "hard nut to crack", but he was very happy with it. He'll get help from his artist partner, the Cypriot Yiannis Hadjipanayis alias Pest. He's already worked on many projects with him.

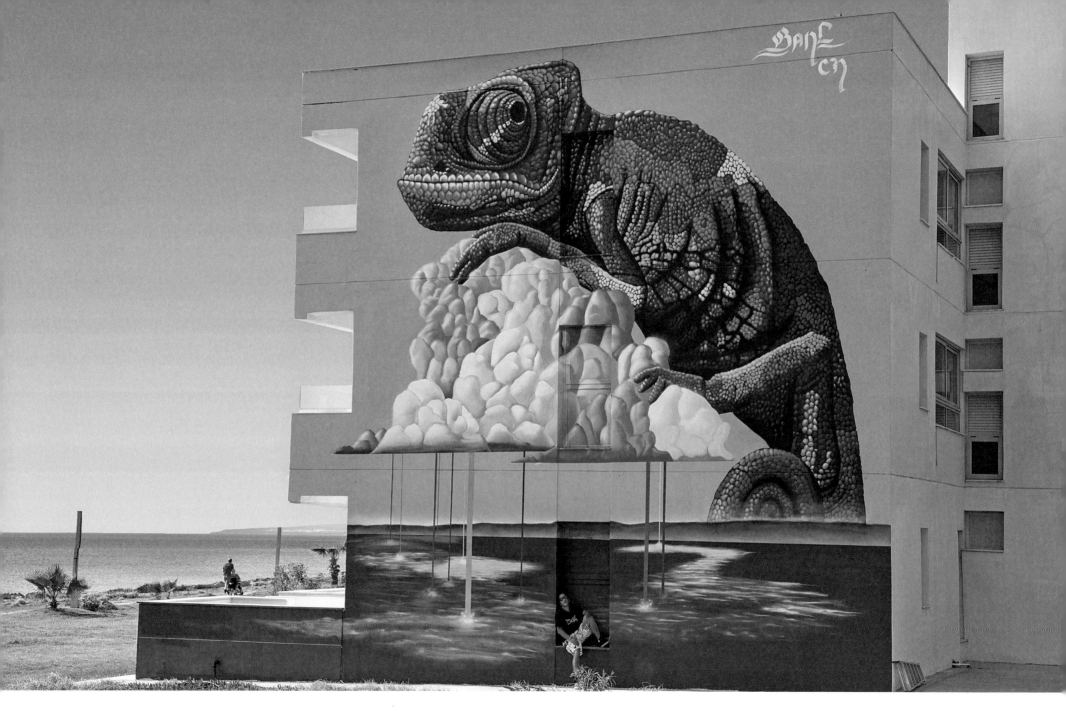

A huge, colorful mural by Bane&Pest on the island of
Cypress at a fabulous location with a view of the sea

SWITZERLAND

Robert Indermaur
"I take the figures and faces from my head"

His figures float, crouch in the corner, look around at the wall of the building or group together. The Swiss artist Robert Indermaur has been involved with people as subjects, for sculptures as well as his pictures. These are no beauties, no silver-screen heroes. Just people like you and I. And his figures touch us, like the numerous family members gathered around the parking garage entrance or the street musician, a mural figure whose hat at the Chur train station one must always hurry by. Indermaur explains that he needs no templates or models for his figures, "I take the figures and faces from my head."

Robert Indermaur is in fact no typical street artist. He is more a constantly inspired jack-of-all trades: In 1974 in Chur together with his wife he founded the first Graubünden small theater. In addition to drawing, Indermaur, now in his seventies, also writes. He sees no reason to slow down and just had a large, one-man exhibition with sculptures and pictures in the Forum Würth in Chur with the title "People's Park Extension".

You're tempted to just toss something into the hat of the violinist at the Chur train station …

A huge figure by Robert Indermaur as gateway to the Forum Würth in Chur

London

Think about street art and London and you'll probably think about the anonymous work of Banksy. He was creating his striking stencil works here shortly after the millennium, stirring up discussion at the time. Today you can almost count the works of his that have survived on the fingers of one hand. But when urban art fans come to the English capital they get their money's worth.

"London has one of the biggest and best collections of uncommissioned street art in the world", according to the Official Visitor Guide. East London, where the scene changes almost every day, comes highly recommended. You can find every kind of street art there, including Banksy's "Guard Dog" in the Cargo Bar beer garden in Shoreditch (see page 139).

One runs across the simple and likeable figures of the London artist Stik in many metropolises

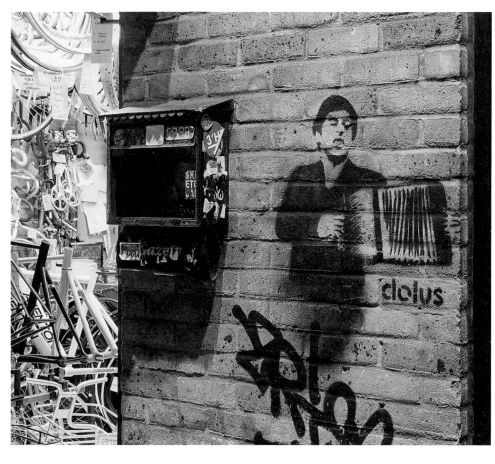

dolus lives in Perth, Australia.
He works anonymously

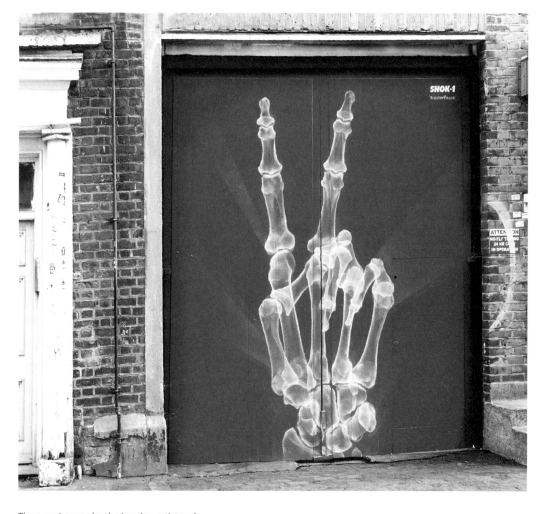

The x-ray images by the London artist and
chemist SHOK-1 are a kind of diagnosis of
21st-century life

Street art in the true sense of the word: On the Millennium Bridge, not far from the Tate Modern, the artist Ben Wilson has transformed hundreds of flattened wads of chewing gum into tiny works of art

"Speak the Truth", one of the abstract portraits for which ALO is known. Born in 1981 in Italy, he lives mainly in Paris and London today

«My work is influenced by many artistic movements, from Cubism to Expressionism.»

ALO, Aristide Loria

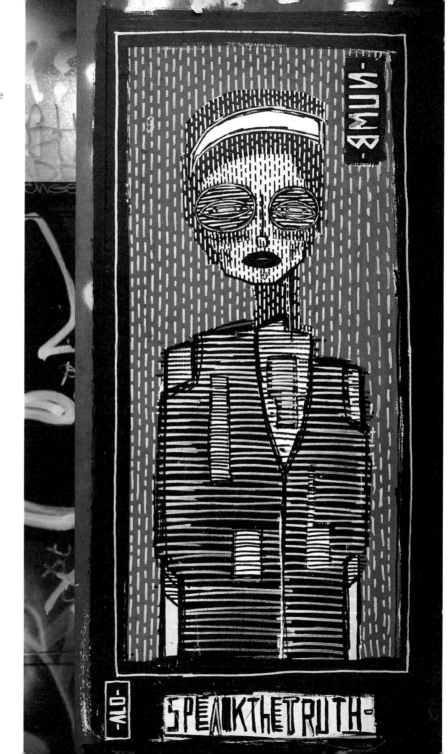

«The abstraction and absurdity are used to pass on messages to human beings, in a subtle and indirect way.»

Bault

Bault, originally from the south of France, today based in Paris, beautifies the streets of the world, legally and illegally

Jason Smith
"Banksy mightily reshuffled the cards in the world of art"

Shortly after the millennium Jason Smith lived and worked in East London. On the way to work he continually discovered new Banksy works in the Shoreditch district, which has meanwhile become a legendary location for urban art. "At that point in time I was able to purchase signed works at Banksy's art publisher, Pictures On Walls, of the up and coming artist", according to Jason Smith, "I liked the pictorial language, with its often humorous, but also critical representations." Banksy, who wants to remain anonymous, had apparently just moved from Bristol to London, where he was creating works of art all over the city. It could well be that Banksy lived in the same area and that the two of them had the same friends in the scene in Hackney. "I don't know Banksy", says Jason Smith, "at least not that I know. It could be that we were at the same parties or concerts."

Banksy had close contacts with musicians. He designed record jackets and CD covers with his famous stencil themes for different groups, like Blur. Jason Smith knows of about 40 such albums which have used Banksy's street art with or without his permission. They've all become sought-after collectors' items.

"Banksy is above all an intelligent, creative fellow. But he developed a brand and very successful business model and mightily reshuffled the cards in the world of art." Banksy still works with spray paint, increasingly with a political statement. His cloak-and-dagger appearances with spray-painted stencil work have blossomed into an extensive art experience for the broader public: from the temporary amusement park "Dismaland" to the boutique

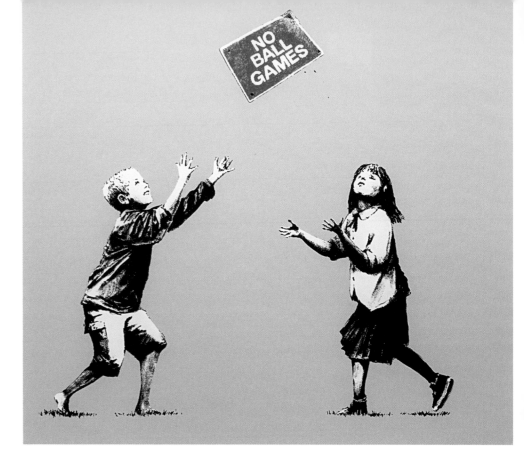

This familiar Banksy work was removed from the streets of Harringey, London, and sold for the benefit of a local organization for handicapped children

hotel "The Walled Off Hotel" in Palestine.

"Nowadays it's not so easy to come by a 'Banksy' directly. If you have the necessary pocket change some of them are available", says the passionate collector of urban art.

The London Banksy collector Jason Smith in front of one of the few preserved Banksy works in the British capital, the "Guard Dog" in the Cargo Bar beer garden in Shoreditch

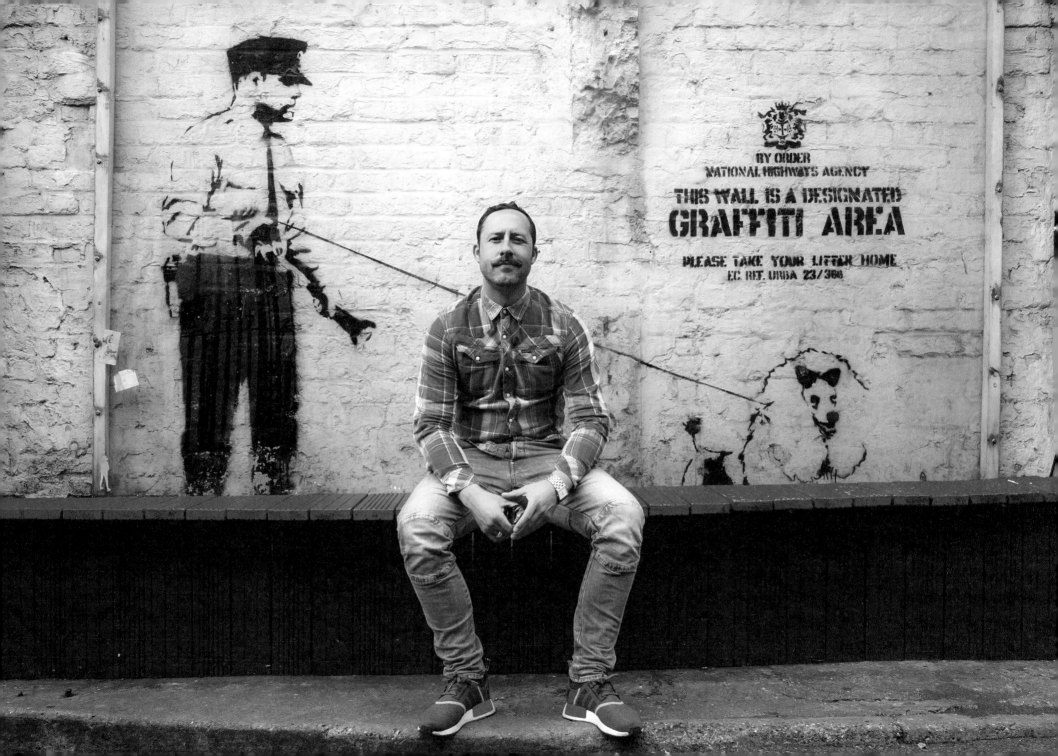

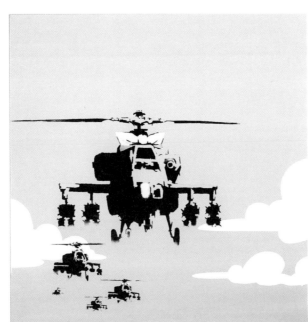

"The Banksy Years", with what is probably an unauthorized "Monkey Queen"

The famous flower thrower from Palestine on the LP "We love you" from 2000

"Yellow Submarine" from 2002

"Flat Beat" by Dirty Funker from 2009

"Future" by Dirty Funker from 2008

"Think Tank" from 2003 is the seventh studio album of the band Blur

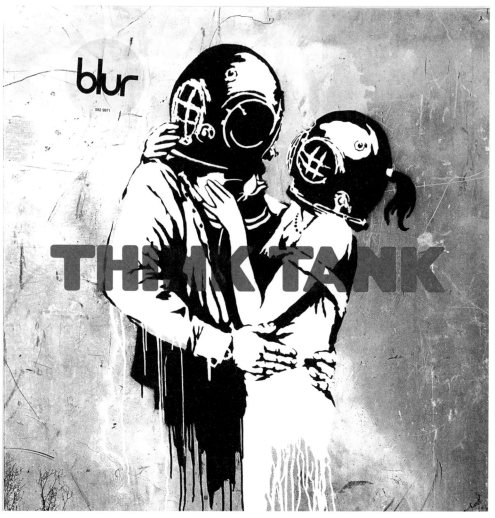

Paris

The Parisian Gérard Zlotykamien is considered one of the first street artists. So it should come as no surprise that the French capital still has an extremely active and many-faceted urban art scene which continues the long cultural saga of the city on the Seine.

Christian Guémy alias C215 created this big cat

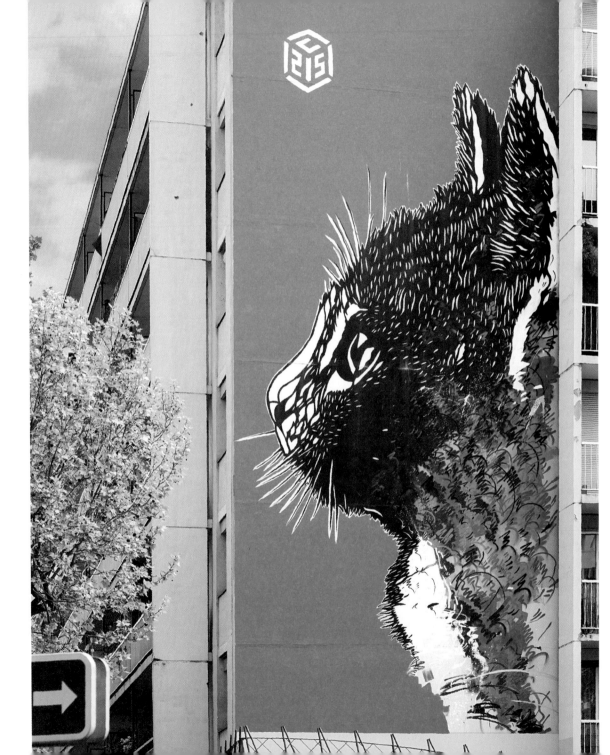

The Frenchman Clet Abraham doesn't just change the street signs in Paris humorously. For more works by the artist see pages 188, 189

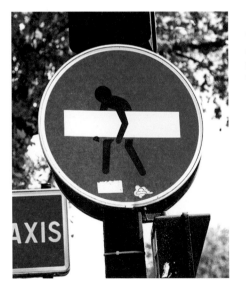

Gérard Zlotykamien and his Éphémères

The inventor of the "little, comical ghosts" was born in 1940 in Paris and in 1963 became the first artist to work in public spaces. His so-called Éphémères, or fleeting moments, were symbolic stick figures sketched at first with chalk and brush and later with spray paint on various walls. Zlotykamien's work dealt with subjects like war, fascism and communism. He was born during World War II with Jewish origins and had to put up with prejudice many times. Zlotykamien has repeatedly addressed the subject of Hiroshima and the atomic bomb. After he officially ended his artistic career in 2003, different new stick figures familiar from his work have cropped up in the last few years.

In one night in January 1979 Gérard Zlotykamien completed a total of 77 works in Ulm, Germany, only a few of which have survived

SWIZ in his studio overlooking the
roofs of Paris

SWIZ
"One stroke leads to the next"

If you want to pay a visit to the French street artist SWIZ in his studio in Paris, you'll have to be prepared for a hike. Although it is centrally located in a building just behind the famous Fontaine Saint Michel, you'll have to trek up 125 steep stairs. That's a kind of flashback to his beginnings as a grammar school student when he used to climb up onto the roofs of buildings in Paris at night. Where the wall stopped and the roof began he would leave behind his tags. "Graffiti was everything for me: my circle of friends, sport club, love and finally the school."

After a few more years in the outdoor scene that the autodidact spent in the Metro tunnels and abandoned factories and warehouses, he started to work in a studio in 2008. He developed his own style with deformed lettering containing graffiti elements. He gravitated to the cubists from the early 20th century and the architectural forms of the large city. "When I start a work, I don't know what it will look like when I finish. One stroke leads to the next." SWIZ works painstakingly in the studio on the transitions until the color gradient and the forms

generate the desired harmony. That can take several weeks. But "dans la rue" campaigns have kept their charm, too. In two or three hours, often with friends, he is finished. His artist's name is a holdover from the graffiti days. "I read comics and there are these sounds like the 'screech'

tires make or the 'bang, bang' in a shoot-out. I wanted something that onomatopoeically expressed a fast, easy stroke. I picked 'SWIZ' and stayed with it."

A work inspired by Cubism architecture and graffiti elements

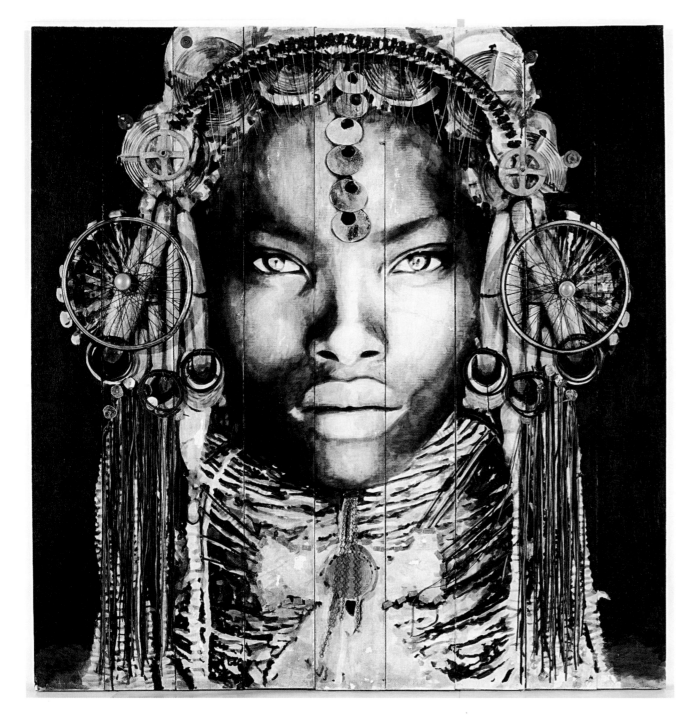

«I wanted to find
out more about
women who wear
head ornaments.»

YZ

"Empress Akinyi" from the new
YZ work group

YZ
"Women as the bearers of the community legacy"

YZ, born in 1975 as Yseult Digan, is one of the few women working in the male-dominated urban art scene. She continually addresses women's issues in her work. For about 15 years now her pictures of young, often lightly dressed women, which recall the period when photography was first considered an art form, have been seen in the streets of many larger metropolises.

In her new group of works, "Empress", YZ, pronounced like the English "eyes", portrays women from smaller nations or communities who are often overlooked by western-dominated society.

"I wanted to find out more about women who wear head ornaments", the slender woman in her mid-forties with the short cut blond hair explains. She has composed all the ornaments in her works from recycled material which has a significance that goes deeper than the purely aesthetic. "They also reflect the identity of individual communities or nations."

The subject of identity is a through-line in the work of YZ, who has roots in France, England and Guadeloupe and considers herself a nomad. "I was often in Africa and always felt an urge to find out where I came from. That's very important for me. I believe our culture and our traditions must be guarded in order to write the history of tomorrow." Which is also the basis for her latest project, YZ explains. She had frequently observed that it was the women in the communities who maintain the legacy and pass on the history. "So it was especially interesting for me to make these portraits of women as the bearers of the community legacy."

Le M.U.R. Oberkampf

Le M.U.R. – Modulable, Urbain, Réactif – is the name of an association which invites artists to tackle a former three-by-eight meter billboard in downtown Paris. After 14 days the work is then covered over by another artist in reference to the transitory nature of advertising. This has been going on for more than ten years. The list of the artists who have participated reads like a "Who's Who" of urban art.

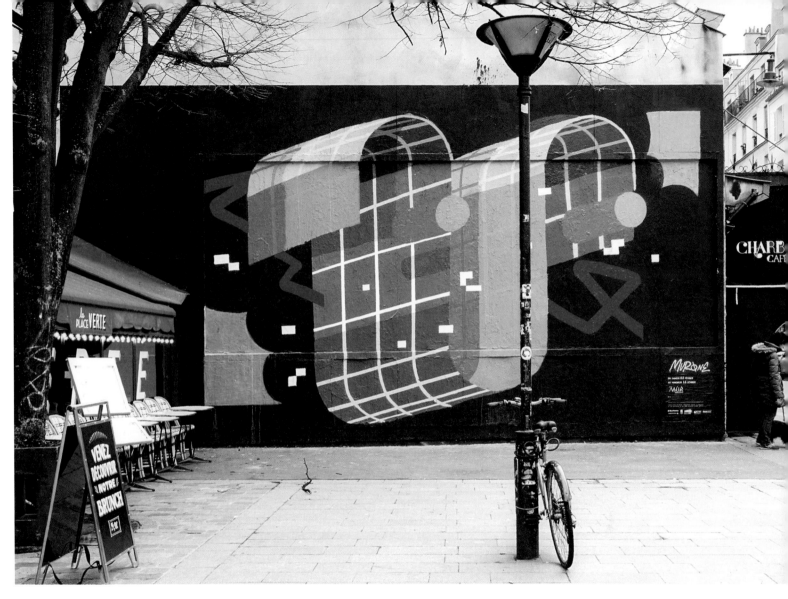

The Spanish illustrator and graphic designer MurOne with work # 251

The German artist couple Herakut (for a portrait see page 82), created work # 195 in 2015

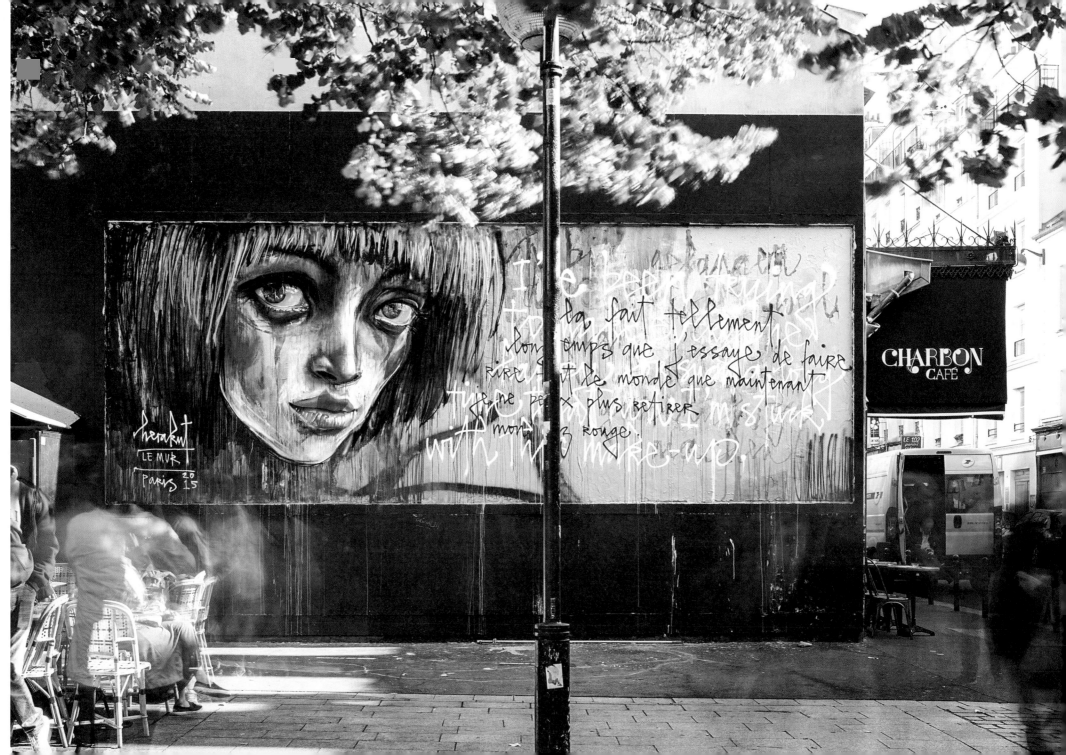

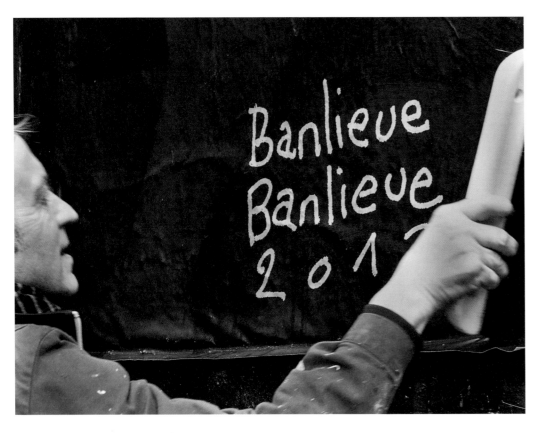

Antonio Gallego finishes the work of
the Banlieue-Banlieue artists' group

He's called Kraken, which means octopus and he
creates creatures with the same name. One of
them can be seen not far from Le M.U.R. with more
in and around Paris

Antonio Gallego:
Banlieue-Banlieue reloaded

If you google the name of Antonio Gallego, you will quickly find a video from 2006 which shows a middle-aged man covering over billboards in the streets of Paris by night. In Gallego's opinion, advertising dominates public space, leaving little space for individuals to express themselves. If one goes ahead anyway, one risks a fine. This was the fundamental criticism of Gallego and a group of artists in the early 1980s when the Banlieue-Banlieue movement was founded. They wanted to bring street art into the suburbs and provide an answer to established exhibitions like "Paris-Moscou" or "Paris-Berlin" in the Centre Pompidou. In 1989 the collective was disbanded. Gallego remained loyal to art, also in public spaces, and became a teacher at the École nationale supérieure d'architecture de Strasbourg. In 2017 a few of the Banlieue-Banlieue activists met in Paris and covered completely legally the Le M.U.R. Oberkampf. "Like we used to", one of the three artists said wistfully. "Working together on a work of art is just great."

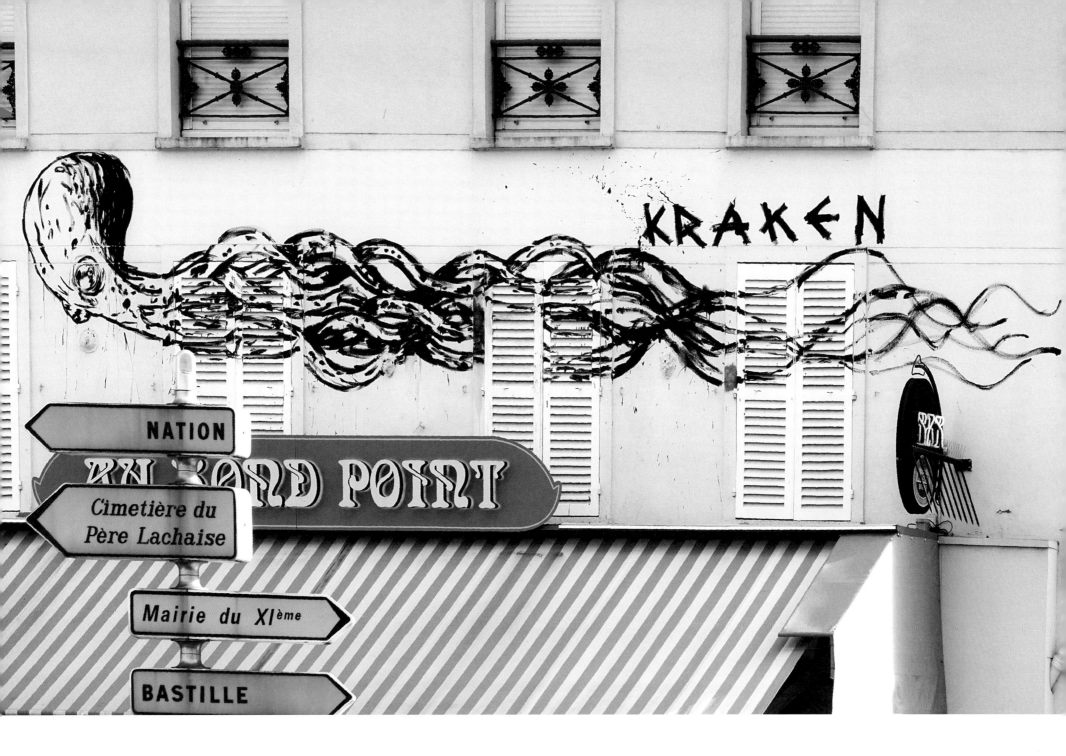

All around the Centre Pompidou

Art attracts artists. Important works of urban art have been created in the vicinity of great museums like the Centre Georges-Pompidou or the Picasso Museum.

Across from the Picasso Museum an Invader-created image of the great painter issues a greeting from the wall

Invader is named after the game "Space Invaders"

Little is known about the artist behind the pseudonym of Invader. He comes from Paris and his mosaics originally represented characters from the "Space Invaders" video game. The artist derived the mosaic technique from the pixel structure of early video and computer games. Since his first works in 1998 in Paris his creatures have gone on to conquer the whole world. 3,620 Invaders in 76 cities require a bit of system, so for instance PA_1265 designates the 1,265th mosaic in Paris. Invader has ascended to the pantheon of urban art.

Invader, "Bikini Girl"

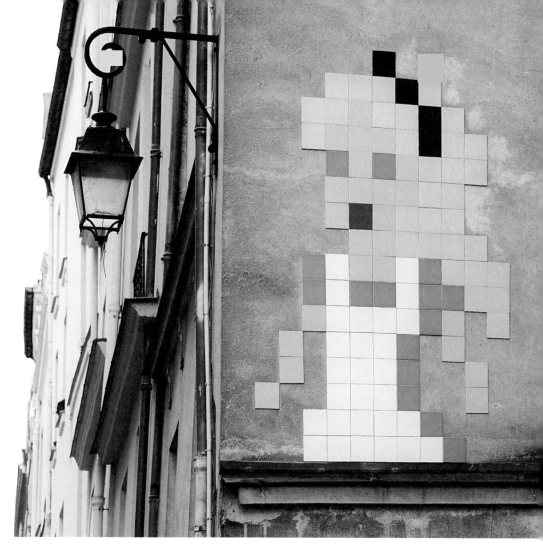

Invader, "Alice in Wonderland"

MisseKat means kitten in Liselotte
Nissen's native Danish

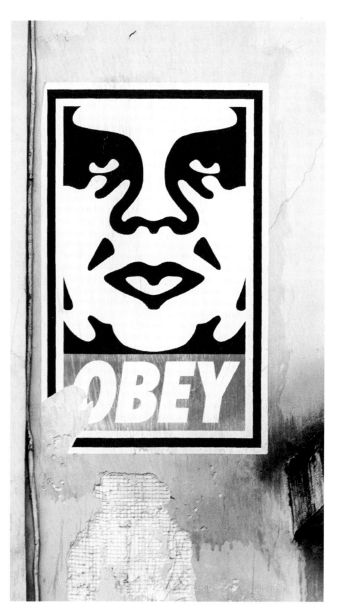

The Obey Giant campaign by the artist Shepard Fairey has become an international success story thanks to stickers

A woman's face made of men's heads by Gregos for Women's Day

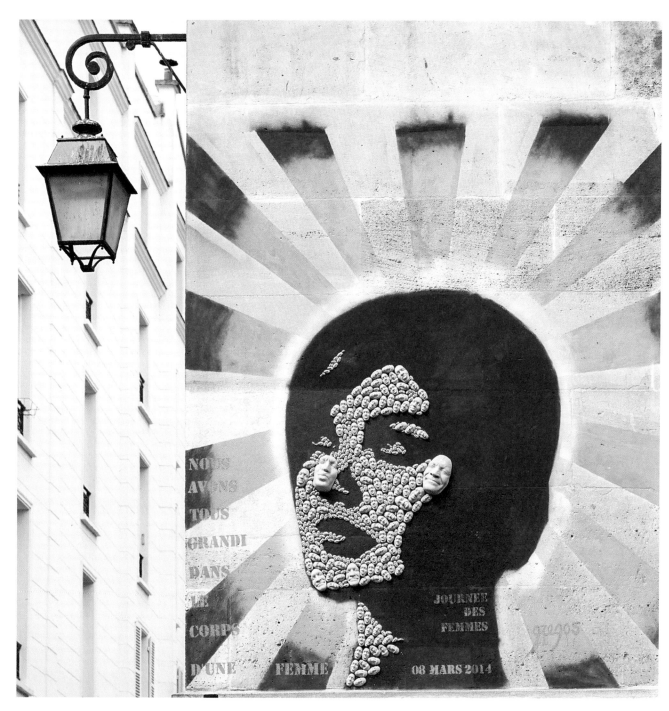

NOUS AVONS TOUS GRANDI DANS LE CORPS D'UNE FEMME

JOURNEE DES FEMMES

08 MARS 2014

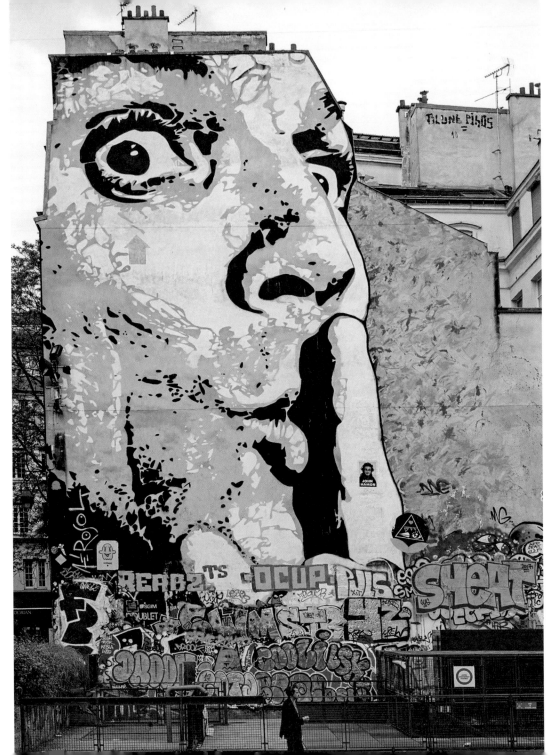

With his self-portrait "Chuuuttt!!!" in the immediate vicinity of the Centre Pompidou Jef Aérosol urges the viewers to listen closely and pay attention

**Jef Aérosol
"I prefer people to things"**

Jean-François Perroy, better known as Jef Aérosol is one of the first urban artists. As a 25-year-old in 1982 he sprayed his first stencil work in Tours, a self-portrait based on an enlarged photo booth picture. Along with other greats like Blek le Rat, Miss Tic and Speedy Graphito, he has influenced the work of subsequent "Pochoiristes".

Jef Aérosol has lived and worked since 1984 in Lille, in northern France. However, his works can be seen worldwide: in the most important cities in Europe, in North and South America, in Tokyo, in La Réunion and currently in Izmir in Turkey. He even installed the famous "Sittin' Kid" as a Great Wall of China paste-on.

Life-size formats still predominate in his work, but over the years he has developed the stencil technique and there are now murals covering entire building façades. He painted his approximately 350-square-meter "Chuuuttt!!!" his largest work to date, in the direct vicinity of the Centre Pompidou.

Most often Jef Aérosol does portraits of celebrities like Elvis Presley, Lennon, Hendrix or Gandhi, but he will also take models from the street like musicians, beggars or completely normal pedestrians of all ages. His motto is "I prefer people to things". The red arrow on every picture is a kind of trademark. When asked about its meaning he leaves the interpretation to the beholder.

Aérosol is a man of many talents. He is a musician, performs solo and in different folk and folk rock bands and has recorded several CDs. He also publishes books and has provided stencil works for a French feature film.

For more works by Jef Aérosol see pages 92, 93, 95.

Is that allowed?
Bonom's hanging,
often bled-to-death
animal and human
bodies ask this
question

Beginning in 2006 the Belgian painter Bonom
has been creating large murals, which can
also be shocking

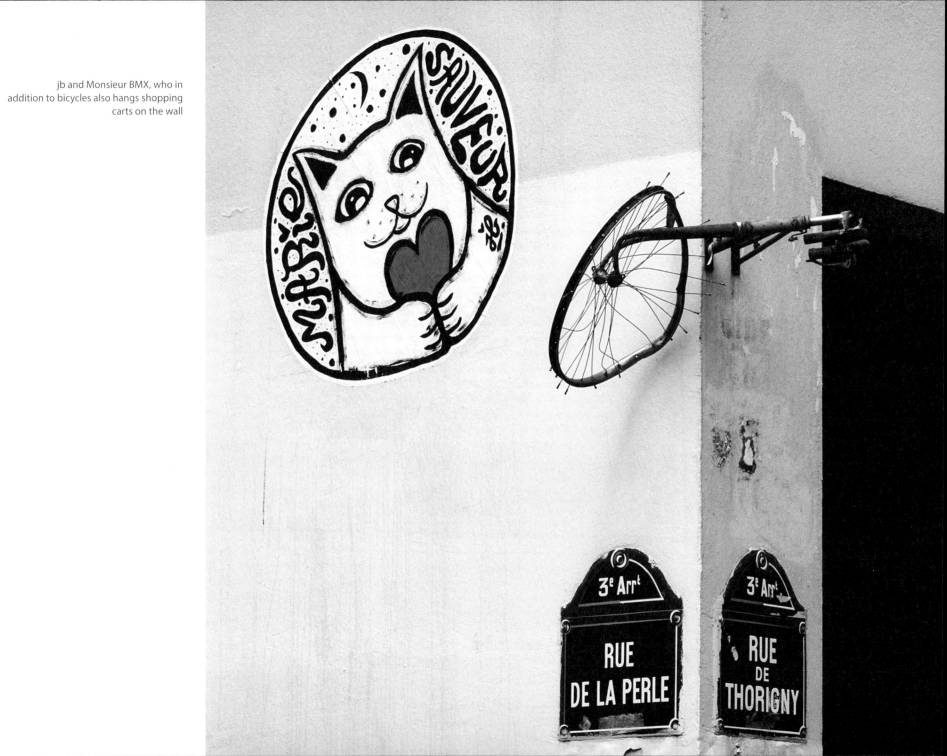

jb and Monsieur BMX, who in addition to bicycles also hangs shopping carts on the wall

The 13th Arrondisse-ment

As part of "Street Art 13" various renowned artists from around the world have created mostly gigantic murals in the 13th Arrondissement over the last few years. The project was initiated by the art gallery Itinerrance and the district government. "No city unites so many works. They're going to energize the whole district", explains Mayor Jérôme Coumet in the daily newspaper "Le Monde".

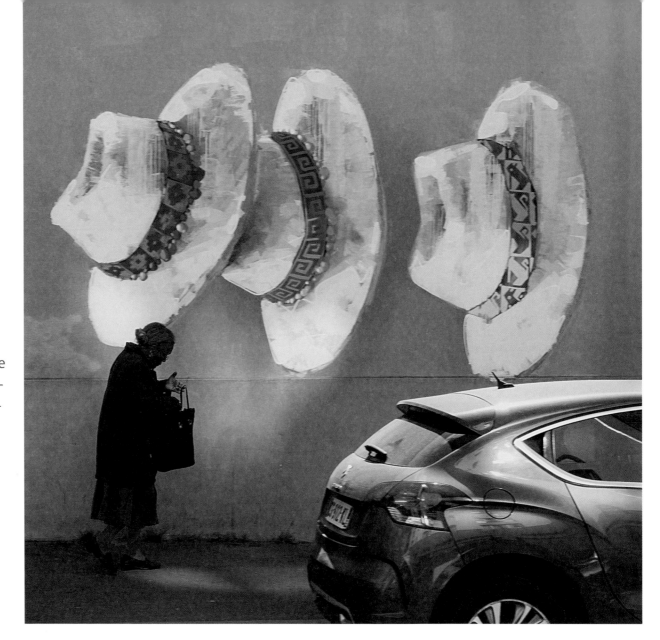

Section of a large mural by INTI showing a reclining Mexican woman whose hat has been blown off her head in a breeze

STRØK, Anders Gjennestad from Norway, uses unusual perspectives in his work

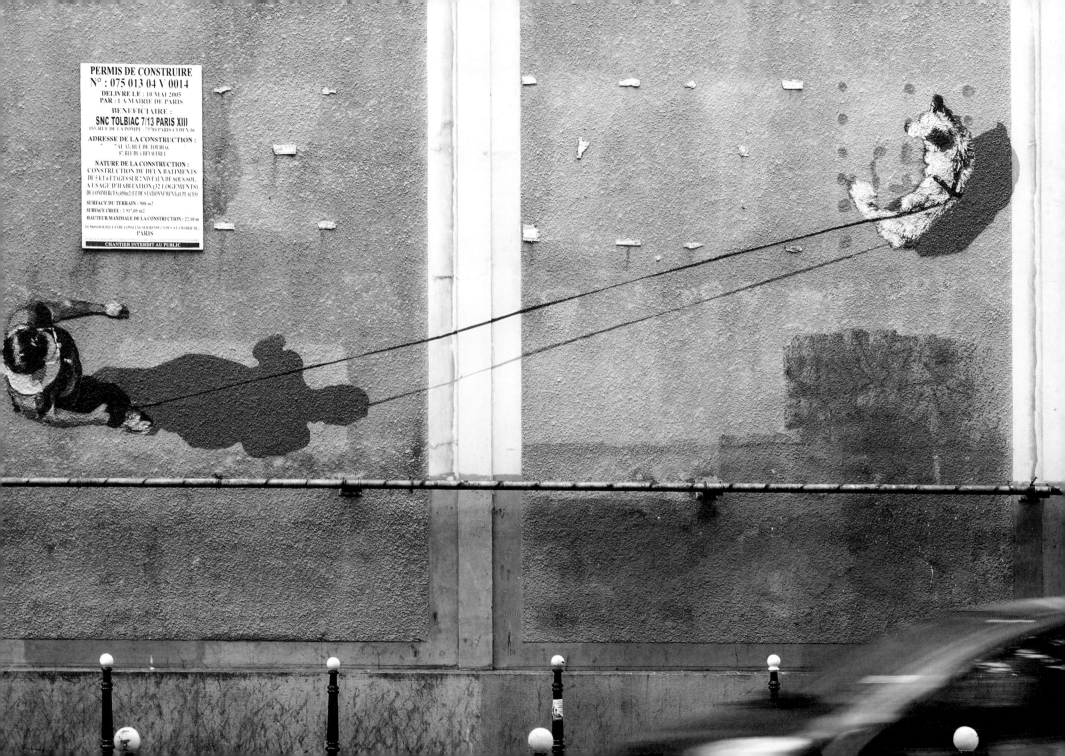

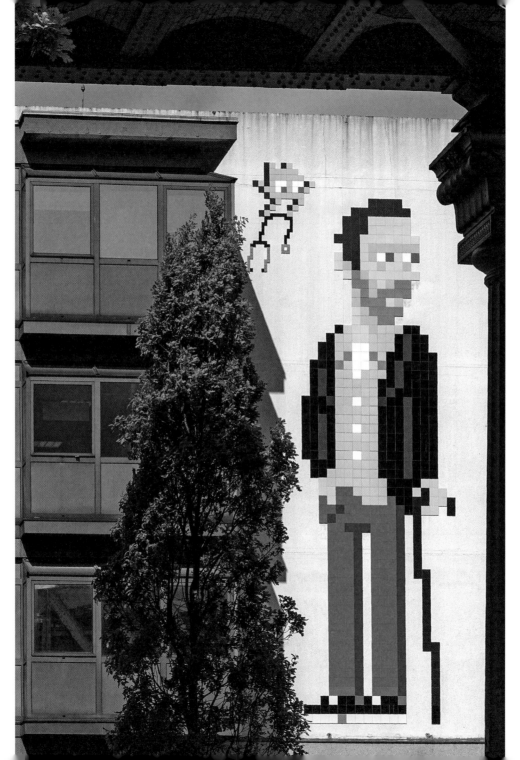

In this ten-meter-high work in the Hôpital de la Pitié-Salpêtrière Invader was inspired by the American TV series "Dr. House"

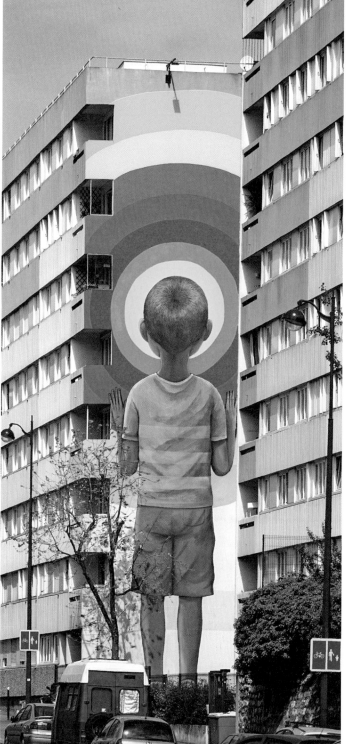

Inti Castro is Chilean and known for his over-dimensional murals. In his native language Inti means "sun"

The real name of the Paris-born Seth Globepainter is Julien Malland

Belleville

Belleville is the multicultural district in Paris, where many artists have settled to be inspired by the atmosphere there.

The "l'Homme en blanc" created for the first time in 1983 by Jérôme Mesnager, decorates walls around the world

"Rejoins-moi! – Hold me tight!", by Arnaud Liard alias HONDA. He grew up in the banlieue of Paris and has his roots in the graffiti scene

Children's portrait by C215, Christian Guémy

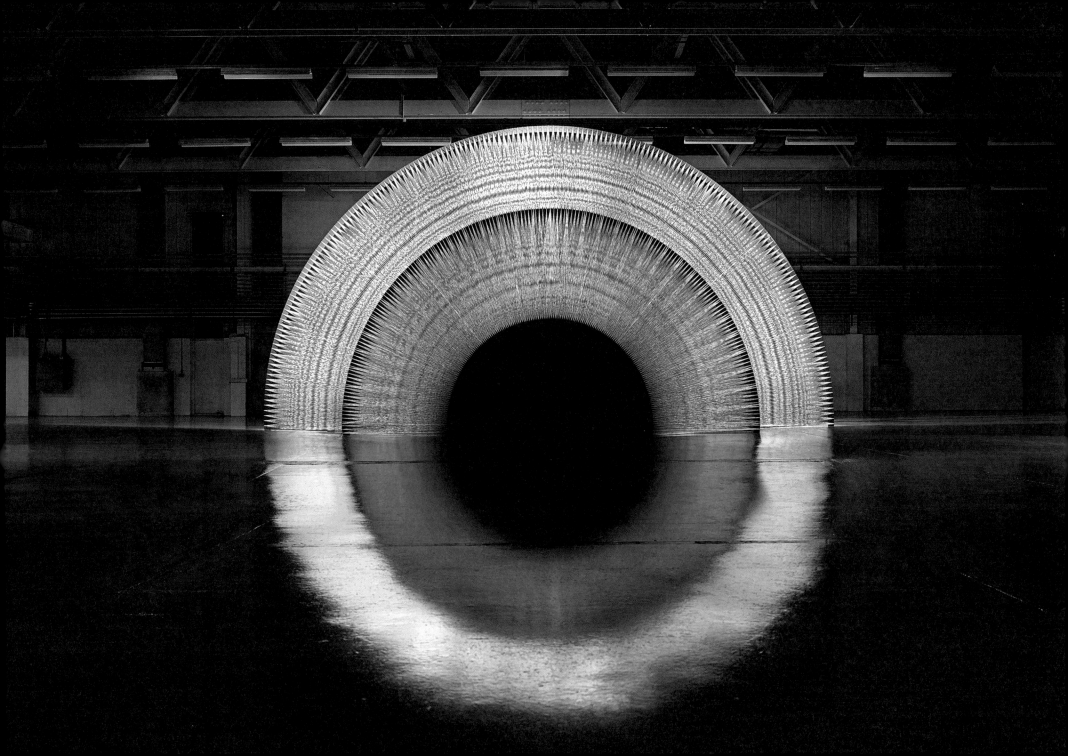

Sébastien Preschoux, "audi"

Sébastien Preschoux
"When the work is finished,
it leaves me"

"I live to work", is Sébastien Preschoux's credo. "I'm always listening, looking for new ideas, for inspiration." He wanted to be a carpenter, "but craftsmanship is not recognized in France", in his opinion. So, in keeping with the wishes of his parents, he studied psychology. But he has never lost his admiration for craftsmanship. Quite to the contrary. He got involved with the Bauhaus theory of Walter Gropius and his New Architecture, which unites art and craftsmanship. But even if Preschoux does not consider himself a street artist, public space is a stage for his wonderful, large-scale installations made of colored cotton string and light.

He couldn't create works like the usual urban artists, he says. First of all, he could not start a work if there were a danger that it might not be completed. Secondly, he couldn't stand up under the pressure to produce something so quickly. And thirdly, snap-shots like that could not do justice to his demands for high quality. The perfectionist never does something twice. "When the work is finished, it leaves me", he says. "Then my goal becomes designing the next project even better."

The island of La Réunion

La Réunion, the French island in the Indian Ocean, is a place where many international artists come to realize their potential. It has something to do with the unusually picturesque backdrops: the ocean, palms and large, dilapidated walls. But many La Réunion street artists have now achieved international renown, like the famous Jace with his "Gouzou" figures, Méo, Sainge, Sept or Floe, with her graphic female figures.

The witch fits wonderfully in the island landscape

Jace, one of the best-known La Réunion street artists, shows his "Gouzou" figure in all life situations

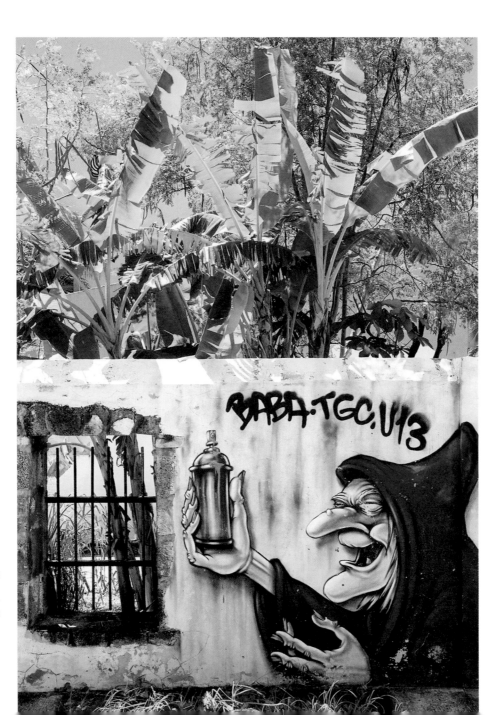

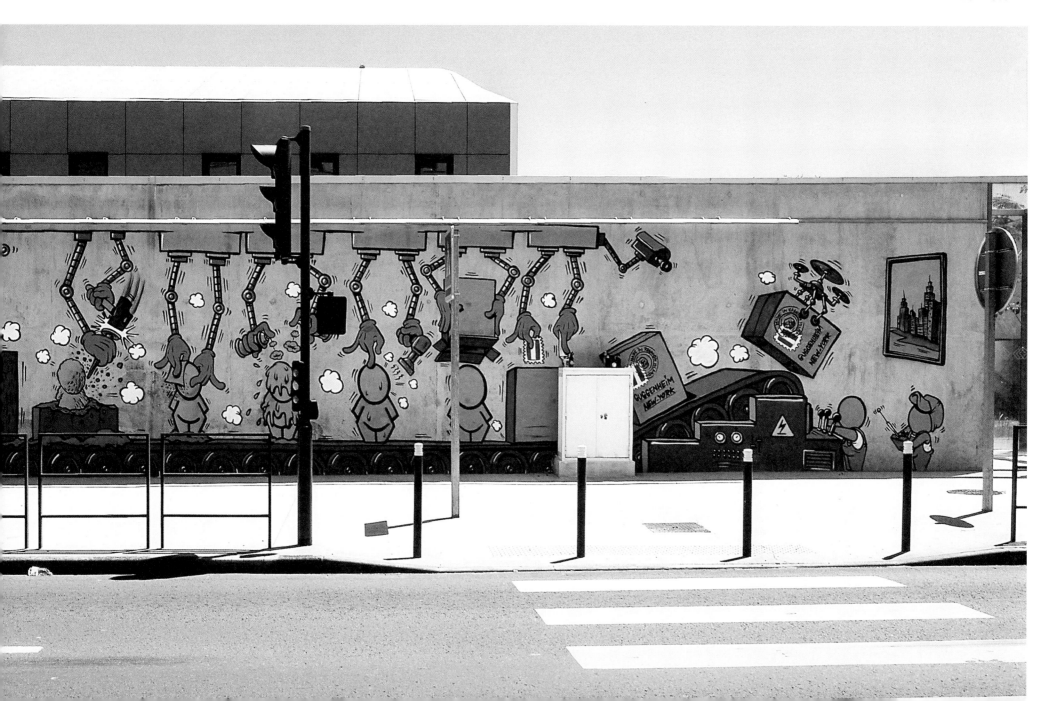

Sept and Box, two La Réunion street artists who often treat island life in their works

Vincent Box's lettering and the red hydrant as a picturesque ensemble

Lisbon

Lisbon has street art for every taste: from small master works on stickers to giant murals extending several stories high or chiseled directly in the wall. The municipal administration seems to have recognized the enormous potential of street art and actively supports this art form. Surfaces for street art are made available and once a year a great street art festival takes place which focuses on new works in the suburbs, where the sometimes depressing concrete fortresses are waiting for colors and contents to breathe life into them.

Among the best-known and most unusual street artists are the two Portuguese artists Bordalo II, who have made a name for themselves with trash art, and Vhils, Alexandre Farto, whose weapon of choice is not a can of spray paint but a hammer, chisel or a jackhammer. In 2017 Underdogs Gallery, operated by Vhils, invited Shepard Fairey (Obey), to Lisbon, resulting in a huge joint mural by both of them.

Shepard Fairey gave a very clear impression of his visit to Lisbon on whudat: "For anyone who hasn't been there, and this was my first time, Lisbon is an extraordinarily beautiful city. The architecture, the cobblestone streets, the ceramic tiles, and the wrought iron balconies have more than enough charm by themselves to be a great reason to visit Lisbon. When you add the contemporary murals, many of which have been facilitated by the Underdogs crew, Lisbon is a must-see for any connoisseur of aesthetics throughout the ages."

"No one had the intention to build a wall …" by AT, Andrea Tarli

In memory of the peaceful Carnation Revolution in 1974, which still symbolizes freedom for Portugal today. But it was with this very work that the artist Adres had problems with the police

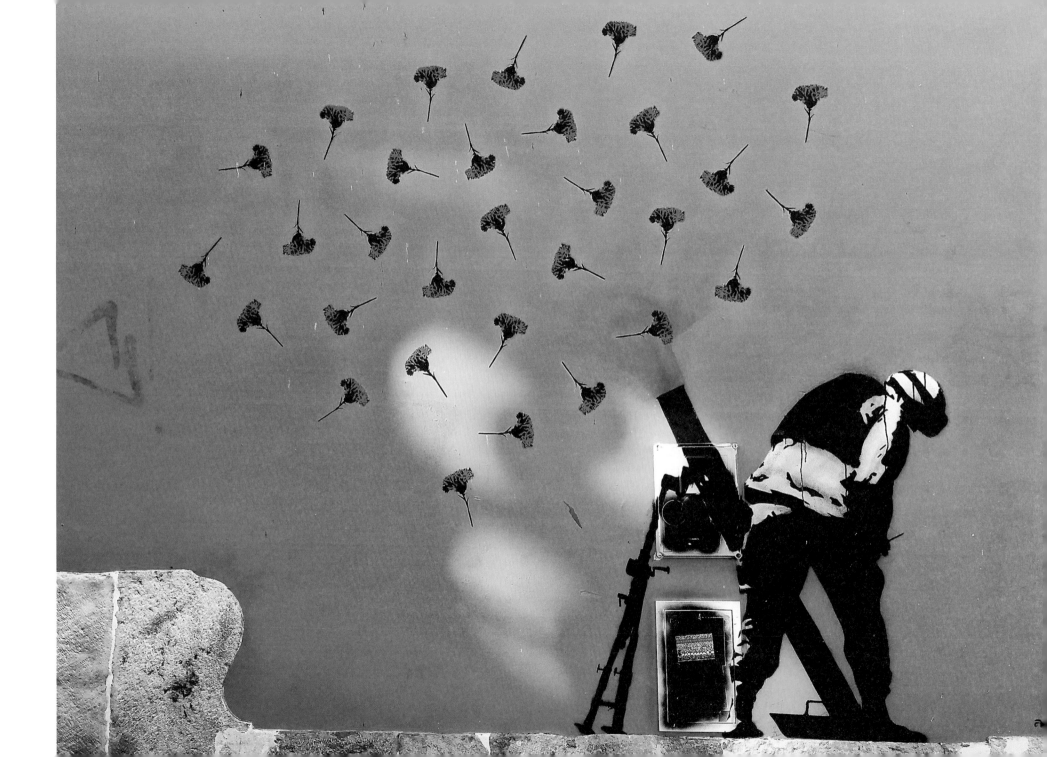

Vhils
"Instead of leaving
something on the wall, I take
something away"

When Vhils was a teenager and graffiti spraying became too boring for him, he started carving patterns and motifs in billboards, covered with layer upon layer of posters. What started out as random patterns, similar to the décollage, or torn poster, which first surfaced in France in the 1950s and 1960s, soon developed clear contours in his work. Today Vhils works mostly on stone walls, chiseling and grinding out the motifs from the walls, creating relief-like sculptures and murals, mostly portraits of people. "I started out with graf-fiti but I'm forging new paths today", declared Vhils. "Instead of leaving something on the wall, I take something away."

In 2007, when he was in his twenties, Vhils spent some time in London to study at Central Saint Martin's College of Art and Design. Tristan Manco (among his other functions curator of Pictures On Walls) immediately became one of his most important supporters. International recognition was not long in coming: His art can be seen on streets around the world, but also in many exhibitions in various cities in Germany, in London, Paris, Hong Kong, Sydney and, of course, Lisbon. His works are often used in music videos, like those of the Portuguese soul/ trip-hop band Orelha Negra.

The Portuguese government bestowed the Knight's Cross of the Order of St. James of the Sword on Vhils for his extraordinary achievement in the service of art, an honor hardly any other street artist has received.

Vhils, Alexandre Farto

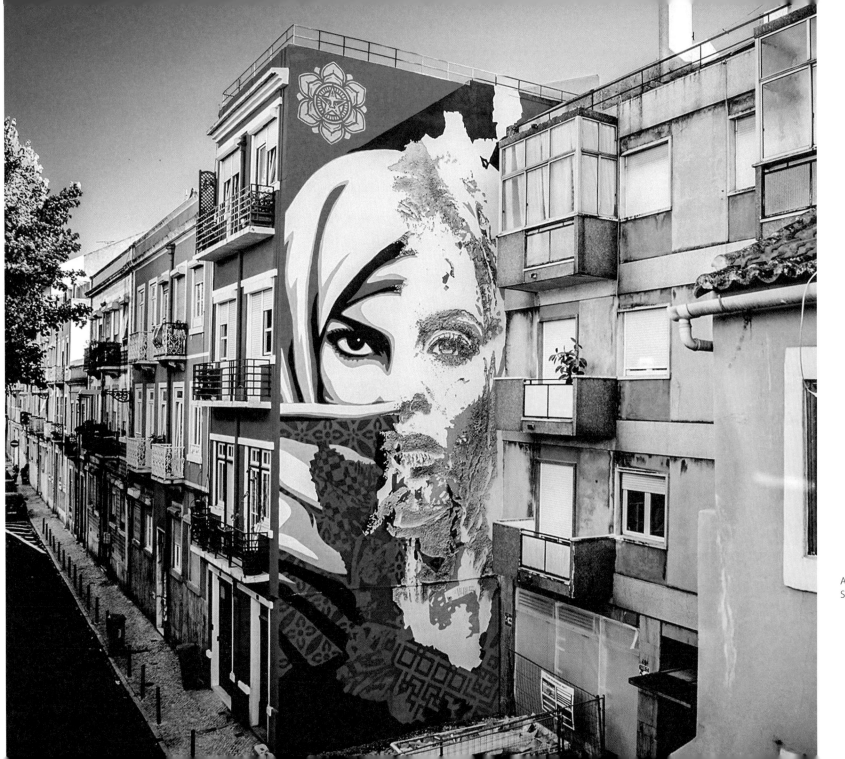

A joint work by
Shepard Fairey and Vhils

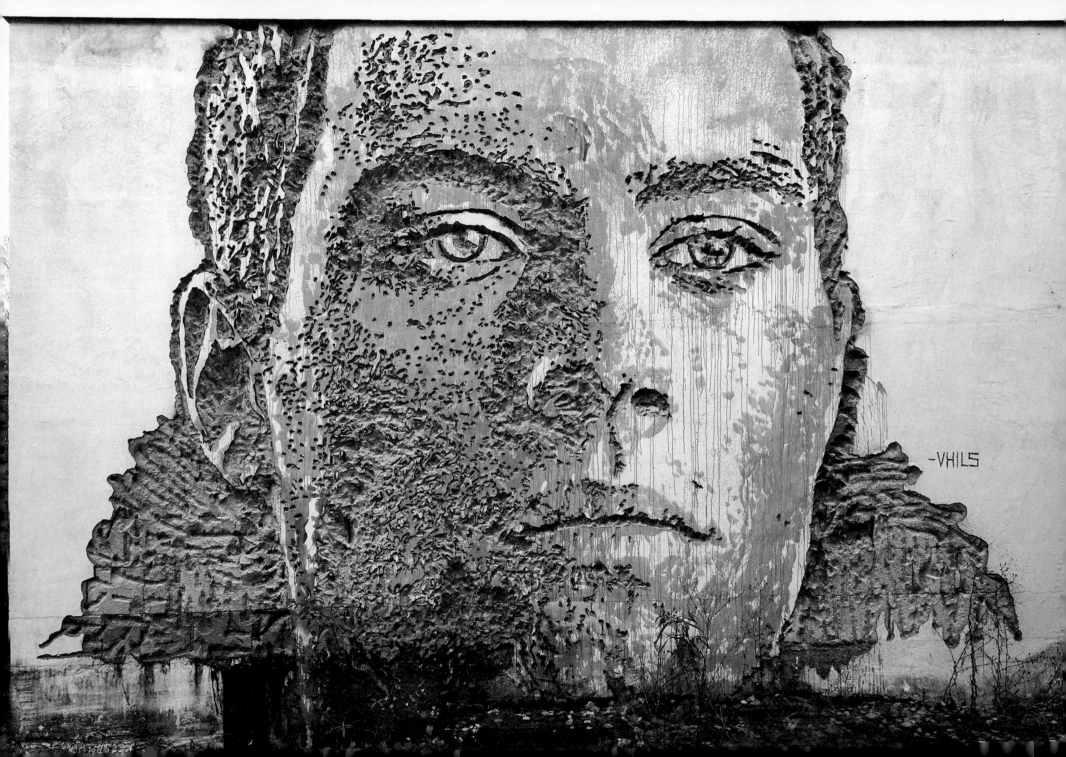

Vhils doesn't use spray paint or paint. He grinds or blasts his art works in the walls, like his over-sized face of a young man from a slum here in the Völklinger Hütte

One of the few women among the street artists: Mariana Dias Coutinho

TONA, a stencil artist from Hamburg, often does children's portraits

Faial

They're actually inscriptions which one encounters in the harbor in the islands of the Azores, not classical graffiti or street art. They're considered good-luck charms belonging to a tradition going back many years. "The legend says that the ship of a sailor who refused to leave behind a 'mural' on the wall of the harbor, was completely destroyed in a storm on the journey from Horta", as Americo Vargas from the Office of Tourism in Horta, Faial tells the story. Since then it has been a must among the sailors here in the middle of the Atlantic between Europe and America to perpetuate themselves on the causeway before continuing their journeys, along with a Gin and Tonic served in the big, rotund glasses with a generous bundle of herbs in the Peter Café Sport.

The Horta quay wall is covered with a layer of paintings

Barcelona

The history of street art in Barcelona is closely woven with political developments. In 1975, after the death of Franco, a new understanding of freedom and democracy unfolded throughout Spain. The police closed their eyes while more and more graffiti, stencils, murals and other works appeared in the alleyways of the old city. Well-known works by artists like Banksy and C215 were to be seen. In 1989 Keith Haring also spray-painted many of his famous dancing figures and snakes on the Plaza Salvador Segui.

In 2006 that all came to an abrupt end when a zero-tolerance law went into effect and artists who are caught spray-painting risked a stiff fine. The city attaches great value to "clean streets" and regularly has the walls cleaned. The artists have increasingly retreated to private surfaces, like the shut-

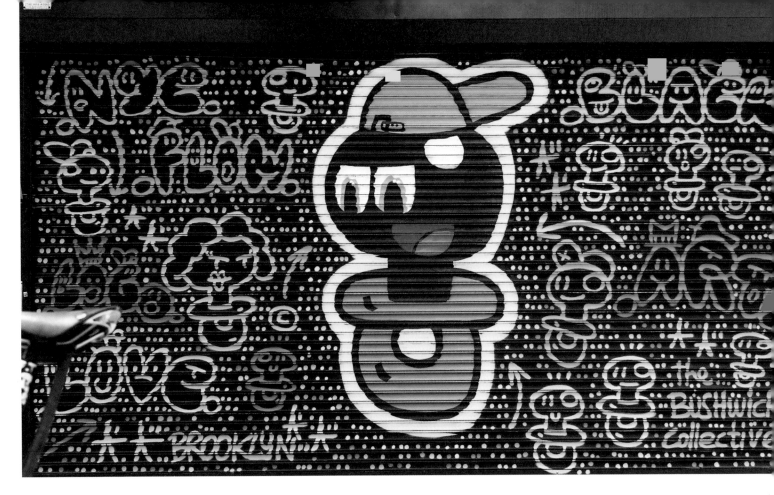

With his black and colored pacifiers El Xupet Negre is among the better known street artists in Barcelona

ters of businesses. And the outlying districts of Barcelona have become more interesting for street artists because the police presence is less there.

"Spain has a proud history of great painters, so I am always inspired by the old masters", explains Aryz, one of the best-known street artists living in Barcelona. In addition to Aryz

there is El Pez ("the fish", whose trademark is a one-eyed grinning fish) and El Xupet Negre (Catalonian for "The Black Pacifier") who is one of the better known names in Catalonia.

Ruben Sanchez alias Zoonchez began his career in the streets of his hometown of Madrid and in Barcelona

One meets up with the grinning one-eyed fishes of El Pez around the world

CARRER
DELS
PETONS

amor antes de nada
real ante todo

The mosaic technique seen throughout Barcelona of the Catalonian architect and artist Antoni Gaudí (1852–1926) lives on in this mural in the middle of Barcelona

Beautiful pictures or nice words on old beverage cans: Chef Love was here

The stencils of Raf Urban from France are mostly portraits

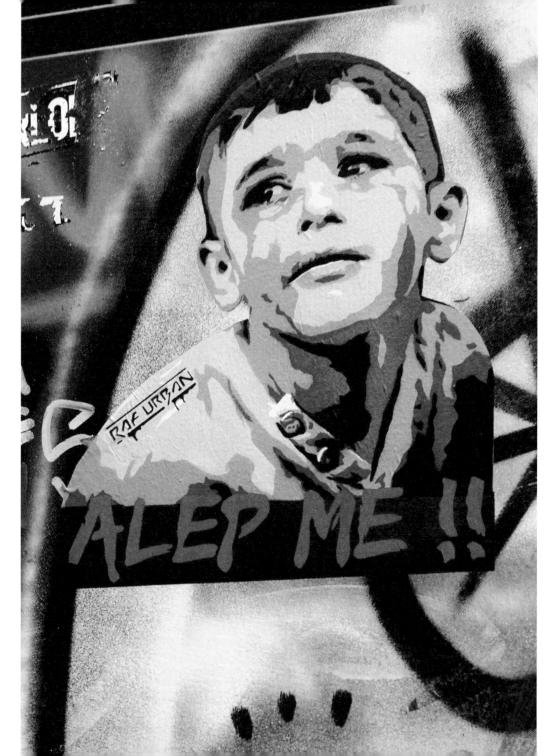

"Blu is one of the most internationally significant street artists"

The international art portal WIDE-WALLS, which by describing the evolution of urban art in Italy draws on great names like Michelangelo and Leonardo Da Vinci, features the Bologna street art and video artist right at the top of a current list of the best. Like Banksy, Blu has succeeded up to now in concealing his identity. He is one of the greats in his trade and his homepage, blublu.org, is one of the most exciting in the internet. For the Goethe Institute in Madrid Blu is "one of the most internationally significant and critical street artists for murals".

Blu has practiced urban art since the mid-1990s. His works can be found in several European countries, on the West Bank and in North, Central and South America. Blu is known in Germany above all for the large surface Cuvry graffiti in Berlin Kreuzberg. They were blacked out in 2014 with his permission as a protest against gentrification.

Screenshots: The homepage blublu.org of the Italian street artist Blu is done as a sketch book and contains exciting and idiosyncratic videos

Venice

Street art in Venice, that sounds like a contradiction. Venice stands for history, tradition and grandeur. And the Palazzi walls are so old and honorable that spray-painted murals and graffiti are hard to imagine. In fact, they are forbidden. But urban art can still be found in the city of lagoons, for instance on the water. An installation by the artist Lorenzo Quinn, born in Rome in 1966, is especially prominent. Two giant, nine-meter-long white hands rise up from the Canal Grande, seeming to support a house on the banks. It's called "Support", and the artist has this to say about it: "I wanted to make a statement about climate change and the role that has to be played by human beings to save the unique world heritage of Venice." A call to combat climate change and the rising sea level threatening Venice.

A Venetian mask with a long nose quickly sprayed on shutters together with the question "WASH?"
The unknown artist himself asks, should the work disappear again? That would be a shame

ITALY

Paolo Pupin
"There are no bare concrete surfaces for you to paint on"

"I would have gladly become an artist, and I would have been a good one. We were active throughout Italy. Some of my former graffiti friends remained true to their passion, for instance as tattoo artists. As a young man under the pseudonym Stain, I spray-painted inscriptions until it was forbidden in Venice. And I can understand that. There are no bare concrete surfaces for you to paint on. The walls are old and not suitable for 'urban canvases'. So I became a concierge in my late twenties. I've been working for 12 years in the same hotel and can show guests who are interested where a few murals can be found."

Parallel to the Biennale in 2017 the Barcelona-based sculpture artist Lorenzo Quinn presented his installation "Support". He took the hands of one of his three children as a model, "to speak to the people in a clear, simple and direct way through the innocent hands of a child", as he wrote on Instagram. Quinn is the son of the actor Anthony Quinn. He lived and studied in New York until he decided to leave the US with his family and settle in Spain. His occasionally monumental works can be found in galleries, museums and plazas around the world

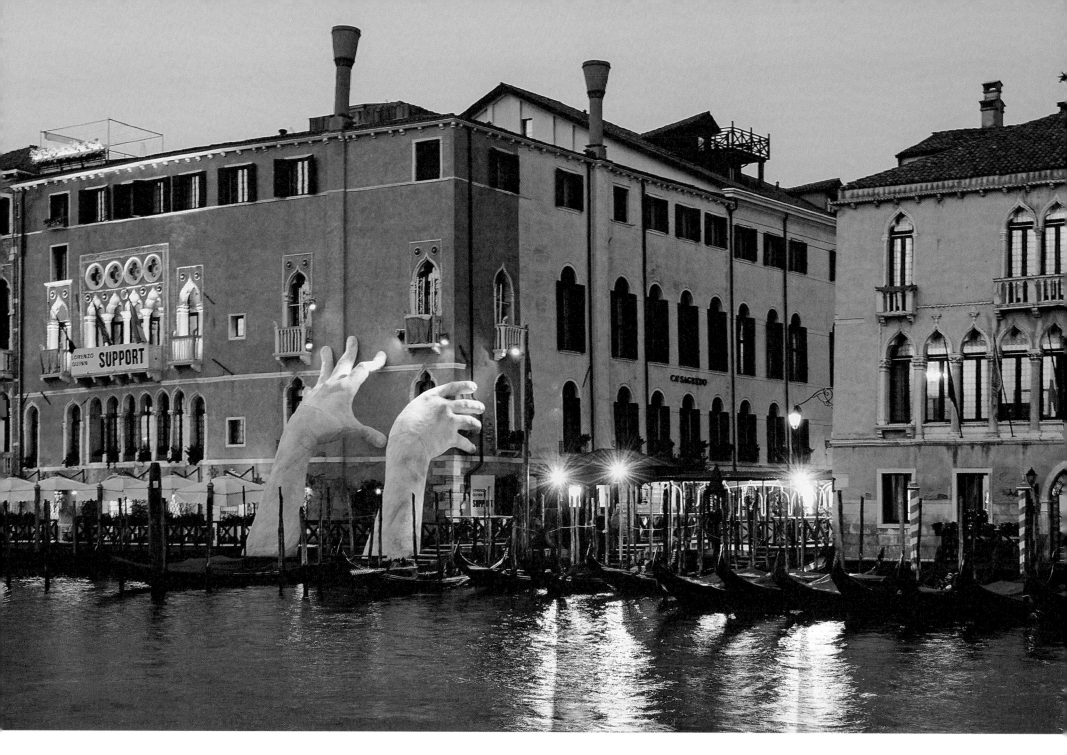

Florence

Florence is called "the world capital of art" or "the cradle of the Renaissance". But the cultural metropolis in the middle of Italy has "dusted itself off" in the past few years and has started offering exceptional contemporary art. And those interested in urban art will also get their money's worth. They can't avoid running into the street signs revamped by the French artist Clet Abraham. "It's like stamp collecting. Certain signs turn up regularly, others are bit more rare and you know that others exist, but you haven't seen them yet. Those are the rare ones", according to Dieter Senn, who has photographically documented the signs.

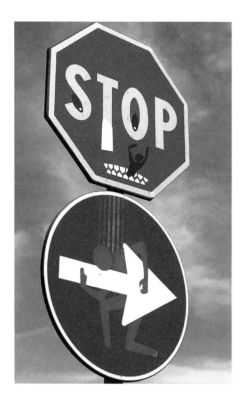

Born in 1966, the Frenchman Clet studied art in Rennes and has lived for many years in Florence. He has been designing street signs since 2010, at first in Florence, then in many other larger cities. He doesn't want his works to be destructive and doesn't think that the street signs confuse the drivers. "I work with symbols. Humor is important for me and I make sure that my design doesn't interfere with the sense of the sign", he explained in an interview with the "Frankfurter Allgemeine Zeitung" newspaper

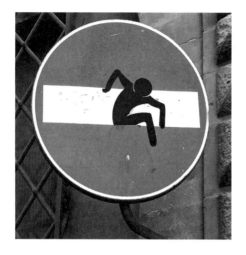

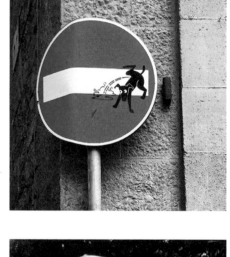

Athens

"There's a lot going on in the urban art scene of Athens overall, not just in painting. Music and dance are part of it, too", says Cynthia Odier Kitrilakis. She should know. With projects of her Geneva cultural foundations, FLUXUM Foundation and Flux Laboratory, the former ballet dancer of Greek extraction is deeply involved in the country.

The street art scene is going on right in the middle of the city. It lives from the many native artists but is also fed by internationally active ones. The subjects are marked by the current history of the crisis-torn country. In an interview with the "New York Times" the Greek painter INO said: "If you want to learn about the city, look at its walls."

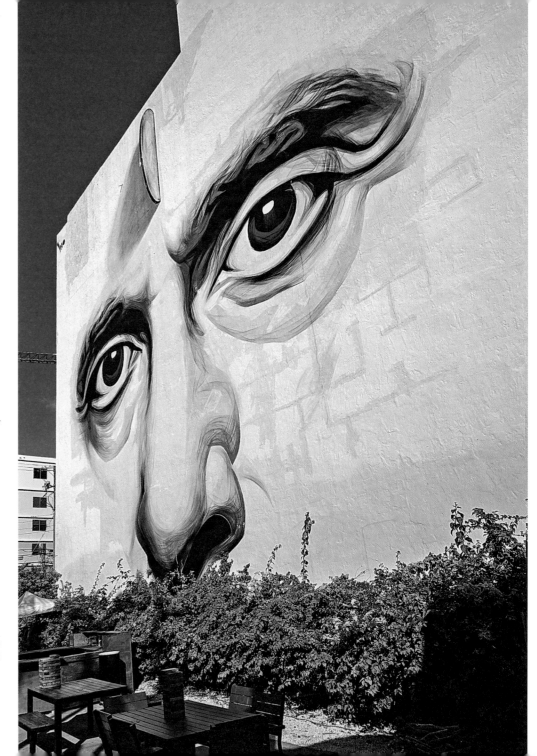

"In Heaven With You", INO's contribution to the Miami Art Basel

WD's mural "Knowledge Speaks – Wisdom Listens" in Athens

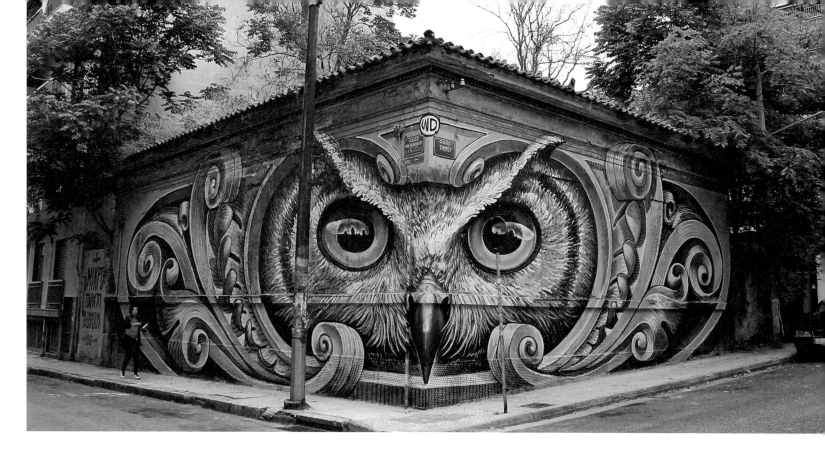

WD's mural "Knowledge Speaks – Wisdom Listens" in Athens

A self-portrait of the artist WD

WD
"Our planet has its own needs"

WD was born and raised in Bali, now resides in Athens, is artistically active in the international arena, and for all his youth is very aware. "Our planet has its own needs, that we have to respect", says WD (Wild Drawing) at the opening of his solo exhibition in the Basel Natural History Museum. "We should not try to control everything just for profit." His works, mostly large surface murals, address important questions of humanity, as can be gathered by the name of his works like "Give Peace a Chance" or "No Land for the Poor". It's not surprising that he tries to create a harmony between art work and the surroundings, which is strengthened by the impression of the viewer. WD has been part of the international street art scene since 2000. He has degrees in fine and applied arts and has never given up his studio.

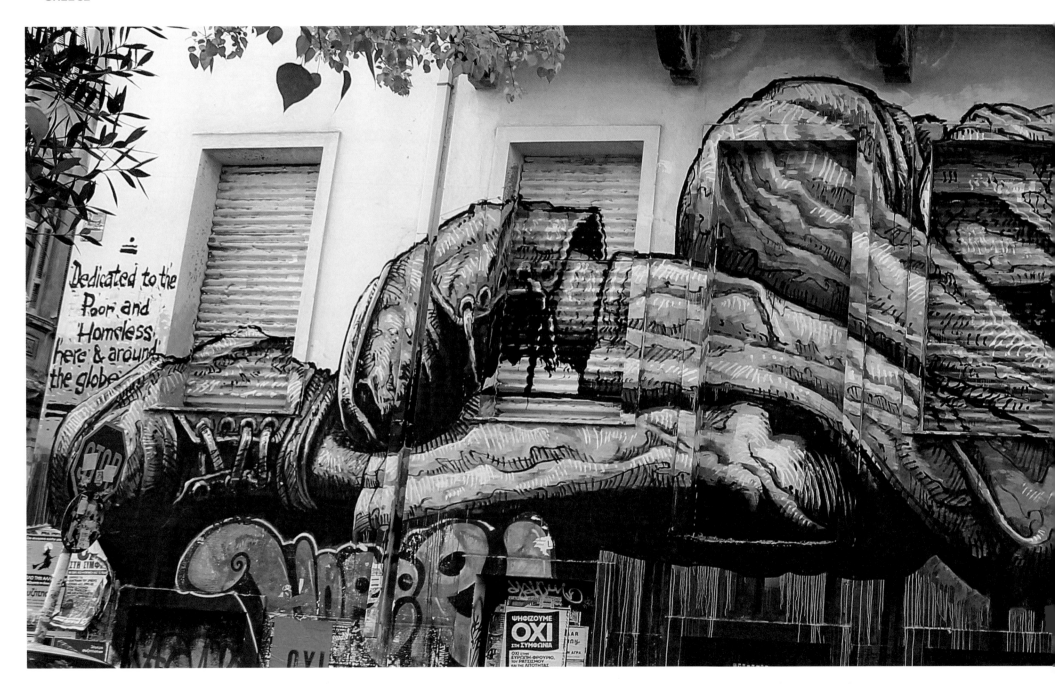

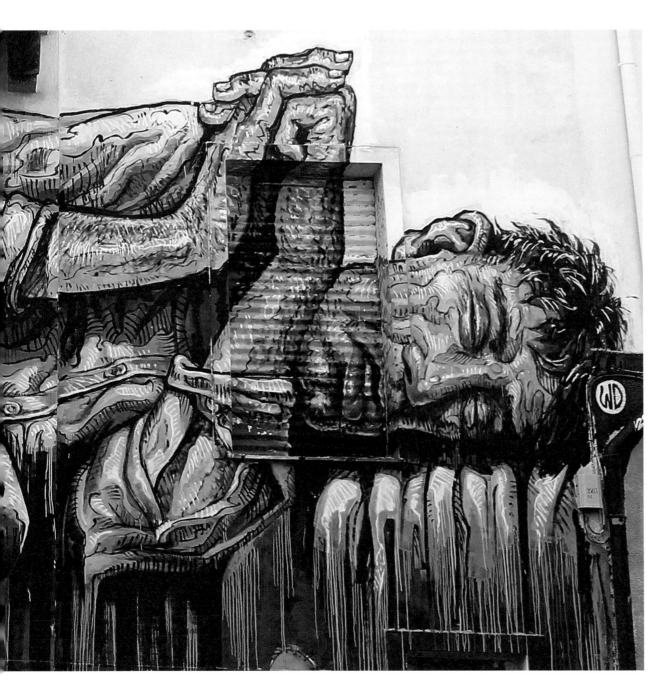

WD dedicated "No Land for the Poor"
to the poor and homeless

▶ Page 194/195
"What if I fall? But imagine, what if you fly?" and
"Give Peace a Chance" by WD in Athens, Greece

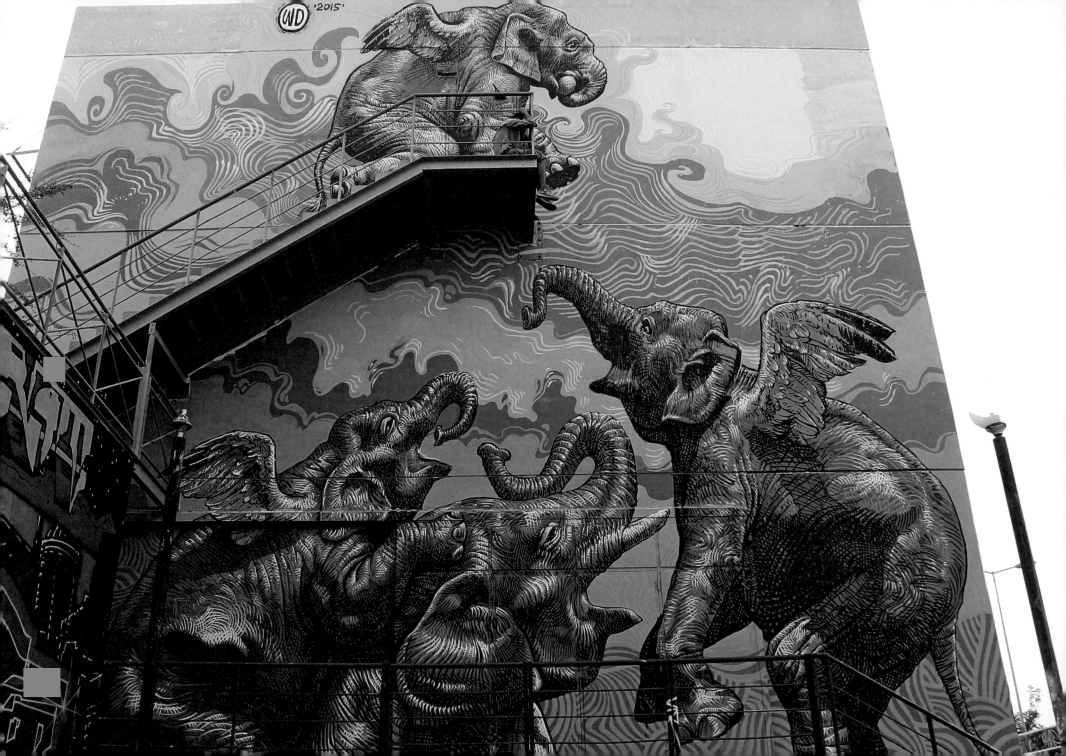

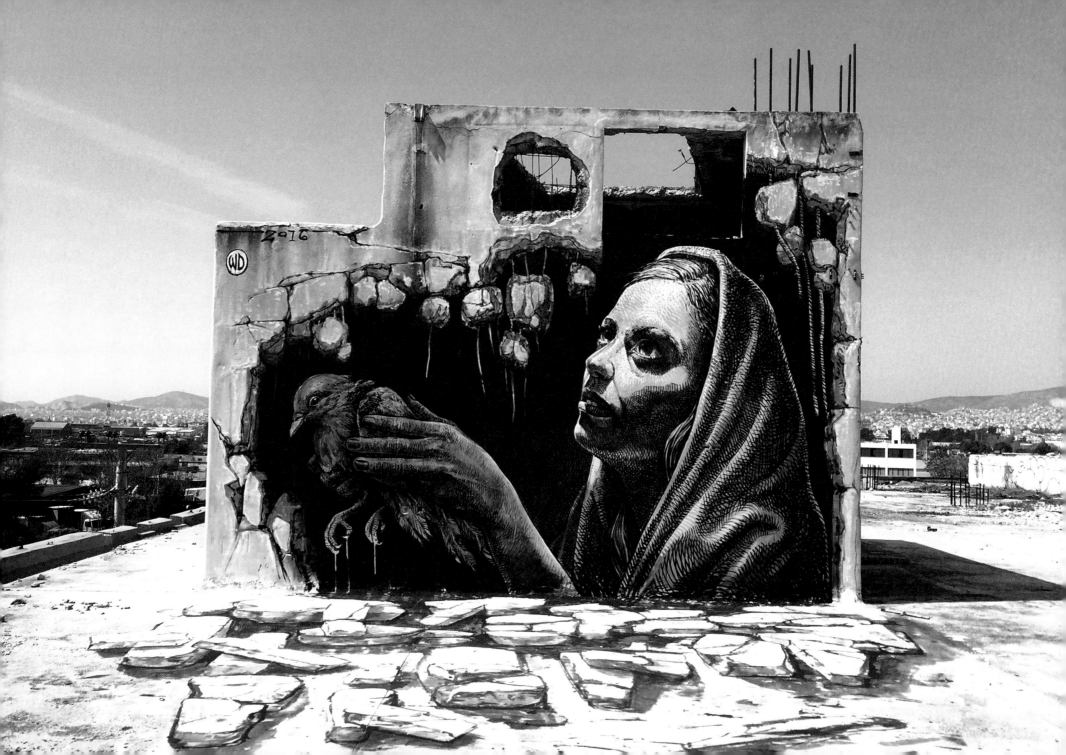

Budapest

When one thinks of Budapest, one thinks of the many traditional, impressive buildings for which the Hungarian capital is famous, like the Chain Bridge, the parliament building or the Hungarian State Opera and the castle district, which is part of the UNESCO World Cultural Heritage. But the city also has impressive new art to offer. One can find a successful combination of old and new in, among other locations, the 7th District, which is especially known for its many "ruin" bars. It's where the group NeopaintWorks, consisting of young art and graffiti talents, has been giving facelifts to old buildings. Many others followed their example.

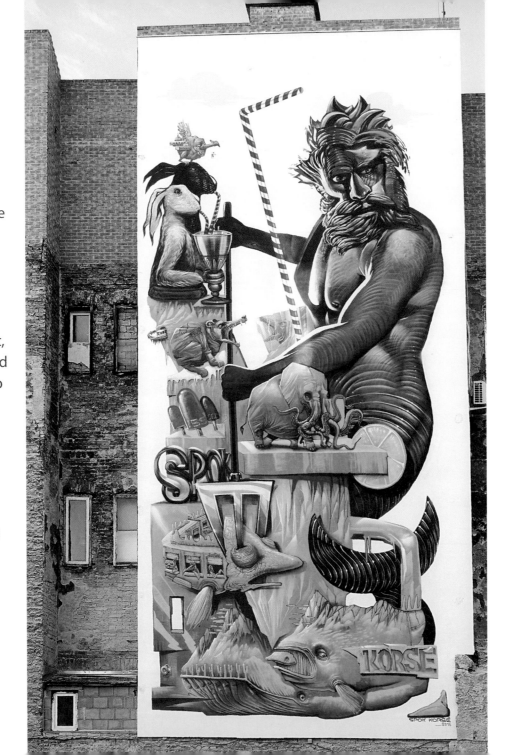

"Poseidon" by Spok (Spain) and Korsé (France) watches over a world of ancient underwater inhabitants and creatures from a modern era with fantastic details

The Russian artist Andrey Adno is at home in many artistic genres. His mural "Urban Style" symbolizes the varied population structure of Budapest. It was created in just three days

The "swallows", a symbol of peace for the Hungarian artist Károly Mesterházy (aka BreakOne). They were realized in the context of the Színes Város Festival in 2016

▶ Page 198/199
Art made of mosaic stones is rare in the Hungarian urban art scene. The artist Márton Hegedüs put together the almost 20-square-meter "HESZTIA"

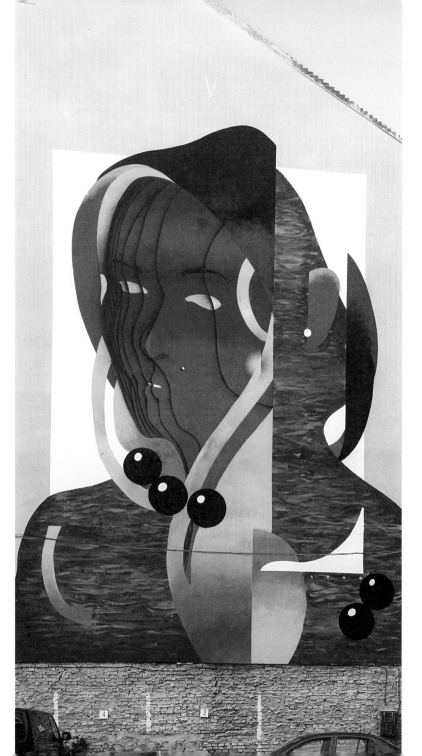